The Lyrical Left

THE
LYRICAL LEFT

Randolph Bourne

Alfred Stieglitz

and the
Origins of Cultural
Radicalism in America

Edward Abrahams

University Press of Virginia *Charlottesville*

THE UNIVERSITY PRESS OF VIRGINIA
Copyright © 1986 by the Rector and Visitors
of the University of Virginia

First paperback printing 1988

Library of Congress Cataloging-in-Publication Data

Abrahams, Edward, 1949–
 The Lyrical Left.

 Bibliography: p.
 Includes index.
 1. Avant-garde (Aesthetics)—United States—History—
20th century. 2. Radicalism—United States. 3. Bourne,
Randolph Silliman, 1886–1918—Contribution in the arts.
4. Stieglitz, Alfred, 1864–1946—Contribution in the
arts. I. Title.
NX504.A27 1986 700'.973 85-17773
ISBN 0-8139-1080-3 (cloth) 0-8139-1211-3 (paper)

Printed in the United States of America

To my mother
and in memory of my father

Contents

Preface

Before the First World War, the Lyrical Left, a loose coalition of cultural radicals living in New York City, dreamed of changing the world with pens, paint brushes, and new publications. They thought they could liberate society by combining radical politics and modern culture. New expressions in art, drama, literature, and cultural criticism, members of the Lyrical Left felt, could have a revolutionary impact on the world's social, economic, and political structures. To advance their belief, in a burst of creative excitement they founded experimental magazines, clubs, theaters, art galleries, and schools. These, they hoped, would shake the foundations of the established world.

The Lyrical Left opposed the politics of reform even more than it opposed the forces of conservatism. Instead of programmatic solutions to real problems, such as those proposed by their progressive antagonists, they offered a transpolitical, redemptive vision of personal freedom and social liberation. Extreme idealists, they fought materialism in both mind and deed. They united thought, feeling, expression, and action in a collective, but also intensely personal, quest for liberation. Fun, truth, beauty, freedom, peace, feminism, and socialist revolution were their bywords and guideposts.

There were hundreds of creative people who espoused the views of the Lyrical Left, some of whom left lasting marks on American culture. Among the more famous were John Reed, Max Eastman, Floyd Dell, Hutchins Hapgood, and Eugene O'Neill. But because Randolph Bourne and Alfred Stieglitz each contributed an essential and complementary component to the movement, an examination

of their lives and thought offers insights into the nature and significance of the Lyrical Left.

This is not to say that Bourne and Stieglitz typified the movement. They did not. Each was an outstanding leader in his own field. Bourne was a political and cultural critic who is best known for his sustained and lonely opposition to America's participation in World War I. Stieglitz was a man of the arts. Long considered the father of modern photography in America, he also introduced modern art into the United States. The two men seemed consequently to have lived in separate worlds and, to be sure, have been studied by historians as if they did. Stieglitz had none of Bourne's political insight, and Bourne for the most part did not share Stieglitz's devotion to photography and painting. But the significant point, one that provides the organizing principle of this book, is that Bourne and Stieglitz had much in common. Each, in his own but similar way, helped shape the Lyrical Left. In their common psychological needs, in their comparable ideas about culture, and in their shared personal and social goals lies a new understanding of the origins of cultural radicalism in the United States.

Bourne and Stieglitz never met. Had Bourne not died in 1918, mutual friends—Waldo Frank, Van Wyck Brooks, Paul Rosenfeld, or Paul Strand, to name only a few—would have surely brought them together. They were kindred souls. Both, albeit for different reasons, were extremely alienated from the capitalistic orientation and genteel nature of mainstream American society. Both in response became radical critics of American culture. Each man's thought embodied a highly personal, almost autobiographical, conception of society and the self, both of which they wanted to liberate by redefining and expanding the limits of the permissible. Neither considered seriously the contradictions between his extreme individualism on one hand and his fervent hope for community development on the other. Angered by personal frustrations and fired by compensating utopian visions, both were drawn to unconventional, antimaterialistic theories of the universe. In contrast to most Americans, who adopted a bastardized version of prag-

matism as their modus operandi, Bourne and Stieglitz were ardent romantics. Like Walt Whitman earlier, they sought to develop a new collective American consciousness. Each man assumed that there was no single correct way to perceive the universe, and from a pluralist perspective addressed the issues that most concerned him. For Bourne, these were, particularly after 1916, the pressing questions of immigration and the war; for Stieglitz, the problems of art's relation to society. Most important, both Bourne and Stieglitz thought of themselves as modernists, and, with the modernist movement generally, they sought world regeneration through cultural renewal. Finally, and not coincidentally, the two men shared, at least metaphorically, a common fate. By 1918 their hopes and dreams lay shattered in the destruction of World War I.

Based mainly on their own explanations in both private correspondence and public exposition of what they were seeking to accomplish, this book aims to understand Bourne and Stieglitz by concentrating on the ideas each espoused. For Bourne, who was a writer, my task was easier than for Stieglitz. Despite the fact that he sometimes wrote twenty long personal letters in a single day, Stieglitz was, by and large, inarticulate. A visual person and a man who preferred working behind the scenes, he never explained clearly what he thought, nor did he bother to reconcile the numerous contradictions and paradoxes that riddle his ideas. To understand what made Stieglitz the man he was, I have had therefore to rely not only on what he wrote but also on what others said in his behalf, on who and what he published, and, finally, on the kind of art that he showed over the years. My central focus, as for Bourne, nevertheless, has been his thought, not his photography or the paintings of the men and women that he sponsored. Formal art analysis I have mainly left to the art historians.

In my effort to recreate the intellectual world of Randolph Bourne and Alfred Stieglitz, I have tried to recapture how and why both men perceived and interpreted reality the way that they did. We are both more sophisticated and cynical than they were,

and, with historical hindsight, we can easily point out their some-times untenable assumptions and often contradictory aspirations. But I have attempted to do something else here as well, and this has proved a more difficult assignment. Believing that the dawn of the modern age was a fundamentally different era from our own, I have sought to uncover the intellectual context in which Bourne offered one of the most determined defenses of the individual in American letters and in which Stieglitz presided over a revolution in the arts. It is my view that Bourne and Stieglitz's firm, if also naive, belief before 1917 that art and criticism could liberate society and that personal freedom and collective unity need not be con-tradictory goals enabled them not only to develop as they did per-sonally but also, in the last analysis, to make their substantial con-tributions to American culture in the twentieth century. While they failed to realize the revolution in American society that had been their guiding objective, it was not for lack of vision or depth of imagination. Indeed, their legacy continued to inspire like-minded cultural radicals a half century after the demise of their generation's dream.

Although the scholarly life is often a lonely one, no book is ever the product of a single individual's work. I have benefited from many kindnesses and criticisms through the course of my research and writing, and it gives me great pleasure to acknowledge the help I have received. Library staffs at Brown University, the Rhode Island School of Design, Yale University, the University of Penn-sylvania, Columbia University, and the New York Public Library made the chores of research easier, if not pleasurable. I want to acknowledge in particular the Beinecke Rare Book and Manuscript Library at Yale, the Rare Book and Manuscript Library at Colum-bia, the Van Pelt Library at the University of Pennsylvania, and the Center for Creative Photography at the University of Arizona for permission to quote from letters in their manuscript collections. Georgia O'Keeffe, Laura Zigrosser, William S. Pollitzer, Miriam

Hapgood DeWitt, and Rosemary Manning have also generously granted me permission to quote from these letters.

Parts of chapter 2 first appeared in my article "Randolph Bourne on Feminism and Feminists" in *The Historian* (May 1981) and are reprinted here by permission of the editor, Gerald Thompson.

James Patterson, my dissertation supervisor at Brown, read my work again and again. He urged me to strive for clarity and precision, but gave me room to explore my own interests and to reach my own conclusions. I would also like to thank William Jordy and Tom Gleason, both of whom offered insightful comments and criticisms during the course of my work at Brown. In addition, less formally, but equally helpful, were Mary Gluck and Elinor Grumet, who generously took time from their own work to read my often unpolished prose and to discuss the issues of cultural radicalism with me. Arthur Cohen, Ruth Kaufmann, and Laurie Lisle reminded me that interest in art and politics of the past need not be limited to the sometimes narrow confines of the university, and I thank all three for their encouragement to continue my research and writing at crucial stages in this book's preparation. So, too, Dorothy Norman and the late Herbert Seligmann spent numerous hours discussing with me their remembrances of times past and their personal knowledge of the figures of this study. Mr. Seligmann, then in his nineties, remembered both Bourne and Stieglitz well. He told me, "You see, they were both against 'The System.' " At the University Press of Virginia, Walker Cowen, the director, and Gerald Trett, my editor, did everything a writer could wish. I thank them both for their assistance and active interest. I also want to thank Josh and Lynn Bell for typing numerous drafts of my manuscript. Most important and most helpful, however, was the assistance of my wife Ruth. She shared all the trials and joys of writing and rewriting this book. Finally, I would like to thank my parents for their love and continuous support through the many years it took to complete *The Lyrical Left*. It is dedicated to them for good reason.

The Lyrical Left

City of hurried and sparkling waters!

 city of spires and masts!

City nested in bays! my city!

<div align="center">Walt Whitman, "Mannahatta," LEAVES OF GRASS</div>

MANNAHATTA

1

Cultural Radicals and the

Quest for Self-Expression

In 1913, Eduard Steichen, an American artist studying in Paris, tried to describe the elusive spirit of his age. His feelings raced ahead of his ability to define precisely both that spirit as well as his place as a painter and a photographer in a changing world. He wrote his mentor, Alfred Stieglitz,

> *The relationship of all this [modern philosophy] towards a clearer and freer understanding of art as a means of expression interests me less in itself than as an element in the final relationship to life and the world problem everywhere and in everything. One is conscious of unrest and seeking—a weird world hunger for something we evidently haven't got and don't understand. To many it is a social and economic problem. —But this is only one of the elements of it— A bigger thing lies struggling*

beneath. —I have a vague feeling of knowing it and yet it looses [sic] *itself in its vagueness. Something is being born or is going to be.*[1]

So Steichen believed in 1913. In only four years he would regard such a notion as a soft-headed romantic illusion. But in 1913, before the Great War shattered the dream, Steichen thought he was witnessing—and helping create—the birth of a new era. He was not alone. His letter exclaiming how antimaterialism, modern forms of artistic expression, and contemporary mass politics would inaugurate a cultural and political renaissance reflected the thinking of his fellow cultural radicals who were living in, among other places, New York City. A year before, John Butler Yeats, a visitor to New York from Ireland, a painter, and father of the poet, had said he could hear fiddles "tuning as it were all over America." Employing the same metaphor, the writer Floyd Dell dubbed 1912 the "Lyric Year" to indicate his feeling too that the era was about to witness new directions in social, economic, political, and cultural life that, when combined, would revolutionize the world.[2]

Historians have confirmed these intuitions. The second decade of the century was one of cultural and intellectual ferment, particularly in New York City's Greenwich Village. From 1915 to the present, they have referred to the phenomenon as "America's Coming-of-Age," the "Innocent Rebellion," the "New Paganism," the "Lyrical Left," and the "New York Little Renaissance."[3] Though each label reflects a slightly different evaluation of the Greenwich Village revolt, all point out its eclectic nature. The rebellion's chief characteristic, they suggest, was its willingness to define politics and culture broadly so that, according to the proponents, the new cultural developments would have significant repercussions on how people organized their lives. The artists, writers, and bohemians who composed the cultural revolt wanted to use art to liberate themselves and society from what they considered to be artificial abridgments of personal and social freedom.

Though easy to ridicule (as many serious scholars have), this early twentieth-century modernist movement represented a conscious rejection of a bourgeois, Protestant, and materialistic life that, to cultural radicals, was personally stifling and socially reactionary. In its place they proposed new, in-depth, psychological definitions of the self, a transcendental and antirational conception of the universe, and, finally, a revolutionary socialist world order that, in their minds, stood for a new freedom for the individual and society.

The movement was worldwide, but in New York City two events illustrate the cultural radicals' means and aspirations. Both took place in 1913 and both were hailed as examples of the creative union of modern culture and radical politics: the International Exhibition of Modern Painting (better known as the Armory Show) and the Paterson Pageant at Madison Square Garden.

Although ostensibly an exhibition that brought contemporary European painting and sculpture by such artists as Matisse, Picasso, Kandinsky, Brancusi, and Duchamp to Americans for the first time on a grand scale, the Armory Show was intended to be much more than an introduction to modern art. Like no other exhibition before or since, it challenged America's basic cultural sensibilities. To admirers and critics alike, the Armory Show was a repudiation of genteel society, which depended upon a strict set of canons in art as it did in morals. For most people the two were interconnected. Commentators were inevitably drawn to a political lexicon to describe what they saw, not because they confused politics and culture, as more than one historian has since charged, but because in their creative innocence they placed a higher value on art and literature than we have at any time since that fertile period of cultural ferment. Mabel Dodge, one of the Armory Show's organizers, was moved to tell Gertrude Stein: "There is an exhibition coming off . . . which is the most important public event that has ever come off since the signing of the Declaration of Independence, & it is of the same nature. . . . There will be a riot & a revolution & things will never be quite

4

the same afterwards." Looking at the Armory Show from the opposite perspective, the *New York Times* was nonetheless inclined to agree. The day after the exhibit closed, the paper called modern artists "cousins to the anarchists in politics."[4]

Less than three months later, on June 7, 1913, over a thousand striking Wobblies put on the Paterson Pageant, a play that, like the Armory Show, was dedicated to changing society through art. According to Mabel Dodge, the pageant was her idea. Big Bill Haywood, head of the I.W.W., had been complaining about his inability to get favorable coverage in the New York press for the millworkers on strike in nearby Paterson, New Jersey, when Dodge suggested bringing the labor struggle to Madison Square Garden in the form of a dramatic production. Her future lover John Reed, who had been arrested earlier for participating in a Wobbly demonstration, liked the idea and volunteered to direct the rally. Reed's play, which employed massive sets designed by John Sloan and Robert Edmund Jones and featured the strikers themselves as actors, reenacted the strike on stage. The play captured the imagination of cultural radicals, who believed that they were helping liberate the workers by organizing a mass celebration of freedom through drama. The *New York Globe* columnist Hutchins Hapgood articulated the idealism which the pageant's organizers invested in their creation. "It is not yet appreciated," he wrote, "how much meaning the Strikers' pageant has in this connection. The unprecedented effort of thousands of workers not only to realize their 'creative liberty' in industry, but also to get it over into drama is a dramatic act of almost unexampled interest."[5]

The strike's eventual failure does not lessen the creative impulse that led to the Paterson Pageant any more than the Armory Show's ultimate inability to alter society undermines the significance of modern art. The faith upon which both events were built was the necessary precondition that made them possible.

The Armory Show and the Paterson Pageant were the most dramatic examples of the Greenwich Village cultural rebellion,

a revolt that cannot be understood outside of its social and in-
tellectual contexts. America's first avant-garde represented a pos-
itive and creative response to the environmental changes that
transformed the United States, and particularly New York City,
during the first two decades of this century. Largely unaware of
the tremendous social problems that industrialization, urbani-
zation, and immigration caused, cultural radicals embraced these
modernizing developments that they hoped would overwhelm the
Victorian world they had grown to despise.

By 1910 New York City's population included almost five mil-
lion people, of whom more than 40 percent had been born
abroad. These immigrants, while they altered the city's social
composition, helped propel and sustain New York's rapid in-
dustrialization during these years. So too, they helped create the
new commercial civilization that bold skyscrapers like the Flat-
iron, Singer, Metropolitan Life, and Woolworth buildings came
to symbolize. A transportation revolution that saw the develop-
ment of large passenger ships, the expansion of an intraurban
rapid transit system, and the emergence of the private automobile
bound New York together and made it an international metrop-
olis. During the Great Depression, reviewing those years of
growth, a federal writers project noted, perhaps a bit nostalgically,
that New York then "had a throbbing, almost a terrifying vitality."[6]

During the Progressive Era, however, many were more terrified
than excited. The immigrants, the unplanned expansion of the
city, and the tremendous growth of industry posed severe problems
for a disoriented and already class-ridden society. To solve them,
a new generation of middle-class leaders and intellectuals
emerged. Appalled by the chaos of their urban, industrialized
world, a world no longer peopled exclusively or even predomi-
nantly by native Protestants, these new leaders, calling themselves
"progressives," attempted to reimpose order on their environment.
Men like Herbert Croly, Walter Weyl, and Walter Lippmann,
the editors of the *New Republic*, a journal of progressive opinion
founded in November 1914, proposed organization as an answer

6

to the perils of industrialism. Armed with innovative, bureaucratic solutions they borrowed in part from corporate managers, these new liberal intellectuals sought to provide the centralized leadership that could offer disinterested and, in their eyes, scientific advice on how to rationalize an unpredictable economy and mold a divisive society. The editors of the *New Republic*, like most nationalist progressives, hoped that by relying on the authority of science to support their claims for control and by defusing class and ethnic conflict, they could preserve the status quo. The philospher George Santayana noted as early as 1913, "Liberalism had been supposed to advocate liberty; but what the advanced parties that still call themselves liberal now advocate is control, control over property, trade, wages, hours of work, meat and drink, [and] amusements."[7]

Cultural radicals had different ideas. They celebrated the turmoil the twentieth century created and saw in the new anarchic social and economic conditions a chance to fulfill their main desire—greater personal freedom. Where progressives, attempting to rationalize the world by fitting people into new bureaucratic structures, failed to realize the hope of the individual to express his or her personality, cultural radicals responded to the increased institutional demands for social and economic conformity by proclaiming the inviolable autonomy of the self. Where progressives such as Croly and Lippmann adopted corporate models for their plans of reform, modernists like Bourne and Stieglitz tried to reshape the world to meet their needs and ideas. These competing prescriptions for the future more often than not clashed head-on: on one hand, a relentless drive for institutional consolidation and control; on the other, a libertarian and transcendental quest for boundlessness and self-expression. By the end of the First World War the first was clearly victorious.[8]

1

Between 1910 and 1917, the year the Seventh Avenue subway integrated it with the rest of the city, Greenwich Village formed

what its bohemian partisans thought was an intellectual and cultural oasis within New York's (and America's) progressive, commercial civilization. "It was a place," as one contemporary writer put it, "of protected freedom."[9] The Village, which in the twentieth century became the equivalent of Paris's Left Bank, was founded in 1822. An epidemic that year forced residents to flee northward where they built homes on meadows that until then had been reserved for tobacco, a potter's field, and the public gallows. Because sandy soil prohibited the construction of multistory buildings, commercial developers overlooked the neighborhood. Consequently, the Village maintained its charm as a residential island within the fastest growing business city in the world. Quiet, crooked little thoroughfares like Gay and Christopher, Bleecker and MacDougal contrasted sharply with Manhattan's checkerboard pattern of numbered streets. Individual houses, each carefully designed to preserve its individual integrity, made the Village a popular residence for upper-middle-class families who, in an increasingly ethnic-conscious city, liked to call theirs the "American Ward." Around 1885, however, when Italian immigrants began moving in, real estate values plummeted and the area declined. Many of the houses were divided into apartments. Low rents, a cozy atmosphere, and the exotic foreign flavor the Italians lent the neighborhood attracted large numbers of poor artists and aspiring intellectuals to the Village.

Floyd Dell, for example, took a large brownstone apartment there with his girlfriend for only thirty dollars a month. For Dell, and many others like him, Greenwich Village was more than a place where struggling young writers and artists could live cheaply. More important, as his living arrangement suggested, was the opportunity the Village offered its occupants to live freely. As Dell wrote later, it was "a place where people were free to 'be themselves.'" The desire to be oneself was deep in those years and defined the main thrust of the Greenwich Village cultural rebellion. "One of the great needs of contemporary life," another Village booster noted in 1917, "is . . . a more general appreciation

of the value of self-expression." John Reed described the Village's iconoclastic independence in his spirited poem *The Day in Bohemia, or, Life among the Artists*:

> *Yet we are free who live in Washington Square,*
> *We dare to think as uptown wouldn't dare,*
> *Blazing our nights with arguments uproarious;*
> *What care we for a dull old world censorious*
> *When each is sure he'll fashion something*
> *glorious?*

Secessionism reached a logical, if farcical, extreme when in January 1917 six artists, John Sloan and Marcel Duchamp among them, climbed into the Washington Square arch where, at midnight, to the accompaniment of toy pistols, they declared Greenwich Village "a Free Republic, Independent of Uptown."[10]

Greenwich Village's bohemian revolt took numerous social forms. Dress, for example, helped the rebels define and express themselves. When Dell left Davenport, Iowa, for Washington Square, he substituted a flannel shirt, which was then very fashionable among Villagers, for his stiff "high collar and black stock." He noted with approval that "one could dress as one pleased in the Village." The necktie he used for a belt did not attract attention. Even the cultural critic Van Wyck Brooks, who was both more stodgy and more serious than Dell, remembered how he "delighted in holes in [his] trousers and the bottoms of [his] shoes." He explained that he "felt [he] acquired a secret strength by reacting in this way against the popular pattern of the young businessman, a type that seemed to me as insipid and banal as the rows of young maple trees on suburban streets."[11] Randolph Bourne, who was a hunchback, wore a long black student's cape and a felt cap that gave him, to say the least, a striking appearance. As if to underline his individuality, he called his costume "son signature." Alfred Stieglitz too was fond of back loden capes, making them as well as his rimless glasses a personal mark of distinction.

Fania Mindell's "Little Russia" on 244 Thompson Street offered

apparel to the Village's residents. Her advertisement reflected their
sentiments exactly: "Just off Washington Square Fania Mindell
has created a shop where the pure Russian atmosphere prevails.
Russian copper and brass articles. See your ideas incorporated
into a new blouse designed while you wait. Hats, handbags, scarfs
may be had embroidered in the true Russian fashion. Indeed,
these Russian embroideries are very fashionable just now, and
add a touch of individuality to the costume."[12] Like the Village
itself, she had the chutzpah to repudiate the Americanizers' goal
of a homogeneous society.

Villagers also created festivals that, like their outlandish dress
and defiant social mores, helped them proclaim their emanci-
pation from mainstream society. Like Fania Mindell, cultural
radicals enjoyed emphasizing nationality in order to add color to
what they considered to be a drab, bourgeois, Anglo-Saxon work
world. On special occasions Villagers transformed MacDougal
Alley into an Italian street, setting up booths and gambling casinos
while admiring crowds watched Isadora Duncan perform ancient
Greek dances. The *Masses* and *Mother Earth* held annual cos-
tume balls at Webster Hall on Eleventh Street near Third Avenue
both to raise money and to stage collective celebrations of their
own counterculture. The *Masses* advertised:

> *Are you a Radical?*
> *Whether or Not, Come to the*
> *Greenwich Village Carnival*
> *Old Home Celebration*
> *Costume Dance*
> *Given By*
> *The Editors of the* Masses
> *and*
> *Artists and Writers of Greenwich Village*

Admission was one dollar for those in costume; two without. The
Mother Earth's "Red Revel" was less expensive but no less cheer-
ful. Emma Goldman advised patrons to wear red.[13]

These, of course, were special occasions. Isadora Duncan did not dance in MacDougal Alley every night, and Greenwich Village balls were annual events. Still, the unsatiated could make their way regularly to one of the Village's many inexpensive ethnic restaurants that added to the neighborhood's cosmopolitan atmosphere. French restaurants like the Lafayette and the café at the Hotel Brevoort were both popular. So too were Mother Bertolotti's and Renganeschi's, which served Italian cuisine. No place, however, rivaled Polly Holliday's restaurant on 137 MacDougal Street. Located below the Liberal Club—"A Meeting Place for Those Interested in New Ideas"—and next door to Charles and Albert Boni's Washington Square Book Shop, Polly's became a center for Village social life. As her advertisement noted, "One sees everybody at Polly's, doubtless the reason why everybody is there."[14]

Polly's chief cook, sometime lover, and main attraction was Hippolyte Havel, an anarchist from Bohemia. He was a short, stocky man who sported a mustache and goatee to match his long, black, wavy hair. His favorite term of abuse, not infrequently employed, was "goddamned bourgeois." Speaking for many villagers, Havel claimed that he was an *individualist*. "To be an individualist," he explained, "means to walk your own way, do the thing you want to do in this life and do it as well as you can." While many Americans may have agreed with his definition, even most Villagers drew the lines around their personal freedom somewhat more tightly than Havel, who was once arrested for relieving himself on Fifth Avenue. When the judge asked him why he didn't go down a side street, he replied, "You mean I should do it where the poor people liff? No, No, I refuse to do it there. I protest!" Havel was fined five dollars which his friend Hutchins Hapgood paid.[15]

Most cultural radicals, including Bourne and Stieglitz, were more serious than Havel. Though central to the Greenwich Village cultural rebellion, they knew how to separate style from substance even if some Villagers did not. Most of the time Stieglitz

remained in his own gallery a few blocks north of Washington Square. And Bourne, a man critical of both friends and foes, said in a wry moment, "Greenwich Village . . . is enough to make anyone despondent." What differentiated them from what one historian studying selected figures in the Lyrical Left unfairly calls "children of fantasy" were their self-conscious attempts to articulate and define an alternative vision of society.[16] Bourne and Stieglitz formed, as it were, two complementary components of a loose intellectual network that made up America's first avant-garde. What they wanted stands out boldly in contrast to the plans and ideas proposed by their intellectual rivals, the editors of the *New Republic*.

Although the offices of the *New Republic* were not situated in midtown Manhattan, they were not in Greenwich Village either. In Chelsea, at 421 West Twenty-first Street, between Ninth and Tenth avenues, the *New Republic*'s editors, Herbert Croly, Walter Weyl, and Walter Lippmann, sought to create an independent focus for their magazine. Washington Square marked an essential division in their ideas and politics which separated them from people like Bourne and Stieglitz. Despite their ideological differences, the radical intellectuals and the liberal journalists did in fact know one another very well, not, as has been suggested, because "the *New Republic* was every inch an organ of the Rebellion," but because their conflicting assumptions and aspirations made them natural and, at times, bitter antagonists.[17] Progressives like Croly, Weyl, and Lippmann thought that society was fragmented; it had to be rationalized and controlled in order to maintain social tranquility. In contrast, radicals like Randolph Bourne, who wrote for the *New Republic* until the editors could no longer tolerate his ideas, believed that the social order should be variegated, open, and spontaneous so that freedom might be attained.

The attacks the progressive writers at the *New Republic* and the cultural radicals of the Village visited upon one another fre-

quently surpassed the intensity of the ones each group leveled at the conservative establishment. The experience of Walter Lippmann provides a case in point.

After graduating from Harvard, Lippmann flirted for a short time with Village radicals and their ideas. He attended Mabel Dodge's salon and even wrote a widely read and provocative book in 1913, *A Preface to Politics*, which argued, as many influential European intellectuals then did, that political reform was inadequate because it did not address basic cultural and social needs. But less than two years later Lippmann changed his mind. After writing a second book, *Drift and Mastery* (1914), which seemingly repudiated the Freudian and Bergsonian interpretations of his earlier study in favor of the rigors of scientific methods, he ridiculed what he called "la vie de bohême" of his former friends who congregated around Washington Square and singled out John Reed in particular for being an irresponsible radical. In one of the *New Republic*'s first issues, Lippmann wrote that the "legendary John Reed" knew "no line between the play of his fantasy and his responsibility to fact."[18]

While the *New Republic* editor saw Reed as a romantic revolutionary whose notions were wild, impractical, and even dangerous, Reed thought Lippmann was something of a young old fogey. Earlier, Reed had made fun of the authoritarian streak in Lippmann's personality and politics, writing:

> But were there one
> Who builds a world, and leaves out all the fun,—
> Who dreams a pageant, gorgeous, infinite,
> And then leaves all the color out of it,—
> Who wants to make the human race and, me,
> March to a geometric Q. E. D.—
> Who but must laugh, if such a man there be?
> Who would not weep, if WALTER L. were he?[19]

Lippmann's column in the *New Republic* followed Reed's privately published poem and may have been motivated by it. Still,

Lippmann's essay and Reed's verse marked a more significant conflict than a personal feud between two recent Harvard graduates. They served notice that Lippmann and Reed no longer belonged to the same intellectual world.

Lippmann's apostasy did not surprise his former associates in the Village. One of them, Hutchins Hapgood, who was also Reed's friend and confidant, dismissed him with the sarcastic comment, "God does not manifest himself at all in Walter Lippmann." Lippmann's new position at the *New Republic* required that he separate himself from the "frivolities" of Greenwich Village. From its inception, the *New Republic* was determined to have an impact on mainstream American politics and society. The editors considered their new journal "the mouthpiece" of influential citizens. According to Herbert Croly, they wanted to establish "a weekly periodical which, without speaking to a large popular audience, would liberalize and leaven American political and social opinion." Obviously, in order to meet these goals, the *New Republic* adopted a language, a style, and a platform that gave it a startlingly different appearance and perspective from, say, the Lyrical Left's main political magazine, the *Masses*, the masthead of which read in part, "A Magazine Whose Final Policy Is to Do as It Pleases and Conciliate Nobody, Not Even Its Readers." Lippmann, unlike Randolph Bourne, adjusted easily to the demands of the *New Republic*'s "little society of like-minded equals" who, as Croly said, determined its editorial positions "by practically unanimous consent."[20]

The *New Republic* was founded when Willard Straight, a wealthy banker who had headed a consortium of investors in China, agreed to underwrite the new weekly. Straight, like many nationalist progressives, had been singularly impressed with Herbert Croly's *The Promise of American Life* when it was published in 1909.

The book articulated the goals and methods of the nationalist wing of the progressive movement. Croly argued that the United States was becoming an increasingly fragmented and disoriented

14

nation, that "the earlier instinctive homogeneity" that had held the country together "had disappeared never to return," and, finally, that democratic government could not survive without "solidarity." Unlike other more conservative commentators on American civilization, such as Henry Adams, Croly did not then throw up his arms. Calling himself a neo-Hamiltonian, he suggested that a disinterested managerial elite could restore "a conscious social ideal" by running the complex industrial nation efficiently, scientifically, and without conflict. If the government were left to experts, Croly was confident, "men of integrity, force, and ability would be tempted to run for office." They, in turn, would "*press* into service whatever public-spirited and energetic men the community possessed," representing "the highest standard which the people could be *made* to accept." When he reached his conclusion—that "the Promise of American life is to be fulfilled . . . not merely by abundant satisfaction of individual desires, but by a large measure of individual subordination and self-denial"—Croly had completely alienated those contemporary readers whose chief concern was not order but liberation, even if his belief that the intellectual could alter society remained appealing to them.[21]

The *New Republic* incorporated Croly's ideas and methods. For example, the progressive journal's proposed solution to the problems of immigration illustrates how its nationalistic faith in science and planning frequently precluded social and individual diversity. In its second issue the editors warned that unless the United States government prepared a program to receive immigrants, after the war the expected deluge would throw the country into chaos. The following month they were more explicit. In an editorial entitled "Wanted—an Immigration Policy," the *New Republic* recommended establishing an agency to control and regulate all aspects of the immigration process. Specifically, the article proposed that the federal government create a bureaucracy to supervise the immigrants during the entire course of their "alienships." Experts could advise, protect, and educate (Ameri-

canize) the new arrivals for their own welfare and, the *New Republic* added, "incidentally for the benefit of the rest of us" as well. The advantages of the plan, the editors argued, far outweighed alternative proposals to allow only literates into the country or to restrict immigration completely because, if their scheme were enacted, the government would be able to regulate the flow of immigrants according to the demands of the economy. At the same time, it could ensure that the immigrants received decent living conditions and fair wages.[22]

The *New Republic*'s editorial revealed that the new liberals, unlike their nineteenth-century forebears, were no longer willing to leave society's balance to the natural forces of the economy. Though concerned and even frightened, most nationalist progressives, like the editors of the *New Republic*, still believed that they could devise a rational government that could solve social and economic problems, thereby making more severe structural changes unnecessary. In 1915, in a statement of general principles it published after its first year, the *New Republic* noted, "At this period of *wreck and ruin* the one power that can save, can heal, can fortify, is clear and intelligent thought." Unfortunately, the editors' "clear and intelligent thought" left little room for diversity, change, or development. At its center was a clear but static vision of a homogeneous, ordered, and rational society. Paradoxically, as the raging war in Europe eroded the viability of that view, the *New Republic* presented it with a deeper but more desperate conviction, a conviction that belied its confidence in the future. Again, the immigrants tested the magazine's fears and hopes. In 1916 the *New Republic* urged its educated audience to consider the necessity of "homogeneity" in governing a complex industrial nation. The editors concluded, "We permit at our peril the planting on our soil of unassimilable communities."[23]

The editors of the *New Republic* were not the only progressives who insisted that stable democratic government required homogeneity. John R. Commons, a progressive economist mainly interested in labor problems, believed that immigrants threatened

the unity of the country and the progress of reform. "To be great," he wrote, "a nation . . . must be of one mind." Following Commons, Edward A. Ross, a progressive sociologist, argued that the new immigrants placed "a drag on the social progress of the nation." The problems posed by immigration, he maintained, using the same logic as the *New Republic*, precluded consideration of the "pressing questions" of hygiene, conservation, monopoly, and labor protection, all major items on the progressive agenda.[24]

The progressive presidents Roosevelt and Wilson sympathized with the Commons and Ross perspective. Although they both opposed proposals to restrict immigration during their administrations, mainly for political and economic reasons, each strongly supported efforts to Americanize the newcomers as quickly as possible. Like the progressive intellectuals, they abhorred divisions within society. In an address to the Knights of Columbus in 1915, Roosevelt declared, "There is no room in this country for hyphenated Americans." His reasoning was simple: American security and power demanded absolute uniformity and undivided loyalty. Wilson, too, believed in "Americanism." In an address delivered in the same year, the president sanctimoniously told a group of new immigrants to forget their past allegiances and to dedicate themselves completely to the United States. "America," he said, "does not consist of groups."[25]

The progressives' obsession with the immigrants was not a blind spot in an otherwise liberal ideology, but was part of their underlying quest for social harmony. It is true, particularly in the first year of publication, that the *New Republic* defended civil liberties and the right of free speech. The journal criticized the mobs in Paterson, New Jersey, which prevented I.W.W. leaders from speaking. It condemned the University of Pennsylvania for dismissing Scott Nearing, an unpopular radical professor. And it supported Henrietta Rodman's right to publish a letter critical of the Board of Education without losing her job as a teacher. But the *New Republic* soon demonstrated the limits to its support of the right to dissent. Even before America's entry into the First

World War, when the progressives' commitment to constitutional liberties completely collapsed, the *New Republic* issued warnings about the dangers of nonconformity. In December 1915 Walter Lippmann, fearing the effects of divisive pluralism, cautioned, "We lie open, unorganized, not unanimous, and therefore in the old sense 'defenseless.'" Three months later, in an essay entitled "Integrated America," he continued his attack on the dangers of dissent. Calling it "the evil of localism," Lippmann lamented the great diversity in American society that, in his mind, was an evil "so radical that it frustrates practically all effort to reform anything." Fortunately, Lippmann argued, the possibility that the United States might enter the Great War "has given a large number of Americans a new instinct for order, purpose, discipline."[26]

Efficiency and discipline, not self-interest or community development, were the keys to Lippmann's vision of a progressive future. More than a year before President Wilson committed American soldiers to Europe, nationalist progressives like Lippmann believed that the exigencies of war would be good for reform and good for the state. His conception of both presupposed a monolithic, static social structure in which a scientific elite directed a docile, relatively homogeneous public. His model of society, a compensating picture for social reality, was the smoothly run, efficient corporation or, better, the military, in which rational orders were handed down and expeditiously carried out. Invoking Theodore Roosevelt, Lippmann called for the "nationalization of America" and, at the same time, demonstrated how the progressives' search for order could easily become an attack on freedom.[27]

The cultural avant-garde, appalled by the progressives' vision of the American future, proposed an alternative conception. Indeed, their opposition to progressivism was the first component in the Lyrical Left's critique of American civilization. In an introduction to a posthumous collection of essays by Randolph Bourne, Van

Wyck Brooks cataloged the cultural radical's complaints about progressive reform. "There was none of the tang and fire of youth in it," he wrote, "none of the fierce glitter of the intellect; there was no joyous burning of boats; there were no transfigurations, no ecstasies." In short, there was no liberation. The reformers, Brooks charged, "had no realistic sense of American life." They "ignored the facts of the class struggle" and "accepted illusions like that of the 'melting-pot.'" But "worst of all," he concluded, they "had no *personal psychology*."[28]

More than anything else, the cultural radicals disliked the progressives' denial of the individual's central place in society. The reformers' belief in efficiency, critics like Brooks charged, led them to support the worst attributes of America's business-oriented civilization. Although the radicals were also impressed by the new machine age — it was difficult not to be — they were not enamored by the methods, goals, or consequences of modernization. Despite other differences between them, the rebels of Greenwich Village were united in their opposition to the proposed hegemony of commercial values. If business leaders needed an exploitable labor force to build and run their plants and machines, cultural radicals supported socialist demands for workers' control and ownership of the means of production. If business helped modernize the country by getting people to orient their lives to the standard units of the clock and calendar, cultural radicals proposed the abolition of the tyranny of time altogether. If business exhorted producers and consumers to plan for the future, cultural radicals believed that people should live spontaneously in the moment.

The avant-garde especially distrusted the materialist emphasis of the new commercial civilization because it seemed to set limits on the expression of personality. By underlining the validity and importance of both personal subjectivity and self-expression, cultural radicals like Bourne and Stieglitz responded dialectically to the increased rationalization of the economy and the standardization of society, both of which denied individual differences and also characterized their (and our) times. Returning to an es-

sentially aristocratic ideal, that of personal cultivation, they op-
posed the emerging bourgeois notion that one is what one does
rather than who one may be. "The chief thing that interests me,"
Alfred Stieglitz once said, "is to see the perfectly natural unfolding
of the so-called innerself."[29] Speaking for other cultural radicals,
Stieglitz assumed that individuals should respond only to their
own self-defined needs, not to standards or values that business
or some other authority had established.

Cultural radicals also opposed America's materialistic civili-
zation because business, in their eyes, denigrated culture. Walter
Weyl's assertion that "however spiritual a structure civilization
is, it is nevertheless built upon wheat, pork, steel, money, wealth"
confirmed their worst fears.[30] Modernists wanted to redress the
weight of Weyl's balance and sought, therefore, to enlarge art
and literature's influence in society. They pointed out materi-
alism's ultimate inability to account for reality, and aimed to
compensate for the promises of a technology that ignored what
could not be scientifically verified by emphasizing mystical or
transcendental awareness. Transferring cultural concerns into a
sphere that had formerly been reserved for religion, modernists
like Stieglitz maintained that art had hitherto unrealized power
to enrich everyday life.

The radicals, hoping to regenerate society through culture, be-
came pluralists willing to consider anything new and different.
In contrast to the *New Republic* progressives, they assumed that
there was no overriding truth, no one way of doing things, no
sole legitimate mode of representation, and no adjudicating au-
thority that could ultimately determine standards and reconcile
differences of opinions. They argued that only a readiness to ex-
periment and to entertain alternatives in politics, in culture, and
in their personal lives made any sense in a dynamic world.

One of the fundamental characteristics of modernism was its
ability to conceive of art and life in experimental terms in which
"laboratories" became "proving grounds" for the development of
new ideas antagonistic to the established way of life. In 1913

Randolph Bourne outlined a theory of pluralism that later gave his social thought its radical edge. "For the rátional ideal," he wrote, "we must substitute the experimental ideal. Life is not a campaign of battle, but a laboratory where its possibilities for the enhancement of happiness and the realization of ideals are to be tested and observed. We are not to start life with a code of its laws in our pocket, with its principles of activity already learned by heart, but we are to discover those principles as we go, by conscientious experiment." Alfred Stieglitz thought of his art gallery, 291, in similar terms. As one of its publications noted, also in 1913, " '291' is primarily a laboratory where the work presented is impartially analyzed, dissected, put through the severest tests for the purpose of finding out the truth whatever that truth may be and whatever results it may have."[31]

Beginning by criticizing the effects of modernization, cultural radicals ended up as modernists. Their pursuit of self-expression and self-definition led them to see themselves as agents of social change. As both critics and exponents demonstrated in their heated participation in the debate over the cultural developments of the era, the modernists were considered revolutionaries. Before 1920 few doubted that a revolution in culture would not also inaugurate major changes in politics and society. Though difficult to conceive today, it is nonetheless true that before the Russian Revolution a whole generation of intellectuals, both conservative and radical, considered cultural expression central to the political and social life of a nation.

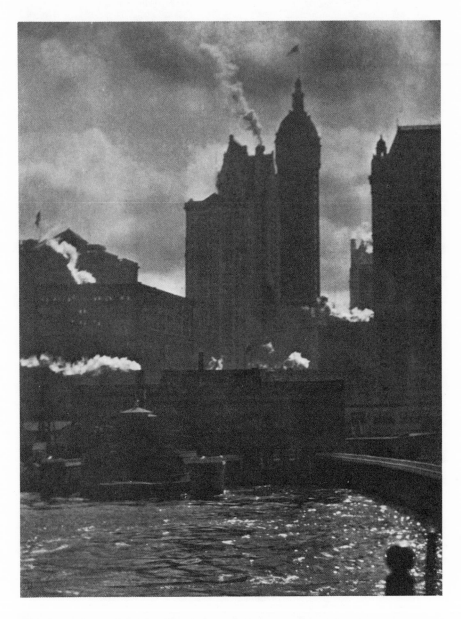

Alfred Stieglitz, *The City of Ambition*, 1910. *(National Gallery of Art, Washington; Alfred Stieglitz Collection)*

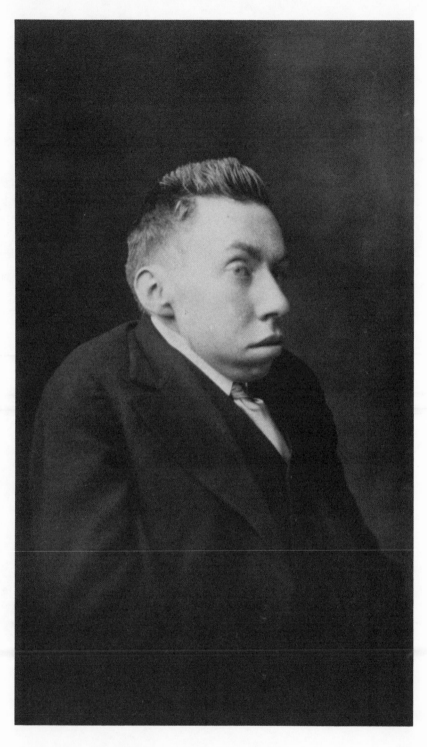

Randolph Bourne, 1916. *(Rare Book and Manuscript Library, Columbia University)*

I have no code, merely a sense of irony.

Randolph Bourne

. . . more air, more light, more expression.

Randolph Bourne

RANDOLPH BOURNE
2 *The Politics of Liberation*

The moment the poet James Oppenheim heard that Randolph Bourne had died, he rushed to the apartment on West Eighth Street in New York City where Bourne lay, a victim of the flu epidemic of the winter of 1918. When he lifted the sheet that covered his friend's face, he felt that Bourne's death "seemed to mean that all had been stopped." It is not surprising that Oppenheim associated his fellow cultural radical's untimely death, six weeks after the armistice, with the demise of a "new vision of the world." For his contemporaries as well as for many intellectuals since 1918, Bourne's life represented an unfinished search for a new culture that would have enlarged personal freedom at the same time that it supported collective social ideals.[1] Few of Bourne's admirers did not interpret his passing as signifying the end of their own hopes for a cultural revolution in the United States.

In a characteristic tribute to Bourne, the *Dial*, a magazine for

which he had written book reviews in 1917 and 1918, noted that Bourne "demanded of life richer esthetic experiences, the companionship of fuller intellectual straightforwardness, more emotional range and flexibility than his American environment could possibly yield without radical transformation."[2] His short life— he was thirty-two when he died—was dedicated to creating that radical transformation. The quest led him to celebrate the virtues of youth, to exalt the liberating potential of socialism and feminism, and, most important, to outline a new conception of radical politics that linked social progress, not to institutional reform, as his progressive contemporaries would have had it, but to cultural criticism. In particular, Bourne wanted to reform education in order to end the alienation of students from their environment and from one another. He wanted to establish a cosmopolitan civilization in the United States in which immigrant communities and cultures could thrive and flourish. And, finally, he vehemently opposed the First World War, which he felt destroyed everything he had believed in.

Bourne's vision of a new America, however, represented more than the sum of its parts. His was an integrated ideology that stressed the cultural roots of social change, the necessity for diverse intellectual and ethnic communities, and, above all, the independence and integrity of the individual. These unshakeable assumptions formed the bedrock upon which Bourne built his radical beliefs. If he directed his life and thought toward achieving a single goal, it was to liberate simultaneously both self and society from what he considered to be arbitrary and oppressive social systems. He dreamed of growth and expansion, but most of all he longed for a new freedom not only for himself but for the society in which he lived.

Bourne illustrated his vision in an autobiographical novel he was writing in 1918 when no magazine would publish his unpopular and unpatriotic political views. He completed only one chapter before he died, but in its first paragraph he developed a metaphor that reveals the central struggle of his life—to get more space.

The paragraph described his early childhood. When Randolph was almost six years old, his mother decided to leave her husband and took her children home to her mother's. For Bourne, the move to his grandmother's "tall white house" represented, at least in his projected novel, "new excitements and pleasures. It was like a rescue," he wrote, "like getting air when one is smothering. Here was space and a new largeness in things. [He] was freed forever from the back-street."[3] To breathe freely, to see more clearly, to explore uninhibitedly the infinite variety of the world, these were Bourne's greatest desires. His pursuit of boundlessness, as his biographical metaphor suggests, provides the key to understanding Bourne's personality and his goals. He wanted room to grow. Bourne's quest for space had its corollary, of course, in claustrophobia. His greatest fear, he told friends, after his outspoken opposition to the war marked him clearly as a subversive in the eyes of federal officials, was that the government would put him in prison, not an altogether preposterous notion considering the assault on dissenters in 1917. He did not think he could survive being locked up.

1

Randolph Bourne's politics of liberation were deeply rooted in his personality and in the inevitable frustrations he suffered growing up handicapped. He was born in 1886 in Bloomfield, New Jersey, a small town four miles northwest of Newark and within easy distance of New York City. His birth was not auspicious. A forced delivery disfigured his face, and, to compound his problems, at age four, he contracted spinal tuberculosis, which left him a hunchback for life. His physical appearance was the most striking thing about him. As an adult, he stood only five feet tall. His back and shoulders were twisted and his left ear drooped more like a nonfunctioning appendage than a vital organ. His skin was drawn too tightly over his face. This made his jaw protrude and his teeth stick out when he talked. To make matters worse, he had trouble breathing and, on occasion, difficulty speaking as well. According to Theodore Dreiser, Bourne was "as frightening

a dwarf as [he] had ever seen," and a dentist who once examined him exclaimed, "When we see such a one as he, we should give thanks to our Creator for making us as we are."[4]

Curiously, with little insight or awareness, Bourne's friends denied the importance of his physical handicap. They did so because he was witty and charming. Even after encountering innumerable social slights, like the French and Italian women in the countryside who crossed themselves when they saw him, Bourne successfully overcame most people's resistance to him. His effort to establish a supportive and loving environment for himself was nevertheless a constant, lifelong struggle, accompanied by intense, sometimes overwhelming feelings of loneliness, self-pity, and alienation. While, on one hand, Bourne was so excruciatingly self-conscious that he never allowed a photographer to take a picture of his full face, on the other, he was a gregarious adventurer bent on experiencing life's fullness. His thought about culture and society was the issue of that tension.

Though Bourne's physical problems were severe, his family encouraged its oldest child to live as normal a life as possible. His mother, Sarah, a religious woman and a member of the local Presbyterian Church, headed the household, which also included another son, Donald, and two younger daughters, Natalie and Ruth. A willful woman, she forced her husband to leave home for good when his business failed and he began to drink heavily. After his departure, her brother helped support the family, which then moved to Sarah's mother's large, three-story house on Belleville Avenue. Consequently, Bourne grew up in a house full of protective, adoring women; his grandmother, a maiden aunt who also lived with them, and his two sisters all looked after him. Bourne's attitudes toward his father are not known. One friend said he referred to the man with pity "as an outcast from his family"; another, as a "failure," but for the most part, he simply did not discuss him nor in fact did he ever mention his brother, who left home when he was nineteen.[5] By repressing or denying the influence of masculinity in his family, Bourne indicated that he preferred the company of women.

Bourne's female-dominated homelife, like his handicap, shaped his personality and, by inference, his thought as well. As a cultural radical, he later sought to change American values, particularly those relating to women. His unorthodox familial background prepared him, as it were, to envisage the good society quite differently from someone who, say, had grown up in a traditional household with a strong father at its head. A large measure of Bourne's desire to reshape American society—to deliver it, that is, from its puritanical, capitalistic, and masculine domination—came from his unconventional upbringing that taught him, in particular, to appreciate women and to value their potential contributions to society. It also contributed to his inflated expectations of women and subsequent disillusionment with radical feminism.

But, most important, being the center of a group of caring women also enabled Bourne to gain confidence in himself which, as a handicapped youth, he otherwise might not have developed. Describing his early childhood, he wrote that he "got in the habit of asking his mother every night whether she was going out. And what assurance and peace there was when she said she was not! He was safe, no matter how long the night lasted."[6]

To be sure, Bourne eventually broke his Oedipal bond and established an identity that was dramatically different from his bourgeois Presbyterian family's. "I have long ago given up any attempt to find congeniality, or even a spark of understanding in literally a single one of my relatives," he wrote in 1914. "It always depresses me to be with them at home."[7] That home's influence nevertheless remained embedded in his mind. Even as he sought to lead a revolt, which he defined as one of youth against tradition, Bourne remembered his past.

Bourne's childhood was less a time of warmth and security, however, than it was a struggle to compensate for his handicaps. While his sister Natalie recalled how she tried to protect her brother from the taunts of playmates who inevitably teased him, Bourne described how his physical problems induced him to seek even harder to be like other boys. He said that it never occurred to him that his failures were due to circumstances beyond his

control. Instead, he imputed them to some "moral weakness," a consequence, he thought, of his "rigid Calvinistic bringing-up." He claimed that he also learned to deprecate the usefulness of what he could do easily and well, such as play the piano or get good grades in school, as he fought to overcome his limits. "I never resigned myself to the inevitable," he wrote. "I strove and have been striving ever since to do the things I could not."[8] By directing his psychological energies toward surmounting his weaknesses, he developed the personal strength that enabled him as an adult to declare his critical and intellectual independence even when his opposition to the First World War made him feel that he stood alone against the world.

The work of Alfred Adler aids in understanding Bourne's personality and psychology. In 1917 Adler's *Study of Organ Inferiority* and *The Neurotic Constitution* were translated into English. The books suggested that people with constitutional anomalies frequently compensate for their physical infirmities by seeking greater mastery over their environments and themselves. Thus, a stammerer, Demosthenes, could become Greece's greatest orator. Adler argued further that mankind's governing motivation was not sex, as Freud thought, but what he viewed, in language borrowed from Nietzsche, as a "will to power." Bourne at least was persuaded. Both Adler's thesis that people, particularly the infirm, were driven by their need to overcome feelings of inferiority as well as his Nietzschean phrase "will to power" found their way into Bourne's thought and writing. Praising Adler's interpretation of the personality of the handicapped, Bourne exclaimed ruefully, "He has described me exactly."[9]

Of course Bourne's mental strength did not erase his repulsive appearance which, as he got older, became more and more important in his relationships with women, a matter of great concern to him. "When the world became one of dances and parties and social evenings and boy-and-girl attachments," he wrote, "I was to find myself still less adapted to it." An uncomfortable period for anyone, adolescence was torture for Bourne. Though sociable and naturally gregarious, he was ostracized by his contemporaries.

Again, though, Bourne succeeded in turning his physical handicap into a personal asset. Unable to join adolescent groups, he developed the keen perspicuity of an outsider. As he wrote, "I would get so interested in watching how people behaved, and in sizing them up, that only at rare intervals would I remember that I was really having no hand in the game." Long before he encountered Freudian psychology, Bourne learned the art of sublimation, that is, directing his sexual frustrations into productive social channels. "I wish I could beat into some sort of expression my frictions and rebounds from the world," Bourne once wrote. "I almost think, if I could do that, I should find it all worth while."[10]

As he matured and his sexual appetite increased, Bourne's "frictions and rebounds" were many. Although he cultivated the company of young women, charming them with his clever conversation, his warm personality, and his piano playing, he had only to make the slightest sexual advance to see them flee in horror.

For someone who once said that friendship was "the most precious thing in the world to him," these rebuffs were certainly painful. Even so, they did nothing to decrease his interest in female companionship or to dampen his passionate desire. As he told one woman who, on his advice, came from a small town in Indiana to study at Barnard College, "I am so keen on girls' friendships. A charming girl . . . is simply a heaven-sent companion, and the blessedest gift of the gods." His numerous platonic relationships, however, usually grew weary, stale, and flat if not unprofitable as well. Another Barnard student, whom Bourne particularly liked, later confessed that she thought "his terrible deformity insulated him against sex" and that she therefore "failed to realize the source of much of his torment." He did not. Bourne once wrote in one of his more poignant self-portrayals that he was a "man cruelly blasted by the powers that brought him into the world, in a way that makes him both impossible to be desired and yet—cruel irony that wise Montaigne knew about—doubly endowed with desire."[11]

Bourne's inability to find what, on one occasion, he called "the right golden and protecting person" frequently led him to despair. In contrast to his friends, who married and established secure domestic niches, he saw himself, not without a good measure of self-pity, as "a homeless, helpless waif," eternally lonely, always seeking. To one acquaintance who had recently announced his engagement, he wrote, "You make me feel suddenly very old and bitterly handicapped and foolish to have any dreams left of the perfect comrade who is, I suppose, the deepest craving of my soul. It is her I write to, meet casually in strange faces on the street, touch in novels, feel beside me in serene landscapes and city vistas, grasp in my dreams."[12] His elusive search for the perfect woman represented more than a quest for a soul mate. In Bourne's mind she assumed mythological qualities that compensated for his intense loneliness. Bourne in fact was fast becoming an ardent romantic, a man whose limited social life made the imagining of an idealistic alternative world psychologically imperative. As he told his newly engaged friend, he associated the woman of his dreams with all of his aspirations. She soon became less flesh and blood than an image of a society based upon personal freedom and collective liberation.

Bourne's difficulty in discovering happiness with a woman, not to mention realizing his transcendental political goals, developed into a continuing source of alienation. Alienation indeed was never far from the center of his consciousness. He felt distant from friends, family, business, in short, from the mainstream of life entirely. Referring to growing up, he noted, "I was truly in the world, but not of the world." The statement describes his adulthood equally as well. Once, for example, when asked about frequent withdrawals inside himself, he said that he felt no one understood him. His friends, he claimed, were all "dodging behind screens," unwilling to help him ease the pain of his feelings of separation from society. Nor was his family in later years any greater source of comfort to him. "I seem very queer out there [Bloomfield] and all my friends seem very queer," he complained.

"I feel at times like a home sick wanderer, not even knowing where my true home is."[13]

It was clearly not in business or among the working class. After graduating from high school in 1903, Bourne began a difficult but formative six-year period in which he unsuccessfully tried to adjust to social demands. These experiences also helped shape his personality and politics. Although he easily passed Princeton's entrance examination, his uncle, who supported the family, decided that he could not afford to send his hunch-backed nephew to college. That decision thwarted Bourne's personal aspirations, and so he set about looking for a job. It was not easy. "Perhaps the bitterest struggles of the handicapped man," he wrote, "come when he tackles the business world. If he has to go out for himself to look for work, without fortune, training, or influence, as I personally did, his way indeed will be rugged." Most employers responded to his entreaties for employment by exclaiming, "You can't expect us to create a place for you."[14] During this period of his life, Bourne developed few fond memories of American capitalism.

Eventually, he did find a job cutting out perforated music rolls for player pianos, then very popular. The boring task, for which he was paid piecework, stifled his creativity and convinced him that he was fast becoming an exploited member of the working class. Later, when he wanted to explain how his understanding of political economy differed from that of a progressive friend, he recalled the experience. The progressive "trusts rights," he wrote. "I trust power. He recognizes only individuals, I recognize classes."[15]

Bourne labored at similar menial tasks for six years before winning a scholarship to Columbia University at age twenty-three. It opened a new world for him to which, considering his background and physical problems, he was most suited. "I don't know really what I should have done," he once said, "if I had not come to college. . . . It has all quite revolutionized my life."[16]

When Bourne entered Columbia in 1909, it had been located

at its present uptown campus on the Hudson River for only fifteen years. Like New York City, Columbia was in the process of expansion. Undergraduate enrollment grew 25 percent to over a thousand students while Bourne was there. The social composition of its student body was changing too, as new immigrants, particularly Jews, were matriculating in increasing numbers. The faculty was outstanding. It included such important intellectuals as Charles Beard, Franz Boas, John Dewey, Franklin Giddings, and James Harvey Robinson. These men, who were collectively engaged in what has been called "a revolt against formalism," greatly influenced Bourne's thought, notably his willingness to view society and culture as fluid.[17]

Originally, Bourne had wanted to major in English, but he quickly discovered that for him "nothing seem[ed] . . . more deadening than the University study of literature for its own sake, " an opinion he held for the rest of his life. The notion that literature, or any other form of cultural expression for that matter, should be understood only in terms of itself without considering its relation to the larger issues of life repelled him. An activist intensely committed to social change, Bourne found the new discipline of sociology, which he combined with history, political science, and philosophy, more to his liking.[18]

Bourne's formal curriculum was only a part of his education. In addition to his assignments, he read Marx, Freud, Nietzsche, Bergson, Maeterlinck, and Rolland. His favorite authors, though, were the American romantics Walt Whitman and William James, whose democratic writings he tried to incorporate into his own thought. "I should like to know your reaction to James," he wrote a friend. "He has settled so many of my own worries that I preach him as a prophet." And on Whitman he noted, more than half to himself, "If one could keep permanently [his] wonderful mood of serene democratic wisdom, that integration and understanding, I think everything one did would be beautiful and right." Bourne also found opportunity for personal growth in Columbia's extracurricular activities. He wrote for the *Columbia Monthly*, a col-

legiate literary journal, and soon became its editor in chief. He made many close friends in college too, particularly among the school's foreign-born population. Bourne called Columbia "a real intellectual democracy," and, undoubtedly, the university provided a model for his conception of a pluralistic society.[19]

Bourne was not one to sing any institution's praises for long, however. Describing himself as "a fearful critic, staying [his] hand at no man, and taking the greatest delight in hurling the mighty from their seats," he also criticized Columbia frequently. Particularly painful to him were the low wages it paid its janitors. "With all its 'sweetness and light,' " he wrote, "Columbia, like other Universities too . . . does not hesitate to teach Social Ethics in the class-room and exploit its labor force on the side." When he later applied for a teaching position in Columbia's English Department, his outspokenness hurt him. In response to his application for a job, his friend Harry Dana told Bourne that he had about as much chance being hired by the English Department as Voltaire had in getting a bishopric. Among other things, Dana cited Bourne's alleged "scorn for scholarship" and "memorable attack on the English Department bulletin board" as reasons for his refusal to help him. "The hand does not instinctively feed the mouth that bites it," he explained, revealing a good deal about both academe and Bourne's iconoclastic personality. When Columbia later fired Dana because of his pacifist views, Bourne was one of the few people who supported him publicly.[20]

Despite his discovery of a new intellectual world at Columbia, Bourne continued feeling left out. Even after he began his career as a writer, his sense of loneliness and separation oppressed him. He wrote to Alyse Gregory, a close friend active in the women's movement, "You don't know how I envy your activity and the chance to reach people with a vital message and in such a direct way. . . .What is cold writing in comparison with direct campaigning? I would give almost anything for that feeling of *participation* in something that you must wonderfully have." But Bourne also knew that he determined his own life more than

most people ever have the opportunity to do. For the freedom he cherished, he was willing to pay almost any personal price. As he explained to Gregory on another occasion, he accepted his "fate as a lonely spectator" and would "give up claiming to be 'in.'"[21]

The contention of one historian notwithstanding, "to be in" was not Bourne's chief motivation. The opposite is closer to the truth. Bourne was a dissenter. From his Columbia matriculation to the day of his death, when he was still at work on his uncompleted essay "The State," he protested against the status quo. He asked questions and confronted issues that other more "realistic" and "involved" individuals preferred to overlook. "I want to be a prophet, if only a minor one," he wrote in 1913, when he again faced the prospect of finding a job. "I can almost see now that my path in life will be on the outside of things, poking holes in the holy, criticizing the established, satirizing the self-respected and contented. Never being competent to direct and manage any of the affairs of the world myself, I will be forced to sit off by myself in the wilderness, howling like a coyote that everything is being run wrong. I think I have a real genius for making trouble." Still, Bourne knew that prophets, even minor ones, have difficulty earning a living in the United States. He fully expected "to be poor and unloved and obscure. I shall probably have enough to be thankful for," he claimed, "if I am warm and fed, and may creep into the Public Library now and then."[22]

Bourne's cultural radicalism clearly had its roots in his alienation which, in turn, stemmed largely from his physical and social handicaps. His politics, which emphasized freedom in all areas of life, began and also ended with an affirmation of the self. Bourne's misshapen body helped give birth to his politics of liberation that, in the first and last analysis, insisted upon the inviolability of the individual. This does not mean that he was mainly concerned with himself or that he was a traditional libertarian. Like the other cultural radicals of his era, Bourne did not recognize the basic inherent conflict between the individual

and the community. Ignoring that dialectic was his most severe limitation as a political thinker. What Bourne wanted was to transcend his personal problems, overcome them by linking the unique, his personality, to the universal, the issues of freedom and social justice. It could not be done.

2

Some historians have suggested that Bourne was not really a radical at all but a progressive of sorts at least until 1917. Then, they argue, he turned against his progressive mentors and their ideology when they supported the war he detested.[23] It makes more sense, however, to see the continuities in Bourne's thought and to keep in mind that when he espoused progressive principles, his goals remained revolutionary. The war highlighted the differences that divided Bourne from people like Croly, Lippmann, and most notably from his former professor John Dewey, but the differences were always there, a fact Bourne himself eventually realized. When he attacked the progressives' advocacy of American intervention in Europe, he merely expressed in its fullest form his earlier hostility to the politics of reform. Not only was Bourne not a progressive, he offered perhaps the most incisive contemporary critique of the reformers' search for order, which dominated the politics of the era. Bourne was a cultural radical who wanted to redesign society along socialist lines in order—ironically, as it turned out—to make it more responsive to the needs of the individual.

Bourne articulated his thoughts on the individual in society in a book he published in 1913 called *Youth and Life*. A collection of previously issued essays, *Youth and Life* marked Bourne's emergence as a cultural critic on the Left. Although relatively few people (about 4,000) purchased the volume, the book quickly became a significant work because it defined "Young America's" new values. The author called himself and his ideas radical. Written in a flowing, almost lyrical style, *Youth and Life* was extremely readable. Despite its effervescent optimism, it contains

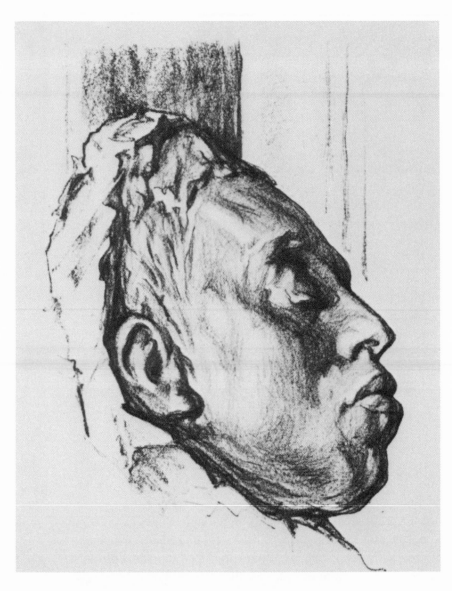

Randolph Bourne, drawn by Arthur G. Dove from the death
mask by James Earle Fraser. (*From* The History of a Literary
Radical *[New York: B. W. Huebsch, 1920])*

the roots of Bourne's more mature thinking. The issues he raised,
the questions he posed, and the values he articulated were those
he was exploring at the end of his life.

Reviewing *Youth and Life*, one commentator noted sarcastically
that Bourne was "in love with love." He shrewdly explained that
the young author wanted to combine culture and politics, writing
that Bourne was "devoted to art and ambitious to reform the
world." The reviewer thought that Bourne "would probably look
on becoming an alderman, writing a textbook, or marrying Susan
as a base and ridiculous compromise with the existing order."
Unlike other contemporary critics, who found the book senti-
mental if not silly, he recognized what Bourne was aiming at:
cultural revolution. "Such young men," he concluded, were
"useful and dangerous."[24]

Youth and Life's genesis lay in the generational conflict of the
day. In 1911 Mrs. Cornelia A. P. Comer, a frequent contributor
to the *Atlantic Monthly*, challenged America's rebellious youth
to defend what she saw as its assault on civilization. In "A Letter
to the Rising Generation," she criticized the new young men and
women, whose bizarre haircuts, colorful clothes, and new ideas
so alarmed her, because they lacked what Victorians summed up
in the word *character*. "Your brand of socialism," she wrote,
showing that she too associated culture with political ideology,
"is made up of a warm heart, a weak head, and an unwillingness
to assume responsibility."[25]

Her haughty missive did not go unanswered. Two months later
the *Atlantic Monthly* published "The Two Generations," by
Randolph Bourne, in which the Columbia student argued that
Comer did not understand how dramatically the world had
changed. Whereas she felt that a young man should work hard
to be independent, Bourne argued, such a possibility did not exist
any more and, moreover, represented an evasion of collective
responsibility. Young people, he said, resented "being swallowed
up in the routine of a big corporation" when what they wanted
was to create a good life not only for themselves but a socially

just world for all.[26] The essay hit the key note of *Youth and Life*'s main theme. Bourne believed that young people should preserve their personal identities at all costs. At the same time, he felt, they must establish abiding commitments to the community at large.

Bourne wanted to find the secret of perpetual youth, which he regarded as a challenge to traditional society. He considered youth a reward to flexible people who responded not to social demands for conformity but to their pressing internal needs and to their sense of justice. Bourne could not conceive that these goals might conflict. The key to youth, he argued, was a "strong, aggressive spirit of daring and doing," remaining open to new ideas and experiences. Obviously, his definition of youth depended less on age than attitude. When Alfred Stieglitz, for example, a man fifty years old in 1913, claimed he was the youngest person he knew, he showed that he understood youth and life in terms familiar to Bourne.[27]

While Bourne praised youth, he did not exalt it as an end in itself nor did he want to build a cult around the young. His over-riding concern was to change the world, or, in his words, to create "a regenerated social order." But, as for the Russian populist N. G. Chernyshevsky, for Bourne too the great question remained, "What is to be done?" In answering Chernyshevsky's challenge, Bourne sought to resolve the contradiction between self-interest and social commitment. The radical, Bourne wrote, "desires self-development and self-expression, and the only opportunities of-fered him seem to be ways of life and training that will only mock the best social ideals he has. This is the dilemma of latter-day youth, and it is a dilemma which is new and original to our own age."

Bourne rejected the Tolstoyan ideal of self-sufficiency and re-treat from a corrupt world as well as the apocalyptic view that only a cataclysmic struggle could transform society. Arguing that these nineteenth-century responses to the evils of industrialization were no longer valid in a modernized, integrated world, he sug-

gested instead that radicals change the system by demonstrating the social superiority of their personal ideals in their own lives. Bourne, therefore, advised prospective revolutionaries to "cultivate" themselves. Lenin, who had a much different answer to Chernyshevsky's question, would have abhorred his advice. In contrast to Lenin, who knew better, Bourne thought that youth could lead by example, as it were, to the "communal life of the future."[28] The road to socialism, he seemed to be saying, was through self-expression.

Bourne's message, however unrealistic, enabled him to resolve the paradox of realizing his twin aims of emancipating the personality while at the same time liberating society from economic oppression. "Into your machines, O my masters, you have knotted and kneaded our lives," he once wrote in a collegiate poem he called a "Whitmanesque effort."[29] In *Youth and Life* Bourne sought to offer an escape from those machines' hold on American society. As he noted correctly, they were increasing their grip on people's lives at an unprecedented rate during his lifetime. While Bourne's counsel to emphasize self-exploration and self-expression relied on an old American intellectual tradition going back through Whitman to Emerson and Thoreau, whom he also read and admired, his utopian insistence that enough free individuals could create a new community based on new values allowed him to transform a nineteenth-century ideal into a twentieth-century response to social problems. Like the optimistic cultural radicals of the sixties, he underrated society's power to mold individuals rather than vice versa. By 1918 even Bourne began to see how naive and hopeful he had been five years before.

A student at Columbia between 1909 and 1913, Bourne, not surprisingly, turned to progressivism for the tools to help him oppose the status quo. He was particularly fond of John Dewey's philosophy of instrumentalism. According to Dewey, the validity of beliefs, customs, and ideas should be evaluated not by their adherence to some abstract conception of truth but by their capacity to solve problems. It is easy to understand how a philosophy

40

which maintained that *nothing* was fixed could appeal to someone with revolutionary intentions. In 1915 Bourne called Dewey a "revolutionist," explaining that his "philosophy of 'instrumentalism' has an edge on it that would slash up the habits of thought, the customs and institutions in which our society has been living for centuries." At the height of the Progressive Era, Bourne naively thought that if society's ideas and practices were first held up to critical scrutiny and then adopted or discarded according to their potential contribution or detriment to mankind, social progress would inexorably follow. He did not realize, or at least until 1917, how crucial was his deeper espousal of personal and collective freedom in determining his early enthusiastic endorsement of pragmatism. In 1912 he even voted for Theodore Roosevelt on the assumption that the Progressive party's presidential candidate stood for "the economic and social welfare of the whole people," though Bourne's extreme dislike of Woodrow Wilson, the governor of his home state of New Jersey, also contributed significantly to that decision.[30]

While Bourne favored progressive means, he nevertheless opposed most of the movement's social and economic policies. For example, on the middle-class progressives' favorite demand that expert administrators replace corrupt but popularly elected officials in the interest of efficiency, Bourne wrote, "Democracy means a belief that people are worthy; it means trust in the good faith and the dignity of the average man. The chief reason why the average man is not now worthy of more trust . . . is simply that he has not been trusted enough in the past." He had no tolerance of the progressive shibboleths of "philanthropy" and "trusteeship." Like his hero Walt Whitman, he believed in "a much more robust humanity" than did any progressive builder of elaborate systems of social engineering.[31]

Bourne felt much more comfortable calling himself a socialist than a progressive. He accused the progressives of being naive in believing that they could eradicate the abuses of the marketplace without changing the capitalist system. While reformers like Croly

and Weyl thought that Bourne was basically soft, he claimed that their plans for government regulation of industry were "most utopian." Bourne believed that the liberation of society would begin at the bottom, with the workers. Unlike the progressives, he did not want to put out the fires of class conflict by maximizing efficiency, increasing output, or improving factory conditions. Instead, he saw in those flames a hope for the future, arguing that all the progressive schemes in the world were no substitute for the proletariat's ownership and control of the means of production. "The only defense we have against the tightening of the feudal bonds," Bourne maintained, "is the mental attitude of the workers themselves. Upon their unwillingness to be bound, under the guise of 'increased efficiency,' . . . will depend the future of society." He hoped that the workers' refusal to become automatons in an industrial regimen would induce them to demand the creation of "a new and regenerated society" in which they could become "true personalities."[32]

Bourne found evidence for projecting his personal wishes onto the workers in the McNamara case, in which two brothers were convicted of blowing up the *Los Angeles Times* building and killing twenty people. He maintained that the dynamiting of the antiunion newspaper office was not an example of senseless anarchy, something most progressives ardently believed, but "a symptom of the class struggle." Although he did not advocate violence, Bourne recognized the legitimacy of workers' grievances. In contrast, Theodore Roosevelt articulated the progressives' view in an article entitled "Murder Is Murder." "The question of organized labor or organized capital," he wrote, "has nothing whatever to do with this issue."[33] For Roosevelt, the case represented homicide, nothing more.

Bourne's conception of socialism, one that he shared with others in Greenwich Village's Lyrical Left, has been all but lost to history. Less a product of political or economic analysis, it concentrated on emancipating the individual by changing culture. He described the socialist world he envisaged idealistically as one

that supported "freedom and richness in life, joyful labor and a developed humanity." At the same time, he insisted that "voluntary association and individuality . . . would be of course beautifully guaranteed under Socialist Industrial Democracy." Bourne's socialism tied together the various cultural movements then engaged in trying to organize a new society. He thought that the combined efforts of these radical groups would lead inexorably to the socialist world he imagined. "I see the social movement," he wrote, "with all its manifestations, —feminism, socialism, social religion, internationalism, etc.— slowly linking the chains of social consciousness, and thus transforming the individual persons, the individual groups, lifting them to a higher level, giving them a more abundant sense of sympathy and unanimity."[34]

Bourne had little patience for piecemeal progressive programs that failed to address what he considered to be the cultural roots of social and economic problems. He favored the socialist politics of Western Europe over the politics of reform in the United States because, he argued, the European radicals realized that cultural and political changes were indivisible. "I wish it were that way in America," he wrote, "and we didn't have progress blocked by the blind recalcitrancy of progressives and feminists of the Jane Addams type."[35] Bourne disliked Addams and her fellow progressives because, by seeming to offer change without really challenging the social and cultural substructure of the American way of life, they, in effect, buttressed the system he wanted to overthrow.

Because Bourne's politics did emphasize culture, he had no difficulty, as did most progressives, in extending his analysis to nonpolitical issues like perception, religion, or, in his words, "the limitless potentialities of life." His reading of William James, particularly the psychologist-philosopher's *The Varieties of Religious Experience* (1902) and *A Pluralist Universe* (1909), enabled him to develop a practical theory of cultural pluralism. James had suggested that there was no single truth, ultimate reality, or

right way of doing things. Bourne, in turn, adopted that radical and, for many, deeply unsettling conclusion in order to argue that Americans should therefore encourage tolerance and stimulate variety in their society. Where progressives like Lippmann inveighed against "the evils of localism," Bourne expounded "the experimental life." In an essay by that name, he wrote: "That same freedom which we demand for ourselves, we must grant to every one. Instead of falling with our spite upon those who vary from the textbook rules of life, we must look upon their acts as new and very interesting hypotheses to be duly tested and judged by the way they work when carried out into action. Noncomformity, instead of being irritating and suspicious, as it is now to us, will be distinctly pleasurable, as affording more material for our understanding of life." And, in opposition to progressivism's basic hope, he concluded on a radical note, "Causes have only finally triumphed when the rational 'gradual progress' men have been overwhelmed. Better crude irrationality than the rationality that checks hope and stifles faith."[36]

Bourne had little patience with those who argued that the methods of rational science, if judiciously applied by disinterested experts, would lead to a more ordered and controlled society. "One does not have to live very long," he wrote in reference to the progressives' programs that were designed to enhance social and economic efficiency, "to see that this belief in the power and desirability of controlling things is an illusion." Because, like James, Bourne was aware of the limits of scientific inquiry to determine the truth, he urged fellow radicals to explore "the boundless puzzling world" without maps and charts, guides that, in the final analysis, he felt, offered little more than the satisfying fantasy of security and control. "It isn't any static life to which we must get adjusted," he argued, "but a lot of moving tendencies."[37] Although Bourne did not know it, the artists at Alfred Stieglitz's gallery, 291, based their new revolutionary work on the same principle.

To understand and interpret the world realistically, Bourne in-

sisted, one must admit the existence of spirit in the universe. Disturbed by the materialistic emphasis of his age and unsatisfied by his own Presbyterian upbringing, he urged acceptance of the unknown as well as the different. He thought of himself more like a romantic pilgrim than a sociologist or an engineer. From his reading of Bergson and Maeterlinck, whose philosophies he sought to explain, Bourne learned to appreciate the irrational, creative, and mystical urges he experienced. He associated his transcendental yearnings with a belief in God's existence, and argued that a universal awareness that began in the self had to go beyond rational analysis before it could comprehend the cosmos. "It is worth while," he wrote, "to speculate about the unknowable things that lie so little below the surface of our matter-of-fact world, to think of the wisdom of the flowers and the instinct of the bee, intuitive sympathies and haunting presences, and all the experiences of aesthetic and personal emotion that defy analysis and conceptual regularity, and yet which bathe the life of every mind of the slightest poetical sensitiveness."[38]

On the other hand, Bourne did not believe that radicals should allow religion to lead them into a life of political or social inactivity. Significantly, one of his essays in *Youth and Life* was entitled "The Mystic Turned Radical," not vice versa. As he wrote to a friend who was reluctant to accept the radical implications of his religious insights, "Your Religion of Humanity I would transfigure into a Religion of Socialism, moving towards an ever more perfect socialized life on earth." Still, in keeping with his generally tolerant attitudes, he recognized the legitimacy of true believers' insistence upon creating their own exclusive worlds apart from the mainstream of human affairs.[39]

The pluralism Bourne outlined in *Youth and Life* provided a foundation for his future consideration of the important cultural and political questions of immigration and war. In 1913 his general focus masked the significance of his ideas. By 1916, however, when events forced him to sharpen his point of view and direct his critical attention to specific concerns, namely, to the problems of the nation's cultural identity and to the issues raised by the

World War, he could rely on ideas he had already developed. In addition, his view of society as basically a repressive agent interested mainly in maintaining conformity was already in place before he witnessed the social and political repression that followed the United States' entry into the war. As early as 1913 he pointed out that "society . . . is one vast conspiracy for carving one into the kind of statue it likes, and then placing it in the most convenient niche it has."[40]

At its root, Bourne's visionary, indeed romantic, prescription for cultural change leading to both increased personal freedom and to collective social development was inherently contradictory. Bourne might have answered with Walt Whitman, "I contradict myself? Very well, I contradict myself." As it was, he was not unaware of all the ironic confounding contradictions that permeated his ideas. "I thought of my impossible essays" in *Youth and Life* he reflected, "in the light of this that all the world was believing and practicing, and wondered what perverse fate had imposed on me a philosophy so cross-grained, so desperately impractical as mine—of scorn for institutions, combined with a belief in their reform, —of scorn of exploitation combined with a need of the wherewithal to live, —of a fanatical belief in mass-movements and mass-ideals, combined with a sensitiveness to unique and distinctive personality. But I was delighted to find that my real faith didn't waver an instant before the deluge; it only served to bring out more clearly, —indeed more than ever before, — the contrast between my Socialism and the old ideals and make me want to crush the latter all the more completely."[41]

In 1913, upon graduation, Columbia awarded Bourne a traveling fellowship to study urban planning in Europe. He used his thirteen months abroad from August 1913 to the outbreak of international hostilities in September 1914 most fruitfully, studying not only the management of European cities, then a popular topic among American progressives, but also developing further his ideas on pluralism, nationalism, and revolution. Traveling

46

and living in England, France, Italy, and Germany at the be-
ginning of the century, when the cultural traditions that divided
Europe were still more or less firmly in place, enabled Bourne
to explore firsthand his ideas about culture, society, and the in-
dividual outside the United States. He met and interviewed as
many people as possible, learned French—he already knew Ger-
man—and relied generally upon his keen intuitions to guide him.
"I collected all the material I could about the operation of the
town-planning act, in case I should have to write a report for my
Fellowship," he wrote to a friend. "But facts and figures are not
my line. I must be interpreting everything in relation to some
Utopian ideal, or some vision of perfection which I am so un-
fortunate as to have."[42]

Bourne was an impressionist, and, indeed, his report to the
university's trustees was no treatise on urban planning supported
by an array of graphs and statistics. It was, however, an interesting
survey that underlined Bourne's radical assumptions about culture
and social psychology. His most striking observation, he ex-
claimed, "was the extraordinary toughness and homogeneity of
the cultural fabric in the different countries." A casual tourist
might have agreed, but Bourne, having benefited from studying
under Franz Boas, the anthropologist who pioneered the idea of
cultural relativism, pressed the conclusion further into an area
where insight becomes concept. "The opportunity, " he wrote,
"to immerse oneself in these various cultures until one feels their
powerful and homogeneous strength, their meaning and depth,
until one takes each with entire seriousness and judges it, not in
American terms, but in its own" supported his knowledge that
national cultures were not better or worse but relative.[43]

Although hardly a revolutionary idea today, cultural relativism
attracted only a handful of people in the Progressive Era. Fol-
lowing the mass hysteria and xenophobia that erupted all over
the world after 1914, its proponents became fewer. Bourne, whose
own youth had taught him to appreciate individual differences,
realized that people were not "just plain folks" regardless of where

they lived. He understood that countries comprised different patterns of thought and diverse social customs and therefore argued, despite passionate claims to the contrary, that no nation represented universal morality. That original insight helped him sustain his opposition to American intervention in the First World War. As he wrote in 1915, when American public opinion increasingly supported Britain's version of the war, "The point that generally escapes us is that this English interpretation is unique. . . . We have succumbed to the temptation of feeling holy."[44]

Despite his tolerance, Bourne hated England. At the end of an era of cultural colonialism when English institutions, customs, and modes of perception dominated American society, Bourne and others blamed the strength of the British example for inhibiting the growth of a native American culture. They assumed, of course, that an indigenous American culture, if allowed to blossom, would express values and ideas more in keeping with their own libertarian and socialist worldviews than conservative Victorians on both sides of the Atlantic permitted. In any case, Bourne's visit to Britain confirmed and strengthened his suspicions. After a few weeks in that country he exclaimed, "I began to feel desperate, almost like throwing a bomb at the House of Lords. . . . In short, it pains me to think how we have allowed ourselves to be hypnotized by England: we need to see it as the stupid, blundering, hypocritical beast it is." Although Bourne claimed that he "was exceptionally well treated in England," the English people's notorious coldness and reserve distressed him immensely. "The English treat everything human as if it were a block of wood," he said. Suggesting that they were "the least introspective of peoples," he argued that even their literature exhibited little emotion. Before he left Britain, if not before he arrived, Bourne was "just about ready to renounce the whole of Anglo-Saxon civilization."[45]

Politically too he felt the nation left a lot to be desired. His visit, at a time of increasing labor agitation, large-scale discontent in Ireland, and a militant female suffrage campaign in full swing,

48 contributed greatly to his political education. He was shocked by the widespread poverty of the country, exclaiming that only a minority enjoyed "anything more than a filthy caricature of human life." Bourne challenged those he met to explain England's social inequality. He visited, for example, Toynbee Hall, a Christian socialist education experiment in Whitechapel, a London slum, which sought to teach the classics to the poor, and concluded that it was "one of the most marvelous demonstrations of the futility of the English mind that I know." Like Hull House, the progressive settlement in Chicago which, as a matter of fact, Jane Addams founded after she visited Toynbee Hall, it struck Bourne as paternalistic and ill-conceived. In general he found the English progressives, like their American counterparts, disappointing. After meeting the Fabians, for example, he decided that he was "far more desperate than they," and, unlike the respectable socialist organization, "welcome[d] any aggressive blow, any sign of impatience." For that reason, he considered the Women's Social and Political Union "tremendously thrilling." Bourne thought that the Pankhursts' group represented a "guerilla revolution against the Liberal Government," deciding that the militant suffrage movement was "the only live thing" in the country.[46]

England offered more than a sounding board for Bourne's political sympathies, however. It also taught him to appreciate "the enormous power of *institutions* and how little the quality of the *individual* character counts in them. That is why I am a Socialist," he explained, "and want brand-new institutions." In order to emancipate the individual, he concluded, a revolution was necessary. Before Bourne left Britain, his radicalism "immensely strengthened" by the visit, he wrote that the country "seems very old and weary, as if the demands of the twentieth century were proving entirely too much for its powers, and it was waiting half-cynically and apathetically for some great cataclysm."[47]

If England enraged Bourne by reminding him of home, France excited him because its intellectual and social traditions were dif-

ferent and new. Living in Paris from December 1913 to April 1914, he felt he breathed "a freer, more congenial air." In France, he noted with great approval that "a democratic diffusion of culture" created a more egalitarian society than in either Britain or the United States. He contrasted French democracy, "where you criticized everything and everybody, and neither attempted to 'lift' the 'lower orders' nor 'ordered yourself lowly and reverently towards your betters'" with the social situation in the United States. "There was a solid, robust air of equality [in France], which one felt in no other country, certainly not our own," he wrote bravely in his report to Columbia's trustees. The French also reconfirmed his pluralist bias. He said that he particularly treasured their "belief in the dignity of infinitely varied human experience, a belief that Anglo-Saxondom," he thought, "wholly lack[ed]."[48]

Bourne's five-month sojourn in France suggested an alternative social model that helped an open-minded writer fashion a new political and cultural consciousness. What Bourne appreciated most in France, despite his comments, was not its social equality or its democratic freedoms, but rather the organic nature of French culture. An ardent believer in national consciousness, Bourne admired the French people's concern for aesthetics, their interest in personal relations, and their intellectual seriousness, all of which, to him, were parts of a whole. While England and the United States showed him what he disliked— class, repression, and social conflict—France demonstrated the kind of organic culture he hoped would take root in America. "Life to the Anglo-Saxon," Bourne generalized, "is what people are doing," but, for the French and Italians, it also included, fortunately, "stream of consciousness, what individuals and also what groups are thinking and feeling."[49]

Assuming that changes in sentiment and style could have revolutionary consequences for American society, Bourne argued that cultural radicals at home should seek to alter the collective mentality of the American people. As he wrote to Carl Zigrosser, a friend from college who shared his aspirations, "I felt on the

Continent how much life was enriched by a certain natural sensitiveness to art as evidenced in the charming villages and the carefully laid-out towns, and even modern architecture. . . . So, if you can do anything towards spreading that sensitiveness at home, you have a work before you as important as that of the best social reformer. Any general improvement in taste means a demand for a rise in the standard of living, and this rise is *the* great fulcrum, I am convinced, in social progress."[50] Zigrosser agreed. He devoted the remainder of his life to art, first in the employ of the Wehye Gallery in New York and later as a curator at the Philadelphia Art Museum. The radical idea that a dynamic culture could change society persuaded many in addition to Zigrosser. It also led, for example, to the establishment of 291.

In the early twentieth century the American radicals' cultural nationalism—which held that the development of an authentic native culture would provide the impetus to alter the country's collective mentality—differed greatly from its counterpart in Europe. By the time of Bourne's visit, the European nationalist movements, which in the previous century had propelled democratic and social liberation, were moving dramatically to the right, spreading the germs of fascism and anti-Semitism. In the United States, however, cultural nationalists like Bourne and Stieglitz maintained their insistence on social democracy and freedom. As Bourne discovered when the war broke out, cultural nationalism was a double-edged sword. It could be used as a weapon by the Right as well as the Left.

Before the war, however, Bourne wrote a significant but overlooked essay in which he revealed his intellectual infatuation with French nationalism while he was in Paris. "Maurice Barrès and the Youth of France" is not included in any of the numerous anthologies of Bourne's work because its implications and conclusions so dramatically conflict with the main body of his democratic thought, particularly in light of political and intellectual developments after he wrote the essay. The piece demonstrates, like his early endorsements of instrumentalism, the potential

dangers of losing sight of ultimate goals. It also shows the importance of the context in which cultural nationalism developed as well as the complexity of a man like Barrès, whose ideas commanded support from both ends of the political spectrum.

Maurice Barrès was a French politician, a popular novelist, and a political theorist who expounded a theory he called "integral nationalism," which emphasized national vigor and cultural authenticity based on a philosophy of "la terre et les morts." By the time of his death in 1923, Barrès personified everything disillusioned radicals despised; indeed, two years previously, Tristan Tzara and other dadaists held a mock trial in which they condemned him for his alleged responsibility in preparing the intellectual groundwork that had led to the Great War. In 1914, though, Bourne could still praise the virtues of Barrès's political philosophy. His, he wrote, "is the nationalism which has called the youth of the rising generation back to a defense of *l'esprit français*, and surely traditionalism has never been preached in such seductive terms!" Barrès's interest in developing "a rich common culture" fooled Bourne, even though he added the wishful hope that the "social and pragmatic feeling" of French youth would insure that they not follow "very far along the path of obscurantism and reaction."[51] The essay underlines the dangers of the search for an organic culture, particularly when intellectuals on the Right set the course.

From France, Bourne traveled through Italy and Switzerland to Germany, where he witnessed the outbreak of the war. Although his visit was cut short by the international conflagration, he still had time to see and appreciate the latest German architecture and municipal planning. He liked both, and was generally enamored by the Germans' "sense of efficiency," as he put it, even though he found "something [disturbing] in the soul of the people," difficult to articulate but frightening nonetheless. The threat of hostilities that hung over Europe during the late summer of 1914 influenced Bourne's impressions of Germany. He now had no illusions about collective national movements. Germany's

preparations for war thoroughly depressed him. On July 30 he wrote from Dresden, "It made me very blue to see the crowds of youth," in whom he had placed such hope, "parading the streets long after midnight the other night, cheering for Austria and the War and singing 'Die Wacht am Rhein.' It will give these statesmen who will play their military pawns against each other such a splendid excuse for their folly, for they can say they were pushed into it by enthusiastic demands of the people."[52] He obviously rejected the notion that they may have been.

The next day Bourne went to Berlin. That afternoon he saw the kaiser, a "grim, staccato-voiced, helmeted figure, [the] very symbol of war," deliver an ultimatum to the tsar of Russia from the balcony of his palace, as it was done in those days, before an enthusiastic mob. Within twenty-four hours, after Russia refused Germany's demands, hysterical crowds of people swarmed into the streets to welcome the oncoming war. "If ever there was a tense and tragic moment, when destiny seemed concentrated into a few seconds of time," Bourne wrote, "it was that 5 P.M. on the afternoon of August first, at the corner of Unter den Linden and Friedrichstrasse, in Berlin."[53] Before midnight, Bourne was on his way home via a short detour in Scandinavia. There would be no socialist congress to attend in Vienna.

Bourne's witnessing of the calamitous prelude contributed to his opposition to the Great War. Although he had been a pacifist before then, his personal experiences in Germany reinforced his convictions about the absolute folly of war, giving him the necessary courage to oppose America's entry into the collective madness in 1917. An article he wrote in November 1914, otherwise simply a travel account, prefigured his future dissent. He used the occasion to again attack progressive political thought. Explaining how the war broke out in Berlin, Bourne wrote, "The whole theory of social and political life seems to be to get the best people to direct things, and then obey them implicitly." In Germany, he warned, that philosophy had led "a handful of men [to] cast the die that might mean destruction of them all," and,

he noted ominously, once the decision was made, there were no dissenting voices.[54]

He was not wholly correct. As in the United States, where a small minority of ineffectual intellectuals, like himself, opposed the war in 1917, in Germany too a few individuals spoke out in futile protest. Yet Bourne's feeling that the war might lead to the end of the Kaiser Reich, an outlandish idea in 1914, proved true.

The war that chased him out of Berlin made Bourne happy to return to the United States. "I never expected to be so glad to come back to America," he wrote aboard ship to New York. "The wheels of the clock have so completely stopped in Europe." His disillusionment with European civilization led Bourne to feel nostalgically perhaps that he had been too critical of his native land in the past, "too snobbishly Utopian," as he put it.[55] But in the next few years, as progressives strengthened their grip on the nation's politics, as preparedness advocates clamored for armaments, as Americanizers mobilized to assimilate immigrants, and as zealous patriots sought to foreclose debate once President Wilson also declared war, he would not think so.

When Bourne returned to the United States in September 1914, he again faced the question that had plagued him since graduating from high school in 1903, that is, what to do? Ideally, he wanted to teach or write. Obtaining a university position, however, was difficult, and newspapers and journals did not want to pay him to express unpopular, radical views. Envisaging his future at the time, he lamented, "The life of a hermit philosopher living on a mere pittance does not appeal to me; indeed even the bare pittance is wanting." In 1914 Bourne was deeply worried. He complained that because he had "boasted the glories of spiritual free-lancing, and acted some of my maxims at Columbia, it looks as if the world would take me at my word and let me free-lance at my will."[56] The prospect did not please him.

As he floundered, his old friend Ellery Sedgwick, editor of the

4

Atlantic Monthly, who had published his first essays, came to his rescue. In April, Bourne had written that he needed a forum when he returned from Europe "from which [he] could preach some disagreeable truths." By May, Sedgwick had convinced Herbert Croly, editor of the forthcoming *New Republic,* to put Bourne on his staff. The editor of the *Atlantic* warned Bourne that the *New Republic* would be "the solemnest procession that ever marched. . . . They can celebrate a Puritan Thanksgiving," Sedgwick wrote, "but whether they can make the Fourth of July hum, remains to be seen."[57] To Bourne, though, Croly's offer seemed like a godsend; in 1914 he did not know that it would turn out to be a Trojan horse.

Bourne was a misfit from the beginning among the progressive intellectuals at the *New Republic.* He could hardly feel comfortable among such serious, practical intellectuals as were its editors, Croly, Weyl, and Lippmann, and his disenchantment came quickly. Even before the first issue came out, Croly rejected two of Bourne's pieces on labor problems because they had not been assigned to him. More likely, they were too radical for Croly's politics and his efforts to influence policymakers in government. Bourne chafed under such restrictions. When the *New Republic* printed several articles reviewing the first year of the European war, overlooking two of his own on the same subject, essays he "was getting quite proud of," he was furious. Each successive issue convinced his "proud spirit" that he contributed nothing to the journal's editorial policy and, in fact, was "a very insignificant retainer of its staff."[58] Clearly, the *New Republic* did not give Bourne the opportunity to relate his "disagreeable truths" to the American public.

With the exception of an occasional column, Bourne wrote about education for the progressive magazine. A crucial topic among reformers during the Progressive Era, it was one Bourne and the *New Republic*'s editors agreed on. Like some radical educators in the sixties, Bourne considered education another field in which to fight problems of alienation in modern society. He

was more interested in enlarging personal freedom, however, than he was in efficiency in the schools, saving taxpayers money, or in socializing masses of children to meet the demands of a new industrial nation.[59] These were the furthest things from his mind when he undertook to popularize John Dewey's philosophy of using education to combat alienation. Confident that the main goal of progressive education was to eliminate artificial inequality and to change cultural values, Bourne wrote a series of essays that, in 1917, he collected under the suggestive title *Education and Living*. They formed an integral part of his cultural radicalism.

Those ideas on education he did not borrow from Dewey, Bourne based on his personal experience. He began by assuming that schools taught little. For him, primary school had been "an enormous joke." Before he entered the first grade, he already knew how to read and write, and his spelling, he claimed, was impeccable. He refused to take his teacher seriously, soon earning the well-deserved reputation of being "a saucy boy." Later he conformed to the strict demands of a classical education, and, as his New Year's resolutions for 1901 reveal, he was less rebellious during his adolescence than he later liked to believe. They were "to be systematic in practicing and studying, to learn one Bible verse each day and read a few, [and] to be more cordial."[60] Nevertheless, when Bourne reviewed his own education, he determined that it represented a personal victory over the institutions to which he had been sent.

Education and Living was based upon premises developed in *Youth and Life*. Bourne's desire to establish an impregnable place for the individual within society propelled the argument of his educational essays. The school system, he argued, could be as iniquitously efficient in stifling creativity and expression as any other. Following the romantics of the nineteenth century, Bourne declared that children were not empty vessels into which authorities should pour wisdom and knowledge but rather were active, creative, even superior individuals who needed only op-

portunities for personally directed growth. If successful, traditional education, he feared, would result in "a terrible levelling of personality."[61]

Bourne's iconoclastic antiauthoritarianism also led him to place more trust in communities than in experts to teach the young. Like Dewey, he reasoned that schools should attempt to reintegrate the skills and values that industrialization had taken out of the home. As early as 1899 Dewey had written "that our social life has undergone a thorough and radical change," and if education was to keep pace, it too had to "pass throught an equally complete transformation." For Dewey, that meant eradicating the artificial division that had developed between schools and society. He wanted to create a flexible system that combined various modes of education and therefore permitted individual growth and personal choice. Although progressive educators adapted Dewey's proposals to suit their own ends, he himself naively believed that "society counts individual variations as precious since it finds in them the means of its own growth."[62] That last sentiment particularly appealed to Dewey's young protégé and leading popularizer.

Armed with these assumptions, Bourne visited his old high school in Bloomfield to observe modern educational practices for his first essays in the *New Republic*. "In a Schoolroom," published in the magazine's premier issue, noted that in 1914 "hand-educated children have had to go the way of hand-made buttons." Massed together as if they were machines in a factory, the students had no chance, Bourne said, to become a dynamic community or to express their own minds and personalities. "Call this thing that goes on in the schoolroom schooling, if you like," he concluded. "Only don't call it education."

Bourne thought of education as life itself. The ideal school, he maintained, should not attempt to teach masses of children any particular subject or skill. Instead, it would provide pupils with the opportunity to encounter "typical experiences" in which children could learn by themselves, unobstructed by the influence

of outside authorities. In the last analysis, he optimistically rea-
soned, "each child will have to educate himself up to his capacity.
He can only educate himself by living."[63] Dewey's disciple also
suggested that schools could combat students' alienation by be-
coming embryonic communities attached to the larger society's
interests and occupations. Then, he argued, students might again
receive interesting and relevant educations worthy of the name.

Bourne thought he saw the "schools of tomorrow" in Gary,
Indiana, where Willard Wirt, a progressive educator, had designed
a new system for that booming steel town. By utilizing the com-
munity's total resources, by moving students from activity to ac-
tivity, and by combining scholastic and technical training, Wirt
offered Gary's students a varied education and its taxpayers a
lighter bill. The *New Republic* sent its education reporter to Gary
to investigate.

In *The Gary Schools*, the book Bourne wrote based on his visit,
he explained how Wirt's system fought alienation by successfully
incorporating Dewey's principles. The curriculum emphasized
learning by doing. English taught "expression," science, "a com-
mand of technical resources," and, most importantly, vocational
training kept "industrial work constantly in touch with the other
activities." The last point created more than a little controversy
at the time, particularly among Jewish students in New York City
who vehemently protested a proposed plan to "Garyize" their
schools. Bourne defended vocational education *within a larger
school system* by pointing out, in keeping with his pluralist phi-
losophy, that since a democracy recognized individual differences,
its schools needed to plan for them. Although he deplored separate
industrial training for selected pupils because he thought that it
would create "invidious distinctions" among students and classes,
his argument that everyone should be exposed to both technical
and academic environments did not allay the realistic fears of
immigrants that progressive city administrators might resort to the
Gary system to save money and to close off the upward social
mobility. As one Jewish mother exclaimed, "We want our kinder

58 to learn mit der book, der paper und der pensil[*sic*] und not mit der sewing and der shop!"[64]

Bourne was not happy with *The Gary Schools*. It is ironic, therefore, that his support of the Gary plan found him sided with the progressives against the immigrants. One of the paradoxes of progressive education was that it attracted people like Bourne and Dewey, who were mainly interested in personal liberation and cultural growth, as well as others such as William Wirt and Abraham Flexner, who liked to argue that the new educational experiment was more efficient and less costly. The role of civic booster and education expert discomfited Bourne, but demands from his commercial publisher and prospective professional audience inhibited his expansive style. "The Gary work is a fearful thing," he decided after completing his manuscript. "I tried to be official and descriptive and to quench all unqualified enthusiasm, with the result that I am duller than the most cautious schoolmen. . . . I shall never touch Gary again."[65] And he did not, even when it exploded in New York City's municipal politics in 1917.

Bourne was much happier in the role of a cultural critic. His reflections on higher education placed him at the beginning of a modern tradition that advocated reform in the universities as a catalytic charge for change in the larger society, a view familiar to future radical students at his alma mater. In keeping with his general emphasis on the importance of culture, he argued in 1913 that for the first time colleges and universities were becoming "a reorganizing force" in American life. He envisaged the university as an integral, influential part of society that would lead the search for radical ideas and new methods. He therefore defended the introduction of new social studies into the curriculum at the expense of an older emphasis on the classics. Political science and especially sociology, he said, were "vital and timely and of real significance." Like another generation of students who demanded "relevant" courses in the curriculum, Bourne assumed mistakenly

that the lessons of these new subjects would automatically lead to social change.

Because he thought that the university was so central to changing American society, Bourne also had little patience for traditional college life, which was becoming institutionalized in the Progressive Era. He lambasted the idea that a university "exists for its athletic teams," and he claimed that fraternities, eating clubs, and proms contributed nothing to what he saw as the democratic purpose of education. According to Bourne, who, suffice it to say, did not play varsity sports, join a fraternity, or go to dances, the students of the teens were awakening "to ideas of larger import than [their] own little world[s]."[66] Here, he might have explored the contradition between self-development and communal commitment, but he did not.

Bourne also criticized the structure of universities. In a thinly disguised satirical attack on Nicholas Murray Butler, Columbia's president, entitled "One of Our Conquerors," he wrote: "The relations between President Butcher and the trustees of Pluribus have always been of the most beautiful nature. The warm and profound intellectual sympathy which he feels for the methods and practices of the financial and corporate world, and the extensive personal affiliations he had formed with its leaders, have made it possible to leave in his hands a large measure of absolute authority." Following the article's publication, Bourne said he was "a little bashful about visiting Columbia in the daytime."[67]

His comment can be read as a general indictment of the progressive idea that power should be invested in responsible administrators. When the University of Pennsylvania dismissed Scott Nearing in 1915, Bourne maintained that the trustees do not own the universities. If they were not willing to share authority with their faculties and even with the communities at large, he suggested, collective action would wrest control from them. By 1917, after dissenters had been drummed out of Columbia, Bourne argued more pessimistically that "under trustee control the Amer-

60

ican university has been degraded from its old, noble ideal of a community of scholarship to a private financial corporation."[68] The main purpose of education, as he then saw it, was to turn out docile, unchallenging, interchangeable students to man the emerging industrial system.

5

Bourne believed that the critic played a crucial role in American life. If, as he argued, culture provided the lever that could move society, it followed that intelligent (i.e., radical) criticism could contribute to social change. He once wrote that "the appearance of dramatic imagination in any form in this country is something to make us all drop our work and run and see." The comment reflected his assumption that writers and artists made a real difference to society. Further developing his hypothesis that art and social change were inexorably linked, with the Paterson Pageant of 1913 in mind, he exclaimed, "The outburst of Pagan expressiveness is far more revolutionary than *any other* social change we have been making. It is a New Freedom," unlike Wilson's he undoubtedly thought, "that really liberates and relaxes the spirit from intolerable tensions of an over-repressed and mechanized world."[69]

Among the first targets of his cultural criticism was the New Humanism proposed by Paul Shorey and Paul Elmer More. Bourne's opposition to their belief that American culture should be firmly rooted in the traditional values of the classics flowed naturally from his antiauthoritarian outlook. For Bourne, Shorey and More—he might have added Irving Babbitt as well—wanted to enclose the boundlessness of youth's desire within a "tight little Greek frame" and thereby preserve a static civilization based on outdated standards.[70] The main problem with the classicists' cultural hegemony, Bourne asserted, was that it denied individual differences and precluded the development of new forms of personal creativity.

Bourne's views did not go unchallenged. Only a week after he

had criticized Paul Shorey's *The Assault on Humanism* (1913) for being elitist, Shorey responded by attacking *Education and Living*. In a review entitled "The Bigotry of the New Education," he called Bourne's book "social propaganda," writing that "the 'imaginative background' of all Mr. Bourne's educational preferences and policies is the socialistic Utopia which he insinuates under the cover of the word democracy."[71] Shorey was of course correct. Bourne did view education as a sharp instrument that could potentially carve out a more democratic (or socialist) society.

Because Matthew Arnold also helped support the cultural status quo, his ideas were equally repugnant to Bourne. During the Progressive Era, Arnold's seminal book *Culture and Anarchy* (1869) still strongly influenced the thinking of both conservative and liberal intellectuals in America. Arnold had defined culture as "the best that has been thought and done," indicating, if one accepted his definition, that culture could be advanced only by assimilating the lessons of the past. Since Bourne was mainly interested in unleashing individual talents, he took issue with Arnold's "Cult of the Best" as he dubbed it in an essay by that name. He found the English critic's assumption that artists and educators should present tested models for the younger generation to emulate and imitate a severe impediment, exclaiming that "as long as you humbly follow the best, you have no eyes for the vital." Arnold's influence, he charged, not only stifled original expression, it also prevented the development of native art forms. Employing the same pluralist logic that underlay his criticisms of American social policy, Bourne declared, "We should get a variety of tastes—some of them traditional, some of them strange and new, but most of them at least spontaneous, indigenous." Then, he maintained, echoing Alfred Stieglitz's position, the United States might develop a sincere, significant, differentiated, but also paradoxically, "integrated culture."[72]

Bourne's concern for creating a new national culture was an important part of his politics of liberation. He felt that the oppressiveness of the Anglo-Saxon, Victorian ethos that, in the per-

sonal sphere, preferred the development of character to the expression of personality had a corollary on the national level in the subjugation of an authentic American spirit. Bourne consequently criticized not only Matthew Arnold but also America's "cultural humility." To remedy the situation, he advised Americans to look within themselves and stop imitating the Europeans. Enjoining his fellow artists and writers to "express the soul of this hot chaos of America," he called for "a new American nationalism" which the ironist, without blinking an eye, labeled "l'esprit americain." As an example of "groveling humility," Bourne singled out the Armory Show which, according to him, was designed to demonstrate the superiority of contemporary French art. Many American modern artists agreed with him.[73]

In the search for values out of which the new America could be created, Bourne proposed that writers articulate the social concerns of their countrymen. In a favorable review of Upton Sinclair's *King Coal* (1917), he suggested judging "sociological fiction" more tolerantly than novels that focused exclusively on individual characters but ignored their social backgrounds. While Bourne did not claim that *King Coal*, a novel Sinclair wrote mainly to expose the terrible conditions of Colorado's mines, was good art, he nevertheless considered it an important document.[74]

In contrast to his praise of *King Coal*, Bourne criticized the little theaters and little magazines, which proffered what he thought were pretentious experiments to approving audiences without unsettling or challenging them. He felt that art which did not convey a spirit larger than itself was destined to decay. Together with Van Wyck Brooks, Bourne wrote, "To treat poetry," for example, "entirely in terms of itself is the surest way to drive it into futility. . . . It will go to seed unless it is understood as an expression of life, pregnant with possibilities." The editor of *Poetry*, Harriet Monroe, who published their comment after she had first defended the little experiments against Bourne's earlier criticism, also had the last word. "Movements pass," she wrote, "but beauty endures." What Monroe failed to realize,

however, was that, for the two young critics, art and politics ad-
dressed the same cultural issues. In her accusation that Bourne
and Brooks had politicized and therefore limited art's scope, she
anticipated a postwar mentality that opposed Marxist attacks on
the legitimacy of "bourgeois" art. Nothing could have been further
from Bourne's and Brooks's intention. Significantly, they did not
suggest that art and literature had to aid the class struggle, an
absurd idea that dominated discussion about culture's role in so-
ciety during the depression. By then, after left-wing intellectuals
made the economy rather than culture their main focus, Brooks
of course agreed with her position.[75]

One writer who did meet Bourne's expectations by opening
new channels in the American imagination was Theodore Dreiser.
Bourne thought that Dreiser's unprecedented, frank discussions
of sex and power in serious fiction broke through the "unofficial
literary censorship" that insisted upon a Victorian sensibility.
Ironically, Bourne traced Dreiser's effectiveness as an American
novelist to his German background which, according to the re-
viewer, enabled him to express "an America that is in the process
of forming."[76] In Dreiser, Bourne discovered a writer who believed
in art for life's sake.

In the last year of his life Bourne wrote an autobiographical
essay entitled "The History of a Literary Radical," which summed
up his unsuccessful efforts to help create a new American society
through literature and art. He explained how as a young man,
"his orthodoxies crumbled," he discovered "irony, humor, trag-
edy, [and] sensuality" which, as literary qualities, "were like ox-
ygen to his soul." The new writers' and artists' expressive power
led Bourne to identify with the emerging avant-garde, the "cultural
'Modernists'" as he called them. Bourne was confident that these
men and women would soon establish a democratic and personal
society based on "new communities of sentiment," one of which,
in keeping with his pluralism, he even envisaged belonging to
the classicists. By 1918, though, Bourne was describing the hopes
of the past better than the prospects of the future, a fact painfully

64

illustrated by the conclusion of his "History." Attempting to close on a positive note, he claimed he saw, in the unprecedented "desire for form and for expressive beauty" in the journal *Masses*, a notable example of the kind of new world he imagined. Bourne's final published essay failed to recognize that neither the journal nor the aspirations it represented would survive the war.[77] No one would mistake the doctrinaire *New Masses* for its ancestor.

6

Bourne's major and most enduring contribution to American social thought was his ability to translate William James's pluralism into a new vision of a multinational America. In 1909 James had employed an analogy to illustrate his thinking. "The pluralist world," he wrote, "is . . . more like a federal republic than an empire or a kingdom."[78] Bourne stripped the metaphor of its analogous qualities and applied James's principle to the social problems the United States faced regarding the increasing numbers of immigrants within its borders. According to Bourne, America might literally become a federal democratic republic and thus realize its destiny as a great nation.

Although Bourne soon emerged as the leading radical exponent of what he called a "Trans-National America," or a country in which immigrant communities would retain their integrity and dignity, he did not oppose by himself the prevailing view that unassimilated immigrants posed a grave threat to the health of the state. John Dewey and Horace Kallen also dissented from the notion that America's strength depended upon its homogeneity. Dewey called Walter Lippmann's proposal to establish a compulsory national service to educate the immigrants and unify the nation "the remedy of despair." Outside the pages of the *New Republic*, Dewey insisted even more explicitly that American "unity cannot be a homogeneous thing." He maintained instead that the country's diverse population made it more like "a vast symphony." In a Jewish publication that promoted such arguments, Dewey argued further that "the concept of uniformity and

unanimity in culture is rather repellent." Indeed, "the theory of the melting-pot," he claimed, "always gave [him] rather a pang."[79]

Nor was Dewey the only progressive who disliked the English playwright Israel Zangwill's popular metaphor. In "Democracy versus the Melting-Pot," a long essay that appeared in two consecutive issues of the *Nation* in February 1915, Horace Kallen argued that creating an amalgamated national unity through coercive conformity was an inherently undemocratic idea unworthy of the United States. He felt that immigrants such as Mary Antin—who announced in the first sentence of her autobiography, *The Promised Land* (1912), "I have been made over"—sacrificed an integral, inalienable part of themselves, their heritage. An immigrant himself, Kallen wanted to establish a viable corporate identity for his fellow Jews within the American democracy.

Social workers were also often more tolerant of cultural and ethnic differences than other progressives. Nevertheless, their movement, which established educational and cooperative institutions in immigrant communities, equivocated on the crucial issues of Americanization and immigrant restrictions. Motivated in part by the spirit of moral uplift, settlement workers had a difficult time convincing immigrants of their good intentions. Bourne, who had a sharp eye for social inconsistencies and who by nature distrusted reformers, likened Jane Addams to "Lady Bountiful." He considered her a prig who condescended to her "neighbors," exploited their cultures, and presented herself to them as "a symbol of smugness and 'sweet charity.'" For most people Addams was not a symbol of smugness but of self-sacrifice, whose efforts on behalf of poor immigrants made Americans feel less guilty about poverty and discrimination in their society. Bourne's criticisms of America's "heroine" demonstrate again how different his sympathies and goals were.[80]

Bourne also went further than Dewey or Kallen in attacking the assumptions underlying the progressives' search for order and uniformity. Bourne's insight into the unity of a worldview that favored Americanization on one hand and war on the other pen-

etrated deeper than theirs. Both Dewey and Kallen failed to see that support for Wilson's war policies was incompatible with their other values. Kallen, for example, wrote Bourne in February 1917 that "in the last analysis . . . might does in a free world really make right," an idea, it seemed to Bourne at least, that under-mined everything else Kallen believed in. Moreover, when Bourne attacked Dewey's opinion that conscientious objection was a futile gesture that failed to recognize the awesome power of a mobilized state, Kallen did not realize that Bourne, in contrast to himself, remained faithful to their shared pluralist principles. Kallen told him that his essay opposing Dewey's position repre-sented an "injustice." Bourne's cultural pluralism, linked to a belief in the absolute right of individuals and communities to be different, was in the end both more consistent and more chal-lenging.[81]

Viewing the liberation of the self and of the community sim-ilarly, Bourne concluded that the immigrants in the United States were not a potential cause for chaos but rather were a possible source of cultural vitality. He argued in fact that the teeming immigrant ghettos, which the progressives so feared, contained the seeds of a future cosmopolitan civilization. "The good things in the American temperament and institutions," he wrote to a friend in 1913, two years before Kallen published "Democracy versus the Melting-Pot," "are not English," as the established elite supposed, "but are the fruit of our superior cosmopolitan-ism." Bourne's "Trans-National America," an important essay inspired by the feverish debate over the war and Americanization of 1916, expressed his opinion that the immigrants possessed an antidote to the sterility of Anglo-Saxon culture. He wrote that they represented the injection of a new vitality into the nation that might yet prevent America from becoming "a tasteless, col-orless fluid of uniformity." Bourne proposed instead that the United States develop into what he called "a cosmopolitan fed-eration of national colonies."[82]

While Bourne's pluralism obviously offered immigrants and

their communities greater freedom for growth than the progressives' insistence on a homogeneous civilization allowed, its romantic bias also vitiated crucial parts of the immigrants' American dream, notably their desires for upward social mobility and material advancement. So, for example, at the same time that Bourne praised the Jew who clung proudly to his faith and "venerable culture," he disliked the one who sought to escape the confines of his community and religion and, for Bourne, "lost the Jewish fire [and became] a mere elementary, grasping animal."[83] His use of a blatant anti-Semitic stereotype points to an important misunderstanding of the immigrants' lives and goals and suggests that Bourne was more interested in using them to oppose the English bias of American culture than in actually helping the immigrants adjust to a new world. His vision of a pluralist nation was nevertheless radical for its time and represents a conception of the country most Americans have come to accept.

The *New Republic* would have no part of "Trans-National America." Bourne gave the article to the *Atlantic Monthly*, ironically a more conservative magazine but one that tolerated dissenting opinions. The editor wrote Bourne that although he profoundly disagreed with his thesis—asking rhetorically, "What have we to learn of the institution of democracy from the Huns, the Poles, the Slavs?"—he considered it Bourne's best essay to date. Following its publication, Sedgwick noted the fury it stirred and was frankly surprised by the letters of commendation the supposedly " 'unpatriotic' paper" received, including one from Jane Addams.[84]

Among those favorably impressed were the Jewish students in the Harvard Menorah Society, who invited Bourne to lecture in Cambridge in the fall of 1916. The address, published under the title "The Jew and Trans-National America," defined even more explicitly the links between Bourne's cultural pluralism and his defense of the individual in society. He told them, "I am almost fanatically against the current programs of Americanism, with their preparedness, conscription, imperialism, integration issues,

68

their slavish imitation of the European nationalisms which are slaying each other before our eyes." Bourne proposed instead social policies that endorsed and supported "a freely mingling society of peoples of very different racial and cultural antecedents, with a common political allegiance and common social ends but with free and distinctive cultural allegiances which may be placed anywhere in the world."[85] In the context of a pluralistic nation, he praised the Jews' cultural identification with Zion.

Bourne's pluralism also applied to blacks in the United States, and Bourne had intended to discuss racial problems as well. In 1911, reviewing *The Mind of the Primitive Man* by Franz Boas, he had praised the Columbia anthropologist for demonstrating the unscientific basis of racial prejudice. Anticipating the ideas of "Trans-National America," Bourne wrote that all races and nations contributed to "cultural progress," a view he hoped that social science would demonstrate conclusively. At the beginning of the twentieth century, when racist books like Madison Grant's *The Passing of a Great Race* (1916) were popular, Boas's view was a minority one. Later, after visiting his sister in Hampton, Virginia, Bourne wrote privately that "the Southern white man's policy of keeping down a race . . . is the least defensible thing in the world." He said that some day he planned to "unburden" himself of the issue, but unfortunately the pressing exigencies of the last two years of his life precluded his addressing that American dilemma.[86] Given Bourne's commitment to liberation and pluralism, it is not difficult to infer what his position would have been.

7

One problem Bourne did extend his critical attention to was the role of women in society. Very early in the development of his political thinking, radical feminism became an important part of his efforts to transform American culture. He was attracted to feminist ideology for two reasons. First, cultural feminists, whose ranks included such diverse and active women as Crystal Eastman,

a labor lawyer and a writer, Margaret Anderson, editor of the *Little Review*, Georgia O'Keeffe, an artist and a member of the National Women's Party, and Emma Goldman, all argued that only a complete social, economic, and cultural revolution could emancipate women (and men) from the shackles of conventional society. Although they too demanded the vote, they thought that the political feminists' campaign to amend the Constitution was but a minor skirmish in a war for total equality. Like other cultural radicals in Greenwich Village, they wanted to create a world in which they would be free to determine their own destinies and to express the full potential of their personalities. Because their ideology stressed the personal dimensions of life and because it also transcended mere political reform by emphasizing social and cultural change, radical feminism was originally very appealing to Bourne.

Bourne's personal background also led him to see radical women as comrades in a common cause. From his family he had learned to associate femininity with his highest values and deepest longings—love, transcendence, community, sex. He therefore eagerly embraced the feminist movement, which he thought supported the kind of world he desired. Liberated women, Bourne reasoned, would also help men achieve freedom. This is "why the feminist movement is so inspiring," he explained in 1914, "for it is going, I hope, to assert the feminine point of view, — the more personal, social, emotional attitude towards things, and so soften the crudities of this hard, hierarchical, over-organized, anarchic—in the sense of split-up into uncomprehending groups—civilization, which masculine domination has created in Anglo-Saxondom." To "work the feminine into our spirit and life," he concluded, would unleash in American culture "the personal, the non-official, the naturally human, and [the] sensitive."[87] For Bourne, that would be a real revolution.

Bourne first confronted feminism directly when two young readers complained about inadvertent, disparaging references to women he made in an early essay. Even though their comments

were not a fair reflection of his attitudes—Bourne wrote privately that "the feminines" he knew were both more spirited and less regimented than his male friends—he welcomed his correspondents' criticism. One of the women who wrote to him was Alyse Gregory, then an ardent feminist, and who in the 1920s became an editor of the *Dial*. As if to establish his credibility with her, Bourne told Gregory, "I got a feeling more intensely than ever before of what women have to struggle against, their hopeless situation in the brute stupidity of 'a man's world.' Perfect equality is the first indispensible step in making over that world." Later he wrote her, "I seem to find many of our American attitudes towards women so belittling still, and so far from the genuine instinctive feeling of equality, which I should think would be the possession of every modern man or woman."[88]

When Bourne returned from Europe in 1914, he looked for people, particularly women, who shared his radical views. In a short time he discovered Patchin's, a feminist consciousness-raising group in Greenwich Village, which at first accepted him as a member. The circle was created by Elisabeth Irwin, a journalist interested in settlement work and progressive education. In 1921 she founded the Little Red School House in the Village. Katherine Anthony, who lived with Irwin at One Patchin Place, also belonged to the group. Like her distant relative, Susan B. Anthony, she too was a feminist intellectual. Speaking for many cultural radicals, Anthony wrote in 1915 that "the basic idea of feminism . . . is the emancipation of woman as a personality," suggesting that she and Bourne shared a common ground.[89] Most of the women, like Martha Gruening, whose brother became a senator from Alaska, were daughters of established, old-line Protestant families. One of them, Helen Boardman, even testified as a character witness for Emma Goldman in 1917. To demonstrate their emancipation, they smoked in public and cut their hair short, years before both became national symbols of rebellion.

Patchin's was joined also by one of Bourne's colleagues on the *New Republic*, Mary Alden Hopkins. Bourne once wrote a sen-

sitive portrait of Hopkins under the title "Sophronisba" for the *New Republic*. In it, he ironically lambasted her unnamed, un-suspecting editors for treating her unfairly because she was a woman. According to Bourne, Hopkins was a "feminist to the core," and though, like most members of the group, unmarried herself, she was particularly concerned about the economic sit-uation of married women.[90]

Patchin's frequently invited guests to join them in discussing the issues of the day. The social worker Frances Perkins attended as did, on one occasion, a savvy prostitute who told the astounded socialist feminists that, in her opinion, free lovers were basically scabs. The most celebrated guest, however, was Carl Jung, who visited Patchin's in 1912. Apparently, the atmosphere was rather stiff until Jung broke through the group's collective inhibitions by exclaiming to a pet dog that was growling at him, "Come, come, be reasonable; I'm not a female." Today's feminists would be less amused by Jung's humor than were those at Patchin's, but in the teens many cultural radicals, feminists included, thought that the new discoveries in psychology would help unleash the full potential of the personality. Hopkins, for one, according to Bourne, was heavily influenced first by Freud and then by Jung.

In 1916 Bourne had a falling-out with Patchin's. At the same time, he developed some serious reservations about radical fem-inism. His experiences and insights demonstrate precisely what Bourne's politics of liberation implied, and reveal again the per-sonal underpinnings of his thought. His critical comments also point out a significant division within the women's liberation movement during the second decade of the century.

One of Bourne's closest friends at Columbia was Carl Zigrosser. The pair had helped put out the *Columbia Monthly*, had taken vacations together, and generally shared a worldview, described by both as "Nietzschean." Bourne had wanted Zigrosser to go to Europe with him in 1913, but he had declined the invitation. When Bourne returned, the two rented an apartment on East

Thirty-first Street, about a block from the East River. The four-flight walk-up consisted of two bedrooms and a large kitchen–dining room that Bourne, more gregarious than the shy, reserved Zigrosser, quickly turned into a salon of sorts. Feminists and suffragettes like Alyse Gregory and Freda Kirchwey were among his many guests. Bourne and Zigrosser got along well at first, and Bourne introduced him to all his friends including those at Patchin's.

Zigrosser, who had even less experience with women than Bourne, fell in love with a member of the group, Florence King. Only months after meeting, the couple married and moved to Twenty-eight Grove Street in the Village. Twelve years older than her new husband, King was an impassioned feminist. After their marriage, she kept her maiden name, listed it in the telephone directory, and cut her long hair very short, all signs that theirs was to be a "modern marriage." When a daughter was born, lots were drawn to determine her family name. Zigrosser won, but King assumed control of the child's education, taking her first to Hollywood in pursuit of a movie career for her daughter and then around the world while Zigrosser remained in New York working. Though never happy with each other, they remained married until King's death in 1945.

King and Bourne clashed almost immediately. She had grown up in a home dominated by a tyrannical Irish Catholic patriarch, almost the exact opposite of Bourne's household. While Bourne had been the center of his mother's, sisters', aunt's, and grandmother's attention, King, according to Zigrosser, fought her father's domination all her life. Bourne was none too happy about losing his flatmate and friend to King, but when she sabotaged a relationship with a woman he loved, he was furious.[91]

While living with Zigrosser, Bourne met someone—he called her L. in his letters—to whom he became deeply attached. According to Alyse Gregory, L. was "the first true, tender love of his life," and his relationship with her "suffused his whole outlook and *lifted him up*." Although Gregory has conjectured that L.'s

feelings for Randolph were based more on "pity" and "dazzle-ment" than genuine affection, Bourne loved her deeply. After sleeping with a woman for the first time, presumably L., he told Zigrosser, "I have had an experience which nothing can diminish or take away from me."[92]

Their affair did not last long, however. Apparently, Bourne informed King, wistfully and ironically, that what he wanted most from a woman was "a soft pillow and a listening ear." The com-ment outraged her. Lacking both humor and compassion, King was determined to protect their mutual friend from Bourne's chauvinist "clutches." Bourne naturally felt threatened by King's meddling in his always precarious personal life and attacked his doctrinaire feminist foe in return. He called a her domineering, "neurotic woman" whose feminism disguised a "will-to-power." Eventually, the bonds of friendship broke, and Bourne lost his girlfriend, Zigrosser, who never wanted to see him again, and his apartment, which he could no longer afford.[93]

Gregory thought that Bourne's losing both L. and his best friend in January 1916 "was the most withering experience of his life and left its ineradicable mark to the end." Loyal to Bourne, she believed that his distrust of King's intentions was well placed and blamed instead his fickle, weak-willed girlfriend for allowing her-self to become "a helpless pawn" caught between two opposite, contending personalities. Regardless of who was at fault, Bourne was crushed. In a moving letter to Gregory he described his hurt feelings and outlined his emerging disenchantment with radical feminism. Telling her first that all his problems were interwoven and that the solution to each was love, he then asked rhetorically:

> Is it Greenwich Village that is the poison, or is it the times that produce the type of fair and serious and life-denying woman, who in the name of a career and her pride and the sacred independence of woman destroys not only you but herself. The philosophy that you are not a man but Man, and therefore, in spite of your

> *sympathy, personal quality, and contribution, really*
> *only a lustful Being who wants you to cook for him—*
> *this is the philosophy that has succeeded in poisoning*
> *all my days and my work. Probably I shall not be re-*
> *venged till Patchin's and King-dom are blotted out and*
> *not one stone left on another. I am inclined to doubt*
> *whether man's wrongs to women are so much greater*
> *than woman's wrongs to men. We certainly have a*
> *particularly acute mechanism for suffering.*[94]

On Christmas Eve, five weeks after writing the letter, and still depressed, Bourne went to the Zigrosser-King home hoping for a reconciliation only to encounter what Zigrosser has called "a melodramatic confrontation." Zigrosser and King were getting ready to eat dinner when Bourne, who had seen a light in the window, rang the bell. Though Zigrosser greeted him coolly, Bourne asked him if he was happy and contented. He then entreated his newly married friend to think of him wandering deserted and alone while he enjoyed the comfort of a Christmas fire. Angered by Bourne's appeal, Zigrosser snapped, "Don't be sentimental; this, I must say is a new role for you," and closed the door. According to Zigrosser, "To have invited him in would have been impossible: we had guests."[95]

Apart from having guests, however, another reason Zigrosser left his old friend standing in the cold on Christmas Eve was that he could never forgive him for having published an uncomplimentary article about him in the *New Republic* the previous August. The first of several essays Bourne wrote that took issue with some aspects of radical feminism, "Making One's Contribution" was written under the pseudonym Max Coe and did not mention Zigrosser by name. Nevertheless, it was a stinging attack on both what Bourne considered the tyranny of the feminist circle at Patchin's and on the only "masculine regular" at their long table, Zigrosser, who "knew his place" and kept it. The critic contrasted Zigrosser's obsequious, deferential behavior with that of Thomas,

a friend, who was, of course, really Bourne himself. Having been ostracized from Patchin's because of his "egotism," Thomas complained that the feminists made so many "claims upon him" that he felt his integrity threatened. He resented their attempts to confine him within their "bonds of anticipations." Because he did not understand or accept the feminists' goal of creating an exclusive feminine community and culture, Thomas was "puzzled why radicals who seemed to have emancipated themselves from so much should be so stern for the social code." Among feminists he always felt that "there was something ceremonial in the atmosphere." Unlike Zigrosser, who accepted the restrictions the feminists placed on his personality, Thomas (Bourne) "longed for the true freedom when nobody had to please anybody any more."[96]

Bourne also wrote an unpublished sketch entitled "Suffrage and Josella" in which he continued to express his dismay with radical feminism's rejection of men as well as the movement's evolution into something akin to an interest group for women. The main figure of the piece bears a striking resemblance to Florence King. In the beginning, he said, "it was refreshing to find a foe who wanted to vote, first, because she was an idealist for woman, and secondly, because she wanted to put men in a hole." Unfortunately, the suffragettes' continued setbacks in addition to the economic and social rebuffs they inevitably encountered created in Josella, at least, "a very bad advertisement for feminism." As Bourne saw it, repeated frustration, both at home and in politics, led her to eschew men and to develop "a peculiar code of 'loyalty to woman.'" That standard demanded the inculcation of such ideals as "character" and "efficiency" that, in his opinion, turned women "into tenth-rate imitations of the most unpleasing types of business man."[97]

In "Karen: A Portrait," Bourne explored further the relationship between women's grievances and their defensive chauvinism, concentrating not so much on suffrage, which, as he knew, was not the main issue, but rather on their social interaction with

men. He based his study on Frances Lundquist, a friend from college and a fellow journalist. His perceptive sketch of her is a revealing picture of a cultural feminist. Bourne described her hard and bitter struggle to overcome the shock of immigration, to escape the necessity of doing menial labor, and to get an education. Seeing his own life in similar terms, he respected Karen's determination to be an independent, free woman. Her life was not without its wounds, however, and, like the Patchin's feminists, she too rejected men. According to Bourne, "She felt the woes of woman, and saw everywhere the devilish hand of the exploiting male. If she ever married, she would have a house separate from her husband. She would be no parasite, no man's woman." After working in the suffrage movement, she put aside her "picturesque peasant costumes," and for Bourne, at least, "made herself hideous in mannish skirts and waists." All her friends were women and the married among them were "to Karen subjects for her prayer and aid." In conclusion, Bourne was ashamed to admit that, after she excluded men from her world, he had no tolerance for Karen either, viewing her now "as a woman's woman."[98]

Bourne's feminism clearly was an integral part of his search for communal and personal fulfillment, something he felt feminists like Florence King rejected. Bourne may have opposed the radical women's desire to create an autonomous, exclusive community because he had to overcome so many of his own fears and inhibitions in order to join the mainstream of human affairs. Expecting no less of others than he did of himself, Bourne invited his female friends to become equal partners in the struggle to remake America. In a book review published in the *Masses* (which, like Bourne, believed that women's liberation and socialism were inseparable), he warned that "inverted sex-antagonism" could have deleterious effects on the feminists' ultimate goals.[99]

Bourne never repudiated those goals. He continued to argue that feminism would be an integral part of the struggle for political, cultural, and economic emancipation after the war. But "the later

feminism," he maintained, would wisely not denounce men nor would it deny sex differences.[100] Bourne needed strong women, and he therefore hoped that feminists would not don "mannish skirts," imitate businessmen, or reject him either because he was a forceful, independent man or because he had a bent back. He wanted men and women to be free, and to be free, he reasoned, they had to be themselves.

Although his quarrel with Patchin's and his loss of Zigrosser's friendship hurt him deeply and account for his outburst against radical feminism in 1916, his position was not new. Three years before, in an essay entitled "The Dodging of Pressures," Bourne had inveighed against the power of any group that seeks "to turn out all its members as nearly alike as possible." As far as he was concerned, the radical feminists failed to meet the standard he had described: "The aim of the group must be to cultivate personality, leaving open the road for each to follow his own. The bond of cohesion will be the common direction in which those roads point, but this is far from saying that all the travelers must be alike. It is enough that there be some common aim and common ideal."[101]

Bourne's opposition to the radical feminists' separatism was not the product only of personal pique nor was it an anomaly in his thought. It was deeply rooted in his abiding belief in pluralism, personal growth, and cultural revolution. In short, it represented his unconditional support of individual freedom. While his commitment to social change remained firm, Bourne nevertheless possessed the strength to criticize even fellow feminists when he felt that they lost sight of the main objective, namely, to create a better, freer world for all men and women.

In 1916 Bourne also found what he had been searching for in his personal life, a woman to love who loved him in return. After vacating his East Side apartment, he found the feminine companionship he needed when he took a house in New Jersey with three women whose understanding and sympathy helped him recover from his misfortunes the previous winter. Within a short

78 time, he fell in love with one of them, Esther Cornell, a beautiful actress whose reddish-gold hair and green eyes gave her a stunning appearance. The two were engaged to be married when Bourne contracted the flu in December 1918. She, two other women, and Paul Rosenfeld were with him when he died. It is fortunate that he did have such loyal friends because, following America's entry into the First World War, his depression deepened as the exigencies of the international conflagration — conscription, censorship, and conformity — relentlessly destroyed his cherished ideals one by one.

8 Although Woodrow Wilson had been reelected in 1916 partly because he had kept the nation out of the European war—Bourne thought only "through sheer luck"—by the following year, events and policies propelled the United States into joining the conflict.[102] Knowing that the centralizing thrust of war would end his dream of a pluralistic nation, Bourne opposed the United States' intervention in Europe with an intensity equaling any in the history of American dissent. His position contrasted sharply with the progressives' view of the war. Ironically, their chief spokesmen were Bourne's editors on the *New Republic*.

Where the "unrealistic" Bourne saw warfare as a satanic force that bends and breaks civilization, progressive intellectuals like Croly, Weyl, and Lippmann discovered a marvelous opportunity to realize their goals of efficient national management, social control, and a revived moral crusade. As early as 1909 Croly had written that before an "American international system" could be imposed upon humanity at large, the world would "be piled mountain high with dead bodies." In 1916, when the chaos in Europe seemed to offer the United States a chance to demonstrate forceably the superiority of its supposedly rational order, Croly advocated increasing America's military and naval strength. Preparation for war, he argued, would also have a salutary influence on the nation's domestic affairs as well. It would enable the

government, in Croly's words, "to use more foresight, more intelligence, and more purpose in the management of its affairs."[103] For a country that had traditionally associated standing armies with tyranny and had not known conscription for over a half century, his was certainly a new departure.

When Wilson did make the momentous decision to send American forces to Europe, the editors of the New Republic labeled it a "great" one and looked forward to "the business of mobilizing the nation," which they said ought to be "put in expert hands." The following week, in response to socialists' charges that capitalists had sacrificed American neutrality on the altar of big business, the New Republic claimed that it was in fact a new class that had "willed American participation" in the war, namely, "the 'intellectuals,' " a class it hoped would play an increasingly important role "in moulding American life."[104] The idea, of course, made Bourne's blood boil.

Conscription fit easily into the progressives' plans. According to the New Republic, which now used a military metaphor to demonstrate its thesis, the draft meant "a right-about-face from our old localism, competition, profiteering, waste, and drift." Carried away by the euphoria of the spring of 1917, the editors claimed that they "accept[ed] almost absolute dictatorship" regarding the draft. They even proposed that the government conscript "responsible executives" into its bureaucracy to promote efficiency in winning the war and in reforming society.[105]

That idea, however, proved unnecessary since so many would-be experts hurried voluntarily to Washington to do their bit. For example, the New Republic noted tersely: "Mr. Walter Lippmann has temporarily severed his connection with the editorial board . . . to enter the service of the War Department."[106] Another of Bourne's acquaintances, Frederick Keppel, also went to Washington, leaving Columbia's administration and, ironically, also his position as secretary of a national pacifist organization to become the third assistant secretary of war in charge of conscription. The transition from being a progressive pacifist and a student

advisor to becoming a bureaucrat responsible for the draft apparently was not difficult for Keppel. Following the war, he returned to higher education as president of the Carnegie Foundation, a post he held until 1941. Bourne never forgave him for his apostasy.

John Dewey was also persuaded that the war created an unprecedented opportunity for reform and renewal. In July and September 1917 he attacked pacifists and dissenters like Bourne who, in his words, failed to "recognize the immense impetus to reorganization afforded by this war." For his former student, Dewey's defection from the pluralist principles Bourne assumed he had held was the hardest blow of all. Following the progressives' reasoning, the pragmatist professor argued that the war "has . . . cleared the way for a science of ideas in action which will trust not to negative forces, to bankruptcy, to bring about what is desired, but to positive energy, to intellectual competency, to competency of inquiry, discussion, reflection and invention organized to take effect in action in directing affairs. The result will not be sudden and millennial. But it will be steady; and, as in all experimental science, a mistake will be a source of enlightment and not a cause of reaction."[107] While Dewey wrote those optimistic words, the Western world was destroying itself in bloody trenches all across Europe.

Although his naiveté was obviously excessive, Dewey did protest against the nightmare of repression inaugurated by "the war to make the world safe for democracy." Within two months of his pronouncement that the war would unify the nation, Dewey lamented how the "bigots of patriotism" had violated civil liberties he had until then taken for granted.[108]

Even the *New Republic* regretted the rise in the general level of intolerance that followed Wilson's declaration of war. While the journal supported the agencies and acts of repression—the Committee on Public Information and the Espionage and Sedition Acts, for example—it spoke out against *individual* violations of freedom: Columbia University's firing of two professors for as-

sociating with pacifists, the suppression of the *Masses*, and the cruel sentence of Rose Pastor Stokes to ten years' imprisonment for expressing reservations about the government's policies. *Collective* opposition, on the other hand, the *New Republic* did not countenance. It endorsed the conviction of 110 leaders of the I.W.W. on charges of conspiring to obstruct the war effort as expression "of the national will to pull the country together."[109]

Although intellectuals like Croly, Lippmann, and Dewey were aware of the new work in social psychology that emphasized the basic irrationality of collective groups, they felt that they could nevertheless manage the nation's policies rationally even after it had committed itself to the total destruction of another country. What the progressives intended was a little like trying to direct a tiger's course by pulling its tail. Bourne never suffered from such illusions, and he did his utmost to reveal the progressives' assumptions about the armed conflict for what they were, fatal compromises with the reality of war.

As early as 1913 Bourne had staked out a pacifist position regarding international conflicts. Reflecting Norman Angell's *The Great Illusion* (1910), he wrote that "nations will fight only when the world has lost all its hope and all its sanity." He did not, unlike many others who subscribed to that view, change his mind when Europe divided into armed camps. In 1915 he tried to help preserve American neutrality by writing favorably about German culture and by reminding his readers that they were not required to share English interests and values because they spoke the same language. The articles were not popular, and denunciations of them poured into the offices of the *New Republic*. Following their publication, Bourne said that he was generally considered "an impious, ungrateful, pro-German, venomous viper."[110]

In the following year he challenged the progressives' assumptions about the war even more directly. He ridiculed their argument that the war was "the apotheosis" of business ideals by noting that beneath the seeming glamor of scientific management and social control lay only "blood and hate and destruction."

While advocates of preparedness argued that universal military training would strengthen and unify the nation, Bourne, following James, proposed substituting a "moral equivalent." A national education corps in which both men and women would canvass the country meeting its social needs, he suggested, would prove more salubrious than a military draft. The progressives' proposals for increased army service, according to Bourne, would take "an infinitely varied group" and turn it into "a mere machine of uniform, obeying units."[111] Unlike Dewey, he never forgot what he stood for.

In the fall of 1916 the *New Republic* all but closed its pages to Bourne. He complained to a colleague on the magazine, "The NR which never knew just what to do with me is getting restive under the burden of paying me a hundred dollars a month— mere living wages—for work they can't find space for. So my 'job' is trembling."[112] In 1917, after he had been demoted to writing noncontroversial book reviews for the *New Republic*'s back pages, James Oppenheim invited him to contribute to his new monthly, the *Seven Arts*. Bourne responded by writing six essays that, together with his unfinished manuscript "The State," marked his emergence as America's most outspoken and incisive contemporary critic.

Each piece called attention to unfortunate developments brought about by the war, and most were directed at positions taken in the *New Republic*. Bourne answered that magazine's opinion that intellectuals "willed" American intervention in a biting article entitled "The War and the Intellectuals." The *Seven Arts* took out a full page advertisement in the *New Republic* to publicize the essay's dissenting point of view. Labeling the war's supporters "English colonials," Bourne argued—as indeed he had in "Trans-National America"—that their outlook represented a "reversion of senility to that republican childhood when we expected the whole world to copy our republican institutions." Ruefully, Bourne concluded, American intellectuals, in their

preoccupation with using the war to reshape society, "seem to have forgotten that the real enemy is War."[113]

Bourne saved his most hostile criticism for the man he once called "America's greatest philosopher." In "Twilight of Idols"—the title comes from Nietzsche—Bourne attacked what he viewed as John Dewey's surrender of his critical faculties. He reasoned that pragmatism itself was worthless because in the ultimate trial its proponents subordinated values to technique. "Is there something in these realistic attitudes that works actually against poetic vision, against concern for the quality of life as above machinery of life? Apparently there is," he decided. It seemed to him as though the war and the progressive liberals "had been waiting for each other." He understood what Dewey did not, that the exigencies of war precluded pluralism, that the engine of destruction tolerated no dissent, and that in the end the mass killing would destroy the world they both desired. "In wartime," Bourne tried to explain, "there is literally no other end but war."[114]

Like the Russian revolutionaries, Bourne continued to think in terms of the "international class-struggle rather than in the competition of artificial national units." The Wilsonian rhetoric that attempted to convert mindless trench warfare into a fight for democracy he regarded as pure sham. Even before the Bolshevik Revolution, Bourne wrote that he was "watching to see what the Russian socialists are going to do for the world, not what the timorous capitalistic American democracy may be planning." He found the progressives' plan for a League of Nations, which the *New Republic* advocated in euphoric, uncompromising terms, particularly wanting. He called it "enlightened imperialism" and suggested in a critical review of Walter Weyl's *American World Politics* (1917) that an organization founded to preserve the status quo and maintain an oppressive peace "might better be called a League to Ensure a World-War." Bourne felt that Russia's "anarchistic communism" promised a preferable future. Indeed, as the two conceptions of man's fate, Wilson's progressive view of

a stable capitalistic order and Lenin's radical vision of an apocalyptic social revolution, competed for humanity's sympathy, Bourne had already chosen sides. "The old American ideas which are still expected to bring life to the world seem stale and archaic," he wrote in September 1917. "It is grotesque to try to carry democracy to Russia."[115]

Bourne's most developed analysis of war and society was, ironically, an unfinished essay discovered in a waste paper basket after his death entitled "The State." Published posthumously first in *Untimely Papers* (1919), it argued that "war is the health of the state," a phrase the author repeated throughout the piece as chorus might in a Greek tragedy. Influenced in part by his recent reading of Franz Oppenheimer's *The State* (1914), which traced the sociological development of the principles of sovereignty, and by Wilfred Trotter's *Instincts of the Herd in Peace and War* (1916), which argued that an individual's social needs particularly during wartime outweighed all others, Bourne explained how the national government used the war to consolidate its control and to extend its hegemony over all areas of life. "The ideal of the State," he wrote, "is that within its territory its power and influence should be universal."[116]

Bourne contrasted the state's goal with a Rousseauean concept of country. Indeed, upon reading Rousseau for the first time in 1914, Bourne had exclaimed, "I found myself feeling so much of him, saying at nearly every page, 'Yes, that is what I would have felt, have done, have said!' " Unlike the state, Bourne argued, the country was a natural and harmonious phenomenon that stood for peace, tolerance, and cooperation. But, he concluded, after 1917 the two models could not coexist. War demanded conformity. It required the government to crush all impediments in order to maximize efficiency. It made dissent seem like "sand in the bearings." As Bourne wrote in another posthumously published unfinished piece, reflecting a sentiment Ernest Hemingway later described in his postwar novel A *Farewell to Arms*:

> *Those persons who refuse to act as symbols of society's*
> *folk-ways . . . are outlawed, and there exists an elab-*
> *orate machinery for dealing with such people. Artists,*
> *philosophers, geniuses, tramps, criminals, eccentrics,*
> *aliens, free-lovers and free-thinkers, and persons who*
> *challenge the most sacred taboos, are treated with great*
> *concern by society, and in the hue and cry after them*
> *all, respectable and responsible men unanimously and*
> *universally join. Some are merely made uncomfortable,*
> *the light of society's countenance being drawn from*
> *them; others are deprived of their liberty, placed for years*
> *in foul dungeons, or even executed. The heartiest pen-*
> *alties in modern society fall upon those who violate any*
> *of the three sacred taboos of property, sex, and the*
> *State.*[117]

Bourne was on weaker ground when he added class to his anal-
ysis. Arguing that only the "significant classes" supported the war
("an upper-class sport"), he claimed that the workers shared little
enthusiasm for the state's goals and symbols. His opinion was
more wish than fact, something even Bourne himself reluctantly
realized. He discussed his "disillusionment" with the workers in
another unpublished essay in which he concluded that he had
indeed placed too much faith in the good judgment of the people.
He noted how, like other optimistic radicals in both Europe and
America before 1914, he trusted the working classes to prevent
war. The "well-wishing of the masses," he discovered sadly,
though, could not stop "the military caste" from mobilizing the
hearts and minds of each nation's citizens. In 1918 he lamented,
"We must learn the stern truth now that there is no such thing
as automatic progress."[118] Still, Bourne could not bring himself
to believe that the masses themselves might lead a country into
war. His "disillusionment" was never total.

The underlying attack on progressivism's subversion of dem-
ocratic ideas gave Bourne's antiwar essays their force and value.

By insisting on imposing a homogeneous political order on an ethnically and culturally pluralistic nation, many progressives sacrificed what cultural radicals like Bourne held most dear, namely, personal freedom and communal development. As Bourne wrote to Van Wyck Brooks in 1918, "The *New Republic*'s sense of leadership . . . is obnoxious because it comes not from youthful violence, but from a middle-aged dignity, that not only presents no clear program of values, but chooses for its first large enterprise a hateful and futile war, with a fatal backwash and backfire upon creative and democratic values at home." The liberal's dilemma, Bourne explained, was that "he has felt that he could ride two horses at once, he could be a patriot and still frown on greed and violence and predatory militarism; he could desire social reconstruction and yet be most reverent towards the traditional institutions." The progressive, Bourne concluded, "looks only to the satisfaction of his sense of order, or his sense of organization" and therefore contributes to the havoc which, say, a world war might bring to democratic and pluralistic aspirations. Elsewhere, he taunted his former colleague Walter Lippmann, writing sardonically, "How soon their 'mastery' becomes 'drift.' "[119]

After 1917 the war dominated Bourne's attention and preoccupied his mind. A letter to his mother described its state. "I have been classified as totally and permanently, mentally and physically unfit for military service, and when [Paul Rosenfeld] returns, it will mean that practically everyone of my friends is exempted from the service in some form or other, either as criminals out on bail, or married men, or psychopaths, or weaklings." The killing in France, the proscription of liberty at home, and his own inability to publish even noncontroversial work after the demise of the *Seven Arts*, which the government helped suppress, severely depressed him.

The worst punishment for his dissent was the added social isolation he suffered. "I seem to disagree on the war with every rational and benevolent person I meet," he complained. "I crave

some pagan monastery, some 'great, good place' where I can go and stay til the war is all over." He claimed he felt "very much secluded from the world, very much out of touch with my times, except perhaps with the Bolsheviki. The magazines I write for die violent deaths, and my thoughts seem unprintable."[120]

One of Bourne's essays in the *Seven Arts*, "Below the Battle," did, however, make a favorable impression on the loose contingent of cultural radicals who still believed in a "Young America." The article delineated a friend's alienation from a nation at war and anger toward the government that subjected him to military conscription. Bourne's clear expression of their amorphous antiwar attitudes, which congealed finally only after 1918, made Bourne a cultural hero and a symbol of a lost cause. A photographer and student of Alfred Stieglitz, Paul Strand, for example, wrote to him to praise "Below the Battle." Strand told Bourne how much the essay had helped him define his own thoughts. Because Strand would be inducted into the army within a few months, his letters pleased the essayist very much. In response Bourne outlined his feelings of separation even from the outsiders. "Being of marked physical deficiency and therefore draftless," he wrote, "I often fear that I write about the war without that poignant sense of it that must come to the men who have the direct issue made for them."[121]

If the war's effects took their toll on Bourne, its conclusion quickly revived his spirit. Planning as his first project a study of conscientious objectors for which he had already begun collecting material, he hoped to revive the radical movement, which had virtually come to a halt in 1917. Even the masses' enthusiasm encouraged Bourne. The day after the armistice he exclaimed, "I rejoice at the innocent uprising of the unconscious desire on the part of the populace for peace, and the throwing off the repressed reluctance for the war. It was most touching, the mood in the streets. . . . How much blither and freer the air!" Writing to his mother only weeks before he died, he noted, "Now that the war is over people can speak freely again and we can dare to

think. It's like coming out of a nightmare."[122] Practically euphoric, 89
he did not realize that a new nightmare of suppression, depor-
tations, and fear had only just begun. As it did, Bourne died of
influenza on December 22, 1918.

In its last issue of 1918, the *New Republic* reviewed the war and 9
its social effects. The editors were not totally pleased; some of
their previous confidence was shaken. They were particularly
concerned by the treatment afforded conscientious objectors. Ap-
propriately using the first person, Croly and Weyl wrote, "We
did not know how many queer sects, how many unusual personal
ideals there were among us. And so when we drew up regulations
intended to insure efficiency . . . we made a rough job of it."
Long prison terms, solitary confinement, and the manacling of
draft resisters to the bars of their cells they considered unnecessarily
barbaric. Ironically, a notice of Bourne's death followed the ed-
itorial. The anonymous author, noting Bourne's appreciation of
the "alien," referred to the "sharp corners" of his personality in
need of "rounding."[123]

The *New Republic* did have the decency to open one of its
pages to Floyd Dell, a friend of Bourne's and a fellow cultural
radical, in the following issue. Painfully aware of the "alienation"
that his comrades felt, Dell referred scornfully, but sadly also, to
the *New Republic*'s politics in his memorial. He offered this es-
timation of his friend's significance: Randolph Bourne, he wrote,
"one of the strong and triumphant personalities of our generation
. . . *was* the promise of our specific contribution to American
life."[124]

Cultural radicals agreed with Dell's estimation of Bourne in
mourning the loss of a man they personally cherished. As Bourne's
mother wrote to her son's fiancée, "Men are seldom loved by
other men as Randolph was. I am so thankful for him that he
was your love and knew it." Most liberals, however, thought Har-
old Laski, a British socialist then teaching history at Harvard and

a frequent contributor to the *New Republic*, was closer to the mark. Laski, whom Bourne had once referred to ironically as one of his "Jewish trinity" (the others were Walter Lippmann and Felix Frankfurter), explained that Bourne fought "to vindicate the ultimate rights of the personality against the demands of authority outside." But he did not eulogize Bourne for long. Laski also criticized him severely for ignoring the cardinal fact that "the business of the world is the business of the world." Though his remark recalls Gertrude Stein, he was serious. Laski concluded that because Bourne did not recognize the corporate nature of modern institutions, his efforts to change the world by concentrating on the individual were futile. "Bourne's freedom is the freedom of a lonely vagabond," he wrote. "A liberty that is not shared with one's fellows is at best a puny thing and, at its worst, a vicious form of self-indulgence."[125] While Laski is wrong in claiming that Bourne did not want to share his freedom, his critical comment does point to the main deficiency in Bourne's politics of liberation.

Bourne did espouse an ideology of freedom that focused mainly on the individual. His prewar optimism, as Laski argued, did not accurately reflect the intransigence of twentieth-century society's institutions. The social structure was not, in fact, as malleable as Bourne and others believed. Businessmen were stronger (and better organized) than artists and writers, and, unlike the cultural radicals, the vast majority of people cared less about freedom of expression than eating regularly if not well.

Bourne, though, belonged to an earlier era, when many people thought that it was possible to change the society by linking politics and culture in the interest of liberation. An illustrative symbol of the rupture that took place in American life in 1919 exists in the postwar reorganization of the magazine the *Dial*. When Scofield Thayer, its publisher and editor in chief, first conceived of the journal, he decided to divide the periodical into two integrated sections, one emphasizing politics, the other, the arts. As the political editor, he had selected Bourne, who agreed to undertake

the assignment. Bourne's death, however, terminated the idea. "Certainly there were other authorities in this field," a coeditor later explained, "but none was quite what Thayer wanted. When we finally obtained control of the *Dial* some months later we agreed to limit ourselves to literary, artistic, and philosophical matter."[126] Affairs of state these new leaders of the postwar avant-garde would leave to others. Their optimistic hopes of integrating radical politics and modern expression were no longer feasible after the First World War.

For many, Bourne's legacy recalls the values and hopes of the prewar years when individual transcendence as well as social development both seemed possible. Laski, writing in 1920, already considered these goals contradictory and fanciful. And, to be sure, he was correct: "The business of the world is the business of the world." Nevertheless, Bourne's struggle still suggests that political goals that do not have cultural ramifications and do not offer some hope for personal freedom and self-expression are incomplete.

Lewis Mumford's opinion of 1930 that "Randolph Bourne was precious to us because of what he was rather than what he had actually written," is unfounded.[127] To the contrary, Bourne's consistent effort to define a place for the individual and the community in a modernizing world remains compelling to those who still believe that the right combination of political change and cultural renewal might yet fulfill the promise of American life.

At least Alfred Stieglitz thought so, as he mourned the death of a man he never met. "Bourne [is] no more," Stieglitz wrote. His "death is a great loss to the country. We haven't many of his kind—clear, deep thinking—Fearless seeing. Fearless expression of that seeing."[128]

I hope somebody does get down the real

history of all that's happening at 291. . . .

I really think you are shaping one of the

most vital things in the evolution of America.

Eduard Steichen to Alfred Stieglitz, November 1913

ALFRED STIEGLITZ
3
Art and Revolution

If Randolph Bourne wanted to be a prophet, Alfred Stieglitz thought he was one. The romantic tradition that sees the artist as a prophet, a man who articulates society's basic values and outlines its paths of justice, appealed to him. He saw himself as a spiritual leader whose mission was to guide the American people out of what he believed was a desert of materialism, misplaced priorities, and misguided behavior and into the Promised Land. Stieglitz, never a believer in using language precisely, did not define that Promised Land, but, for him, "Truth," "Life," "Spirit," and "291" were some of its many names or, in a word he was particularly fond of, its equivalents.

Unfortunately for Stieglitz, few people were willing to accept the authenticity of prophets in the twentieth century. Instead they wished to attach more applicable and reasonable labels to his various vocations—"photographer," "artist," "collector," "patron," "dealer," for example. Their insistence upon interpreting his work within conventional categories only reinforced his con-

Alfred Stieglitz, *Self-Portrait (Cortina)*, 1890. *(National Gallery of Art, Washington; Alfred Stieglitz Collection)*

viction that he was a misunderstood genius, a "seer." Stieglitz fiercely resisted any delimiting definition of himself, particularly the most common one, "dealer," an epithet he felt violated everything he stood for. To illustrate his point—that labels confine and destroy the integrity of what they modify—he assumed the prophetic posture and told a story.

One evening in 1913, he recounted, his first wife, Emmeline, his daughter Kitty, then fifteen, and Abraham Walkowitz, a struggling young avant-garde painter, were having dinner. Suddenly, Kitty announced, "Father, you've gotten me into trouble again." Apparently, Kitty, who was a student at a fashionable school—though Stieglitz, by his own testimony, was "not addicted to fashion of any kind"—had been asked her father's occupation. When she replied, "I really don't know," the teacher exclaimed, "Why, he's the greatest photographer in the world." Unfortunately, the title did not satisfy the young girl because her father had told her that Steichen was the great photographer, and he never referred to himself as such. The teacher then said, "Well, he's a great artist." But her second suggestion caused more consternation than the first. Only a week before, Kitty had heard Stieglitz say that if anyone called him an artist he would shoot the person on the spot. She turned to her father and asked, "What are you anyway?"

For Stieglitz, his daughter's question demonstrated superbly his successful effort to remain in flux. "You see, I'm a little over fifty," he told her, "and if anyone asks you again what your father is, tell them this story, and say that I told you that I'd spent all my life trying to figure out who and what I am."[1]

Even at the end of his life, nearing eighty, in 1942, Stieglitz took issue with one-dimensional explanations of what he was doing. Replying to an institutional questionnaire, he wrote, again within the prophetic mold, "I have been fighting for fifty years for the liberation of the American people from the most damnable of all idols—THE LABEL—in whatever form it may appear."[2]

Still, if language circumscribes comprehension, as Stieglitz in-

sisted, it also communicates. Many people who knew Stieglitz tried to express his essence, a word he did approve of. Irresistibly, by the power of his personality and by the strength of his prophetic persona, they were compelled to employ a religious metaphor to describe him and his struggle. From "Alfred Stieglitz, Artist, and His Search for the Human Soul," an article that appeared in the *New York Herald* of March 8, 1908, to the publication of Dorothy Norman's adoring biography in 1973, *Alfred Steiglitz: An American Seer*, this has been the case. In *Our America* (1919) Waldo Frank, for example, called him a "Jewish mystic" and a "prophet," writing that he "was the preserver of faith, the great life-giver." Paul Rosenfeld, who, like Frank, also began his career as a cultural critic writing for the *Seven Arts*, repeated in *Port of New York* (1924) that Stieglitz stood for the "perpetual affirmation of a faith that there existed, somewhere, here in very New York, a spiritual America." He compared 291 to a "house of God."[3]

Stieglitz, of course, never said outright that he was a prophet. As he noted, he rejected any self-limiting description of his goals or work. On one notable occasion, however, in the middle of the Great Depression, he did employ a revealing and significant epithet to portray himself. He told Waldo Frank, "I have always been a *revolutionist* if I have ever been anything at all." Frank, who had just been elected chairman of the League of American Writers, a left-wing organization that wanted to infuse a sense of class consciousness into American culture, succeeded in eliciting that rare, relatively unambiguous self-definition from Stieglitz by expressing his disappointment when Stieglitz refused to join the Communists. Stieglitz's explanation— "In reality, I am much more *active* in a revolutionary sense than most of the so-called Communists I have met"—demonstrated the social and political assumptions that had defined his thought for decades. Unlike most intellectuals in the thirties who were then reexamining the links between art and social change, Stieglitz simply refused to reconsider his point of view. Where Frank, albeit temporarily, adjusted to the demands of the emerging Communist vanguard,

which had replaced the prewar avant-garde as the Left's leaders, Stieglitz maintained steadfastly that he had always been a "revolutionist" and therefore saw no need to change his ways or attitudes.[4] In the new intellectual climate of the thirties, his reasoning seemed to most people curiously anachronistic if not altogether incomprehensible.

Stieglitz declared that art alone had the power to liberate society. The springs that fed his modernist vision, tapped at the beginning of the century, had not run dry. In 1935 he still believed, as he had thirty years previously, that creative young men and women, by the force of their cultural contributions, could establish a new world not only for themselves but for everyone. Stieglitz justified calling himself a "revolutionist" because he assumed that these individuals, if not stifled by traditional society and conventional expression, could inaugurate a real revolution based on personal freedom and social change, his main goal and the chief object of all his work. Thus, he considered himself a more active revolutionary than the Communists, who in his eyes were like those engineers whose new designs called for the same tired materials. If they maintained that the road to a new revolutionary culture lay in altering the substantial conditions of life, Stieglitz countered by arguing, as he had for years, that only competing art forms, diverse means of expression, alternative life-styles, a reintroduction of the sacred into modern life, and new relationships between men and women could lead to meaningful change.

Before the First World War these convictions led Stieglitz to lay the foundations for the art of modern photography, to found the Little Galleries of the Photo-Secession (291), which explored the latest expressions of abstract art and modern philosophy, to publish *Camera Work* and *291*, which disseminated the European and New York avant-garde's new discoveries, and finally to support and encourage a small group of American artists, who, he was certain, would have a major impact on the national sensibility. The ideas and ideals that supported Stieglitz's activities were the same ones that Bourne simultaneously explored: self-liberation,

cultural pluralism, and the development of new communities that, in their fullest form, would launch a new nationalism based on art (for life's sake). Like Bourne, Stieglitz also naively believed that he and other similar-minded cultural radicals could turn the consolidating and, he thought, dehumanizing institutional developments of the twentieth century in new directions. Like Bourne, he also had no clearly conceived, well-outlined plan that might have enabled him to realize his utopian goal of social regeneration through cultural renewal. And, finally, like Bourne too, he consequently failed to bring about the broad-based social and cultural revolution that both men had envisaged.

99

Alfred Stieglitz was born in Hoboken, New Jersey, on January 1, 1864, the first of six children. His parents, Edward and Hedwig, both German Jews, had emigrated separately to the United States. The Stieglitz household was rather well-off, informal, and more European than American in its preferences and customs. Good food, wine, relaxed conversation, sports, music, and art filled their lives. The family's gemütlichkeit and open nature left a lasting impression on Stieglitz, who later recalled that his parents had "created an atmosphere in which a certain kind of freedom could exist," a freedom, he decided, that explained his "seeking a related sense of liberty as [he] grew up."[5]

1

Stieglitz's mother, Hedwig Werner, came to the United States as a young girl in 1853. Her forebears were scholars and rabbis, and, although the Stieglitzes were not religious—indeed the family kept few Jewish customs—she passed on a sense of natural wonder to her son, who, in adulthood, sought to rediscover a supernatural unity in the real world which his maternal grandparents had found in tradition and study. She was an avid reader. The German romantics, whose writings would later influence Stieglitz—Goethe, Heine, Schiller—were among her favorite authors. Someone who knew Hedwig described her as "cultured, soft, hospitable, generous, in nothing the bourgeoise." Her second

daughter-in-law, Georgia O'Keeffe, considered her "dignified."[6] Stieglitz adored her.

Stieglitz's relations with his father were not so warm. Edward Stieglitz emigrated to America with the wave of migrants who left Germany following the defeat of the Revolution of 1848. Like many German Jews who settled in the United States, he did very well financially, becoming, after the Civil War, a wool merchant in Hoboken, New Jersey.

In 1871 the Stieglitzes, who had been married nine years, decided to move to New York City. Their new home, just off Fifth Avenue, was modern, comfortable, and large. It befit a rising commercial family; the house had all the latest conveniences— steam heat, gas chandeliers, as well as hot and cold running water. But the elder Stieglitz was never happy selling wool, and he hated to think of himself as a businessman. He much preferred an active sporting life of fishing, horseback riding, and racing. He wanted to expand his perspective and cultivate his interests, which included, in addition to sports, painting and music. He became a minor patron of the arts as well as a gifted Sunday painter himself. For Edward Stieglitz business became a means to support his family, his interests, and his unorthodox friends—artists, writers, actors, and musicians.

Alfred Stieglitz thus grew up in a world divided between antagonistic material and cultural definitions of the good life. He never learned, as his father apparently did, to reconcile business and pecuniary values on one hand with art and self-expression on the other. Not only were his father's contradictory messages confusing, they were also delivered in an emphatic and overbearing manner. Edward Stieglitz was a patriarchal figure who, according to his eldest son, "could brook no contradiction." His children and his wife lived in fear of his tempestuous moods. More often than not the root of recurring family tensions was money. "The scenes between my parents had a powerful effect on me," Stieglitz later explained. "They caused me to grow up with a feeling about money as a source of release but, at the same time, as a deadly poison."[7] Later, repudiating the influence of

that "deadly poison," he rejected his father's willingness to seem-
ingly compromise the joy of art by being a businessman. Com-
petition with the elder Stieglitz's example soon led him into the
labyrinths of a cultural revolution, one of whose main goals was
to eradicate the preeminent position of money in American so-
ciety. In the meantime he had to content himself by beating his
father at billiards, a source of great pride and a story he told on
many future occasions.

An energetic youngster, Stieglitz grew up just as Americans
began to discover the joys of physical exercise and athletic com-
petition. He loved to push his limits, learning at an early age to
row, swim, and play tennis. His favorite activity, though, was
running, a sport that caught his imagination after his father first
took him to the track at Saratoga in 1873. "I was proud of my
running." he said. "I loved the hundred-yard dash, the broad
jump, the high jump—to do everything as fast and as well as
possible. Racing was in my blood. I jumped over tables and
chairs." For Stieglitz, sport, like art, later assumed essential,
transcendental qualities that opposed the corruption of mundane
and matter-of-fact living. As his many photographs testify, horse
racing always thrilled him, and the horse in particular became
a personal symbol of energetic and sexual vitality, the antithesis
of the business-oriented world. Stieglitz not only had a remarkable
eye for taking timeless photographs and recognizing significant
artists before anyone else, he could also pick horses with consid-
erable skill. "I saw a great Racehorse at Saratoga," he wrote a
friend in 1919, "Man of War, a wonderful 2 year old."[8] Man of
War, of course, became the greatest stallion in thoroughbred rac-
ing, winning all but one of the twenty-one contests he entered.
Stieglitz, however, refused to profit financially from his ability
to choose winners, fearing that by betting he would debase his
adoration for sport—or of art for that matter.

Stieglitz was a very sensitive, impressionable boy whose earnest
intensity earned him the nickname "Little Hamlet." The day be-
fore his thirteenth birthday, he wrote in "an album for confessions
of tastes, habits, and convictions" entitled "Mental Photographs"

that his favorite color was "cardinalion black," an unusual choice but one that suited Stieglitz. His favorite flowers were violets and forget-me-nots (the second no doubt a projection of a personal wish), and his favorite tree was the oak. He preferred twilight to any other time of the day, and his favorite season was "whenever there is no school." He liked Beethoven and Mozart, read Shakespeare, Longfellow, Dickens, Scott, and George Eliot, though the book he said he would "part with last" was a "pocket-book filled with money." What he admired most in men was "honesty," and in women, "truth." At thirteen he was already becoming a romantic. His idea of happiness was "to be married and live happily" while the competitive Stieglitz's notion of misery was "to be beaten in a race." His "bête noir," "to be buried alive," represented a fear that stayed with him all his life. His distinguishing characteristics, he thought, were his "inquisitiveness" and his "changeableness." These too remained central aspects of Stieglitz's mature personality.

Stieglitz's memories of his childhood were not all happy ones. Sadness and loneliness, he emphasized later, best described his youth. His earliest memory was of a friend of his mother's, a woman who liked to highlight her fair skin by wearing black. Stieglitz called her "the lady in black." After her visits, he recalled, he became very depressed. "I know of no pain," he said, "any more intense than the one I experienced when she departed." Later, he associated the "heartache" which never left him with the source of his deepest feelings. His main goal, he noted often, was his lifelong effort to stay in touch with "the lady in black." For Stieglitz, she personified a bottomless need for love and its expression, whether in personal affection or in "vital" art. Even in old age he claimed he felt the same way he did as a little boy, sad, lonely, and different. "I still am the same," he said. "I still have the same heartache. I have not grown up one bit."[9]

Many people later accused Alfred Stieglitz of being spoiled, domineering, and cantankerous, not unlike his father. In order

to demonstrate his ingenuity and individuality, he himself recalled that, as a youngster, he liked to make up new games for other children to play, the standard ones being so banal. Unwittingly, his tale also reveals how he, the handsome, adored first-born son, found it easy to dominate others. Not referring especially to his youth, Stieglitz's second wife, Georgia O'Keeffe, maintained after his death that "he was the leader or he didn't play." Much earlier Stieglitz's friend Sadakichi Hartmann, who also aspired to reshape American culture, told him, "I . . . got tired of your dictatorship. For years you imposed upon me, and as I never resented it, your attitude towards me grew worse from year to year, until I could not stand it any longer." Waldo Frank criticized Stieglitz's personality along similar lines, writing in a personal letter, "I feel that you are incapable of a relationship of equality with anyone. You demand in some way, the 'other person' accept your ascendancy, before you function in serving him, in understanding him, in helping him."[10]

To be sure, Stieglitz did not suffer for lack of self-confidence or the courage of his convictions. His independent character, which some saw as towering and others as inflated, enabled him later to see art in a personal and original way. By the strength of his personality, he became the leading supporter and advocate of the artistic avant-garde in America. If he was domineering, he also, as Georgia O'Keeffe has additionally written, "gave a flight to the spirit and faith in their own way to more people—particularly young people—than anyone I have known."[11] In many ways his role as a patron of an art that envisaged a new world based on alternative values was a creative solution, both personally and socially, for expressing his personal need to be a leader and for resolving the psychological conflict he experienced growing up in a home in which culture constantly competed with materialism.

In 1881 Edward Stieglitz decided he had enough money, nearly $400,000, to retire and take his family to Europe in order to paint and travel while living on his investment's income. A relative

who taught at City College, where Alfred was then in his second year, had advised correctly that the future lay in the hands of engineers. Because the elder Stieglitz was sure that his son could get a better scientific education in Germany and because he preferred German culture anyway, he reasoned that returning made the most sense. Alfred was less happy about the move than his father. He later thought that his leaving City College as well as an earlier transfer to a public institution from the Charlier Institute, a prestigious French private school, "uprooted" him. The feeling of being "out of place," he said, never ceased.[12] While merely changing schools was unlikely to create a permanent sense of insecurity especially in someone as personally sure of himself as Stieglitz, the cultural confusion the American and European institutions represented in his life undoubtedly did.

Stieglitz had the personal advantage, or misfortune, of living between cultures. This was perhaps the single most significant source of his modernist sensibility. Never wholly immersed in Jewish, German, or American ways of life, he enjoyed an intellectual freedom that was extremely rare in the nineteenth century, at least in the United States. While all three cultures contributed to his personal and mental development, no single one determined his point of view or mode of thought. But Stieglitz's freedom had a price. If cultural marginality freed his vision, enabling him for example to become a great photographer, it also fed his sense of spiritual separation from mainstream, bourgeois society. Wherever he lived, he felt slightly uncomfortable. Like Randolph Bourne, Stieglitz claimed that he "always felt outside the group."[13] And like Bourne too, he was driven to overcome his alienation by discovering or, if necessary, creating a new world that might resolve otherwise irreconcilable cultural contradictions.

Only seventeen in 1881, Stieglitz began a nine-year European sojourn that completed the process of "unpreparing" him for conventional society. After briefly studying in a gymnasium in Karlsruhe to improve his German, he enrolled in the Berlin Polytechnic. His father selected the university in Berlin when he learned that his previous choice, the Zurich Polytechnic, was a

coeducational institution popular among Russian women who were reputedly very free sexually and who supposedly smoked large cigars. Alfred did not oppose his father's decision to send him to Berlin, nor did he at first reject paternal pressures to prepare a career in the sciences. He wrote to his cousin, "I have not yet decided what profession I'll follow, still my choice has dwindled down to the two following subjects 'Maschinenbau' and Chemistry."[14]

If the letter indicated only slight uncertainty regarding the future, Alfred's first year in the university all but severed his moorings. He was not ready for the rigorous demands of the Berlin Polytechnic, and he found the lectures almost incomprehensible. Stieglitz asked his physics professor, the famous Hermann von Helmholtz, if he could simplify his discussions. When told, "Young man, I am making this course as simple as I can. I am discussing the ABC of physics," Stieglitz decided to attend no more. Confronting failure incapacitated him. Rather than risk not succeeding, Stieglitz preferred creating his own challenges, even if to do so he had to venture into uncharted territory. He rationalized his reluctance to follow traditional paths cut by others, which might prove impossible to negotiate, by turning his fear of failure into a personal principle—a willingness to experiment with new materials and new standards of success. "In looking back over my life," he said sixty years after deciding not to become a mechanical engineer, "I find that the keynote to whatever I have done has been unpreparedness."[15]

After floundering for a year or so, Stieglitz discovered photography. In 1883, when he bought his first camera, photography, both technically and artistically, was in its infancy. As he noted proudly, "I went to photography really a free soul—and loved it at first sight with a great passion."[16] Stieglitz has suggested that he discovered the new medium independently, by luck as it were. More likely, after his initial boyhood introduction to the mysteries of the darkroom, his close friend Ernst Encke introduced him to his future vocation. Encke was a photographer living in Berlin whose brother, Fedor, a prominent German painter, had lived

with the Stieglitz family in New York. Ernst Encke took numerous photographs of Stieglitz and undoubtedly exposed him to the other side of the camera as well. While Stieglitz also sat for Fedor, who painted a romantic portrait of him as a youth, Ernst's pictures stimulated Stieglitz's imagination more. One of his first serious photographs was a study of Encke's shots of himself! Perhaps Stieglitz never picked up a paintbrush because he wanted to find a means of self-expression in which he would not have to compete directly with his father.

Fortunately for Stieglitz, the faculty at the Berlin Polytechnic also included Hermann Vogel, who taught photochemistry and the aesthetics of photography. An innovative experimenter, he was actively engaged in developing photography's technology. Stieglitz transferred into his course and studied under Vogel's direction for several years. He claimed that he was less interested in earning a degree, which he did not, than in establishing photography as a legitimate art. He worked hard, always reaching for a perfection which the medium's primitive techniques yielded reluctantly. When one of his first pictures, A Good Joke (1887), won an award in an international contest judged by Peter Henry Emerson, then the leading pictorial photographer in the world, Stieglitz was elated, though later, he claimed, not for himself. "I am very glad for my father," he said. "Winning the prize is tangible proof for him that my time is not being wasted."[17]

Perhaps the elder Stieglitz's misgivings about his son's decisions resulted from the bohemian life Alfred led in Germany. A modest allowance met his needs, and, when he was not working on his photography, he was able to enjoy his "free-lance" existence fully. His appetite for culture and an active social life was never satiated. He frequented the opera, the concerts, and the theater. He visited the great European museums and historical sites. And, of course, he had plenty of time for horseracing, billiards, and the local cafés. "There were no set times when I had to do anything," he recalled nostalgically. "If tired, I slept; if hungry, I ate. When I wanted to read, I read."[18]

His favorite writers were mostly romantic. Goethe, Lessing, Schiller, Lermontov, and Byron he read and reread. Stieglitz also admired naturalists like Emile Zola, whose autograph he requested and received, and Mark Twain, who reminded him of his American roots, which he did not want to forget. Both impulses—romantic and realistic—influenced his early photographs, the first in his choice of subject matter, the latter in his mode of presentation. In music he preferred Beethoven, Mozart, and Schumann. Wagner's grand, mystical operas particularly moved him as they did most young Germans who made the pilgrimage to Bayreuth to escape the confines of materialism.

Stieglitz's deep immersion in late nineteenth-century neoromantic German culture had an enduring effect on him. His emphasis on linking the individual to the supernatural world and on emancipating the spirit, or the Geist, as the Germans called it, provided the foundation for his future forays into abstract art and cultural criticism. His European education in the 1880s, coming just before the cultural crisis that characterized the fin-de-siècle, prepared him well to understand a little later in New York what European friends were about to experience. He had no difficulty empathizing with their desperate search to create viable ideas and vital forms dynamic enough to construct a new cultural identity in a world radically altered by the impact of modernization. Although his only exposure at the time to what the next century called modernism was the plays of Henrik Ibsen, Stieglitz's nine years abroad sensitized him to an antirational and antimaterialistic point of view that enabled him to become the focal point for America's avant-garde. He had not yet encountered Nietzsche, Maeterlinck, Freud, Kandinsky, or the French post-impressionists, but, when he did, he was ready to understand their new departures, at least intuitively, which, as his romantic teachers had suggested, was the real key to knowledge anyway.

Stieglitz's room in Berlin reflected his interests and personality. His photograph My Room (1885-86), in which an old-fashioned high-wheel bicycle occupied the foreground, was in many ways

a self-portrait. In the days before stereo equipment, pianos were common and Stieglitz's upright was usually open. Although never a very good pianist, he enjoyed playing Wagner and Gluck, which he said he liked to do, naked, late at night. Over the piano there hung a painting Fedor Encke had done of Stieglitz's mother, a gift of the artist that Stieglitz treasured. Above the portrait he had placed another present, a hand-sewn, twelve-foot-long American flag a friend had made for him because he knew of Stieglitz's strong attachment to the United States. These four objects—the bicycle, the piano, the portrait of his mother, and the American flag—represented symbolically his lifelong romantic devotions: sport, music, art, and country. For Stieglitz, after returning to America, these concerns opened up new, potentially radical definitions of self, culture, and nationality.[19]

Being an American in Berlin and a Jew in Germany inevitably presented its problems. The rabid anti-Semitism of the era, which represented the darker side of Young Germany's inability to adjust to the new industrial age, dismayed Stieglitz. His inevitable alienation as a foreigner in an increasingly nationalistic environment led him to forge an idealistic conception of the country he had left. Stieglitz's future cultural nationalism, in fact, owed much to his German friends' assumptions that a nation should be spiritually sound and devoted to some transcendental, communitarian goal. When a German professor, for example, claimed that the Brooklyn Bridge, then a symbol of American ingenuity and vitality, would fall down, Stieglitz defended it vociferously, later explaining, "It was, after all, my America I was defending."[20]

In 1890 Stieglitz's parents, who had returned to New York four years earlier, asked him to come home. He did not refuse. A sister had died in childbirth, and his father was growing increasingly impatient with his son's unconventional way of life. He assured him that the United States, where in the past nine years Stieglitz had spent only a single summer, would be as exciting and lively as Europe.

Unfortunately, it was not. The culture shock he experienced on returning to New York proved overwhelming. Stieglitz found

the city dirty, the people crude, and the way of life crass. Feeling
that he could establish "no point of contact with anyone or any-
thing," he recalled that he "cried every night . . . from a sense
of overpowering loneliness."[21] The trauma of being twenty-six,
living at home after nearly a decade's carefree independence, and
having no practical direction depressed Stieglitz. No less than
Bourne, he had severe difficulty in finding a secure and productive
place in the world where he could be personally creative. His
father suggested that he sell his photographs or open a gallery.
Both ideas seemed equally repugnant since, in his mind, each
required the commercialization of aesthetics. To Stieglitz that
meant violating his personal integrity, not to mention photog-
raphy's.

Stieglitz found a temporary resolution to his professional and
personal crisis when a family friend asked him if he wanted to
take over a photoengraving enterprise in which his father had
invested one thousand dollars. He enlisted the aid of two partners,
former roommates in Berlin, and agreed.

Stieglitz's short career in business taught him everything he
wanted to know about commercial life, and, as he put it, he "got
out" quickly enough, that is before its "poison" could corrupt his
soul. Characteristically, when Stieglitz assumed responsibility for
the Heliochrome Company, in his ardent desire to affirm his
own identity, he changed the firm's name to the Photochrome
Engraving Company. He told the concern's six employees that
he considered the company "one family working together for a
common good" and that he was less interested in personal profits
than in the collective welfare. Throughout his life, Stieglitz was
unwilling or unable to accept either the reality or the legitimacy
of economic and political conflict, insisting instead on imagining
some perfectly unified utopian social order in which all people
("true workers") would find personal fulfillment. His idealistic
conception of the engraving company as a family with him at its
head proved most unrealistic in the world of business, divided as
it was among interests and classes. A more disciplined or prescient
political thinker than Stieglitz may have realized the near im-

possibility of successfully applying communitarian principles to the realm of economics. Stieglitz's communal inclinations did find fruitful expression later, not in business to be certain, but in his future support and sponsorship of a "family" of artists at 291. Those artists, of course, sought to offer an alternative to capitalism and its values.

To Stieglitz's astonishment, he discovered that his company's few customers cared more about speed than quality, that they rarely paid their bills, and that the workers did not appreciate his benevolent paternalism. In addition, he was far more interested in taking pictures than in publishing insipid advertising, a fact that irritated his partners no end. They complained that he spent too much time walking the streets of New York searching for good photographs or else, when in the office, looking at so-called artistic shots of naked women. The Photochrome Engraving Company was not Alfred Stieglitz's calling. By 1895, exclaiming that to do business in the United States required a "policeman on one side and a lawyer on the other," he decided that he could no longer afford to remain in the unprofitable company his father had helped set up. In keeping with his anticapitalist sentiments, the reluctant entrepreneur "turned over" his share in the company to the workers.[22]

Two years earlier Stieglitz had done something from which it was less easy to retire. He got married. His wife, Emmeline Obermeyer, the sister of one of his business partners, suited him even less than a career in business. She did not share his interests, his ideas, or his temperament. Describing his spouse to a friend in 1907, Stieglitz wrote, "My wife has been absolutely against my work. . . . she understands nothing of what I do and attempt." Nine years younger than her new husband, Emmeline was a simple woman who idolized her eccentric mate without understanding him. Why Stieglitz married her remains one of the mysteries of his life. That she was wealthy, of German-Jewish background like himself, orphaned, available, and in love with him all contributed to his decision. In addition, his father's offer to give him $3,000 a year, a hefty sum in 1893, even as it reinforced his

paternal dependence, must have helped persuade Stieglitz to try "settling down," as his parents so obviously wished. In the future her money proved crucial in supporting the "free-lance" life to which the young Stieglitz had grown accustomed. When his father died in 1909, he left him only $10,000, not enough to have enabled Stieglitz to have continued living as he desired, that is, without having to think about money.[23]

Throughout his life Stieglitz so frequently referred to his "fight for photography" in reference to everything he sought to accomplish that the struggle soon assumed metaphysical overtones. In time he came to consider photography, as he put it, "an entire philosophy and way of life—a religion." Since his main means of self-expression depended on the camera and since he was unwilling to compartmentalize anything, preferring instead to bring the full force of his ideas to bear on all his activities, Stieglitz created a metaphor—the "fight for photography"—to unify his multiple interests and varied past. Thus, he explained in 1913, "It will be thirty years that I have been in harness trying to give photography, *the idea of photography* its place. . . . Of course back of this so-called 'Photographic Fight' of mine, there is something bigger than appears on the surface of things."[24] Ardently believing that photography's potential equaled that of any art, Stieglitz argued that it could express the photographer's personal will and vision, enabling him thereby to make a universal statement. In his mind the "fight for photography" became the artist's struggle for liberation.

2

Not many photographers shared Stieglitz's views or vision, and, not coincidentally, few developed photographs the equal of his in either originality or power. One who did was Paul Strand. Stieglitz's onetime protégé recognized that "photography became for [Stieglitz] the symbol of a great impersonal struggle." According to Strand, Stieglitz succeeded, ironically, as it were, in taking the camera, "a despised . . . rejected thing," because it

was a machine, and turning it into "a symbol of all new and young desire." In Stieglitz's hands, Strand wrote, photography was "a weapon . . . a means of fighting for fair play, for tolerance of all those who want to do anything honestly and well."[25] As Strand saw it, Stieglitz not only sought to lay foundations for photography's emergence as a fine art, he tried to create a cultural revolution based on his new vision.

In 1883, however, when Stieglitz first began his career in photography, his aims were less comprehensive and more specific. He wanted to take pictures and to be recognized as an artist.

Invented in 1839, photography was not easily or quickly accepted as a form of artistic expression. Graphic artists, threatened by the immense popularity of the new medium and by the seeming competition photographers posed, were disinclined to welcome cameramen into their ranks as artists. Most agreed with Charles Baudelaire, who in 1850 launched a devastating attack on photography's inroads into French culture. When the government of France yielded to public pressure that year and allowed photographs to be shown at its annual Exhibition of Fine Arts, Baudelaire articulated the fears of many artists who faced the threat of industrialization, one whose products was the camera, and outlined the terrain photography's exponents would have to negotiate before the mechanical medium might be awarded the status of a fine art. "I am convinced," he wrote, "that the ill-applied progress of photography has contributed much, as do indeed all purely material advances, to the impoverishment of French artistic genius already so rare. . . . Poetry and progress are two ambitious creatures who hate each other instinctively. And when they meet on the same road one of the two must give way to the other. If photography is allowed to stand in for art in some of its functions it will soon supplant or corrupt it completely thanks to natural support it will find in the stupidity of the multitude."[26]

In arguing that photography reflected and supported a materialist and narcissistic view of the world, Baudelaire articulated the conventional wisdom that dominated art critics' and curators'

attitudes toward photography for at least the next half century. Almost invariably, most people who considered the subject, apart from the photographers themselves, believed that because photography relied on physics and chemistry rather than the human hand, cameramen could at best aid the artist but certainly not compete with his creations.

No individual was more responsible for establishing the conditions that eventually led to photography's emergence as a fine art than Alfred Stieglitz. Unlike other advocates, Stieglitz understood Baudelaire's criticism of photography's aggrandizing claims. His main insight in countering critics' fears was to demonstrate that photographers need not oppose the artist's struggle against industry's encroachments on the reserves of culture but could, on the contrary, potentially join his cause. Stieglitz did not challenge Baudelaire's goals; rather, he attacked the poet's assumption about which side of the barricades the photographers were on. It is no coincidence that Stieglitz's ultimately successful "fight for photography" was also a battle for modern art, one of whose intellectual roots lay in Baudelaire's antimaterialistic polemic against photography and an exaggerated realistic style of painting that tried to compete with it.

Stieglitz's ideas about photography and art evolved very slowly. At first he challenged the prejudice against the camera as unsuccessfully as did other photographers. In 1884, for example he showed his new work to two traditional German genre painters, Adolph Menzel and Ludwig Knaus, artists then well-known and admired by many, including Stieglitz. Claiming that they respected his audacious attempts to create with a camera what painters do with a brush, the two told him that, while he might be a "genius," he was still no artist. If their begrudging admiration pleased the young photographer—and it did—he nevertheless resented intensely his critics' patronizing attitudes toward photography.[27]

Stieglitz recognized the importance of disseminating ideas in advancing any cause or career and therefore decided to put his

views in print. After returning to the United States, he published "A Plea for Art Photography in America" in 1892. Characteristically, his first American essay noted two themes that dominated his future thinking: the urgent necessity for original expression and the close relationship between art and national identity. "Originality," Stieglitz wrote, "hand-in-hand with simplicity, are the first two qualities which we Americans need in order to produce artistic pictures."[28]

In the early 1890s Stieglitz believed that photography's credibility depended upon its capacity to express an imaginative vision, not on its ability to approximate other forms of art. To that end he encouraged and contributed to technological experiments that he and others hoped would free photographers from their dependence upon the external world. "With the modern methods," Stieglitz argued, "there are virtually no limitations to the individuality that can be conveyed in the photographic print."[29] The modern methods he was referring to, namely, the glycerin platinum and gum-bichromate processes, perfected at the end of the century, enabled photographers to develop prints that could convey a personal point of view, even though these new photographs were still remarkably similar to etchings and other drawings. By manipulating chemically either the negative or the paper on which it was printed, photographers such as Eduard Steichen and Robert Demachy dramatically extended their scope of expression. Some, like Frank Eugene, even scratched their negatives to create a mysterious impressionistic mood.

Many photographers opposed these new initiatives vehemently. One illustrator wrote that "to fake up photographic prints so that they look like drawings or paintings is sham." But Stieglitz argued, at least originally, that they would demonstrate the viability of photographic art. In 1893 he called those photographers who insisted upon pure, sharp photographs "imbeciles who strut about examining pictures with a magnifying glass stuck in their eye."[30]

Within a decade Stieglitz changed his mind and became the foremost advocate of "straight photography." More significant than

his tergiversations on the issue of manipulated prints, however, was the constancy of Stieglitz's pluralist frame of mind, which he demonstrated for the first time in 1893 in a discussion of the various methods of photographic printing and development. Stieglitz's undogmatic willingness to allow opposing conceptions of photography to compete in their ability to move the medium forward helped prepare him to appreciate the significance of the new experiments in art when he encountered them in the next century. With prescience he wrote, "There are many schools of painting; why should there not be many schools of photographic art? There is hardly a right or wrong in these matters, but there is truth, and that should form the basis of all works of art."[31]

If photography could express "truth," an elusive metaphysical quality, more a product of personal imagination than a fixed objective standard, it could justifiably call itself an art. In 1904 Stieglitz realized that his goal of hanging photographs "in juxtaposition to the best of other arts without detriment to themselves or to those who might have the courage so to place them" depended upon photographers' stressing the characteristic qualities of their medium. Photography, he reasoned, could compete with the graphic arts only by being different. "Unless photography has its own possibilities of expression," he argued, "it is merely a process, not an art."[32]

The task—to make photographic prints that emphasized the integrity of photography and at the same time enabled the photographer to express his personal point of view and inner vision— seemed a formidable one in 1900, when Stieglitz proposed it. To advance his goal, he helped organize the New York Camera Club in 1897, founded and edited *Camera Notes*, making it the most beautiful and critically advanced photographic journal in the world, and in addition, arranged numerous successful exhibitions of photographs. None of these efforts would have been enough, however, if Stieglitz had not also personally extended the limits of the craft by taking some of the most striking and original pictures anyone had seen.

3 Referring to the period of Stieglitz's life after 1918, Georgia O'-
Keeffe has remarked that he never traveled anywhere in order to
take pictures. "His eye was in him," she explained. "Maybe that
way he was always photographing himself." Although earlier in
his career Stieglitz certainly did go places to photograph, her par-
adoxical insight—that Stieglitz's art mainly reflected his self-im-
age—applies to his best work before she met him as well. Stieglitz
himself noted that in photography and, he added, in his personal
life too, what concerned him most was "hitting the point beyond
the center," making direct contact between his inner needs and
the essence, as he defined it, of the object photographed or the
person loved. Equating the two, he said, "When I make a picture
I make love. If what is created is not made with all of oneself
. . . it has no right to be called a work of art."[33]

Stieglitz's success as a photographer depended upon his ability
to transcend the limits of photography's primitive technology by
imposing his personal vision on its finished product. Patience
combined with a willingness to experiment made his task easier.
He was one of the first serious photographers, for example, to
demonstrate the effective use of the hand camera, which he used
to portray the movement and vitality of life in the city as in *Fifth
Avenue, Winter* (1893). He also helped pioneer taking pictures
at night and in inclement weather. More important than these
technical achievements, however, though they did produce re-
markable results, was his ability to create poetry where there had
been only physics and chemistry before. In the words of one early
international critic, Stieglitz almost singlehandedly established
"a new medium of individual expression."[34]

Although that was his goal, realizing it, particularly in the be-
ginning when he was merely a student in Germany, was an ar-
duous process. Despite some auspicious successes like his portrait
Paula (1889), which perfectly blended alternating stripes of light
and shadow to create an original photographic effect, and his
picture *Venetian Boy* (1889), where the subject's tattered clothes
and challenging facial expression were too real to be sentimental,

most of Stieglitz's early experiments were failures. Like the nine-teenth-century German photographers, whose influence he felt, Stieglitz still concentrated too heavily on competing with tradi-tional painters to produce original work. *The Old Mill* (1887), for example, taken in the Black Forest, did not represent a personal vision; rather, it traded on *volkish* associations with the German countryside to create a romantic aura. So too a photograph like *The Letter Box* (1887)—which showed two young girls dressed in traditional German costumes depositing a letter—was not wor-thy of any claims to originality. These as well as other equally unsuccessful photographs, most notably his series of manipulated prints, he later eliminated from his oeuvre in order to give a false impression of constant quality in his development.

More successful and interesting were Stieglitz's seascapes taken in Katwyk, Holland, in 1894. Although these stark, refreshingly simple compositions also portrayed picturesque peasants in tra-ditional garb, and though they too were inspired by naturalistic paintings of similar subjects, *The Net Mender, Gossip,* and *Scur-rying Home* begin to express successfully Stieglitz's personal style. To be sure, as Sadakichi Hartmann pointed out, Stieglitz's *Net Mender* bears a close resemblance to Max Liebermann's painting by the same name. And it is also true that the Katwyk photographs border on becoming sentimental and nostalgic. Nevertheless, Stieglitz's prints reveal *photographically* his point of view. By blending the neutral tones of *The Net Mender*, by eliminating all unnecessary detail around the subject, and by creating a per-fectly balanced composition, the photographer portrays a woman whose world he considers simple, total, complete. About *The Net Mender*, which in 1889 he said was his favorite photograph, Stieg-litz wrote, "All her hopes are concentrated in this occupation—it is her life."[35] Perhaps his reflection was accurate; more signif-icant, however, for Stieglitz's maturity as an artist was his ability to make it true—at least in the moment he snapped her picture.

While Stieglitz's European photographs frequently look back to an agrarian world fast disappearing at the time, his first pictures

Alfred Stieglitz, *The Net Mender*, 1894. *(National Gallery of Art, Washington; Alfred Stieglitz Collection)*

of New York City, taken between roughly 1893 and 1902, eliminate the romantic sentimentality of his earlier work and capture the quality of life in the city at the end of the century. These photographs nevertheless remain essentially deeply personal pictures. In fact, on occasion, Stieglitz even considered them self-portraits. He explained, for example, how his overpowering loneliness upon returning to America inspired him to photograph a man caring for horses harnessed to a public carriage. "How fortunate the horses seemed, having a human being to tend them," he recalled many years after shooting *The Terminal* (1893). "I decided I must photograph what was before me."[36] In portraying solitary figures in the midst of the metropolis against a soft-focused background, *The Rag Picker* (1893) and *Spring Showers* (1902) also capture the photographer's melancholy sense of himself during the period.

These pictures retain their immediacy even after almost a century because Stieglitz was able to convey personal feelings of loneliness and solitude in his compositions. Despite the everyday quality of the street scenes he shot, photographs like *Spring Showers* have become universal statements about the human condition that speak through time. Figuratively bearing Stieglitz's signature, they are unmistakably a product of his imagination. Explaining why he took his camera into "ugly New York," this time a few years *before* painters were moved to portray the same setting, Stieglitz noted in 1896, "I dislike the superficial and artificial, and I find less of it among the lower classes. That is the reason they are more sympathetic to me as subjects."[37] While we are apt to suspect such impulses, Stieglitz's results confirm his honesty and insight. Unlike the ashcan school's paintings before World War I, which were in fact frequently sentimental, Stieglitz's attendants, ragpickers, and street sweepers all assume a quiet, anonymous dignity that belonged as much to the man behind the camera as to the subjects of his lens.

Stieglitz's second series of New York prints attempted to go beyond his studies of human activity in the city. Taken in the

Alfred Stieglitz, *The Hand of Man*, 1902. *(National Gallery of Art, Washington; Alfred Stieglitz Collection)*

first decade of the century, they endeavored to capture New York's new aggressive spirit in toto. By being reprinted so frequently, these photographs have formed our visual image of what New York looked like on the eve of the modern era. As Stieglitz, waving his hand over lower Manhattan, told Theodore Dresier in 1902, "If we could but picture that mood!"[38] While he wanted to show the city, Stieglitz, not unlike the writer, also wanted to affirm his identity through his work.

Two photographs stand out, *The Hand of Man* (1902) and *The Flatiron Building* (1903). The first, a shot of an oncoming locomotive emitting heavy black smoke into the gray clouds above,

and the second, a study of one of Manhattan's then boldest sky-
scrapers, are both strong statements with masculine overtones.
They illustrate not only the burgeoning mood of an aggressive
urban civilization but convey also the artist's emphatic awareness
of his own sexuality. Stieglitz's symbolism may have been un-
conscious, but it was nonetheless obvious. Symbols such as a
moving train, usually associated with sexual energy, enabled the
photographer to express his personal concerns. In addition, the
vertical design of *The Hand of Man* reinforces the suggestive,
anthropomorphic intent of the photograph's title.

The Flatiron Building is no less sexually evocative. Like *The
Hand of Man*, it too rises skyward, like the city and civilization
Stieglitz wanted to depict. A tree in the picture's foreground,
which runs the length of the photograph, enabled Stieglitz to
understate the building, which is clouded in snow, while still
accentuating its aggressive nature. The Twenty-third Street sky-
scraper seems as if it is in motion. Stieglitz said that the building
reminded him of "the bow of a monster ocean steamer" moving
toward him, and that he thought of his study as "a picture of the
new America which was in the making." He recalled that he had
watched the building being constructed daily but that it had not
occurred to him to document "the course of its erection." His
probably unconscious choice of words points toward "the passion"
he said he once associated with the Flatiron Building.[39]

Stieglitz's most famous photograph, the picture he said at the
end of his life "represented" him best, was *The Steerage* (1907).
Taken, ironically, on an eastbound crossing of the Atlantic—
ironically because the photograph has come to symbolize an entire
generation of immigrants *to* America —*The Steerage* reflects
Stieglitz's lyrical views of humanity as well as his intuitive sense
for abstract composition. Bored by the ocean liner's nouveaux
riches, from whom he wanted to separate himself but whose ac-
commodations he nevertheless continued to enjoy, the photog-
rapher walked to the opposite end of the boat, where he observed
the huddled masses in the ship's hold. He said that he stood

Alfred Stieglitz, *The Flatiron Building, Winter*, 1902–3.
(National Gallery of Art, Washington; Alfred Stieglitz Collection)

"spellbound," noticing how "shapes related to each other" and how the people seemed to express "the feeling [he] had about life." He knew that if he could photograph what he saw and felt the picture would "go beyond" all his previous successes. In a way, it did. Although, as in his earlier studies, Stieglitz's subjects retain their anonymity and thus represent a spirit larger than themselves, his new feeling for the dynamic movement abstract shapes can convey added to the impact of the composition. Stieglitz maintained that for him *The Steerage* was not a picture of immigrants but rather "a study in mathematical lines, in balance, in pattern of light and shade." Nor was he alone in so thinking. Picasso, for example, as Stieglitz's friend Marius de Zayas wrote him, "came to the conclusion that you are the only one who has understood photography. [He] understood and admired the 'steerage' to the point I felt incline [*sic*] to give it to him." Rarely did Stieglitz defer to the views of others, but Picasso's compliment he treasured. Referring to Picasso, he said that he "value[d] his opinion tremendously" and was "especially pleased that he liked the Steerage."[40]

One of the reasons painters like Picasso admired Stieglitz's photography was that they identified with his search for authentic self-expression. Like their work, Stieglitz's best photographs pointed toward the artists' new appreciation of the importance of personality. Though intensely formal and sometimes even remote, they went beyond their subject matter and uncovered unsuspected levels of consciousness in both the artist and the viewer. As early as 1902 Stieglitz tried to articulate his photographic ideal, an ideal that depended in large part on a platonic conception of beauty. "The secret of serious pictorial photography," he wrote, was basically "individualism . . . working out the beauty of a picture as you see it, unhampered by conventionality—unhampered by anything—not even the negative."[41] For Stieglitz the affirmation of "truth," which relied on personal vision, not standards or techniques (i.e., the negative), was the highest aim of art (and photography).

Alfred Stieglitz, *The Steerage*, 1907. *(National Gallery of Art, Washington; Alfred Stieglitz Collection)*

By the early 1920s, Stieglitz did succeed in developing a series of abstract prints that, in fact, do almost penetrate the material world. These were his cloud studies, his *Song of the Skies*, or, as he called the pictures increasingly after 1922, the *Equivalents*.

In 1923, explaining how he came to photograph clouds, Stieglitz noted that, the previous year, Waldo Frank had annoyed him by arguing that his success in portraiture depended upon hypnotic powers. Actually, Stieglitz misinterpreted Frank, who had only pointed out that Stieglitz's portraits, like most of his photographs, reflected Stieglitz's will better than his sitter's personality. He was not wrong. Stieglitz's portraits of his intimate friends, fellow artists like Hartley, Dove, Marin, Demuth, O'-Keeffe, Sherwood Anderson, even Frank himself, bear an uncanny resemblance to one another and, not coincidentally, to his own self-portraits. All convey a rather serious, self-conscious, semidetached, almost mournful awareness, as if they too shared the sorrow that Stieglitz said dominated his whole life. In any case, having misunderstood Frank, Stieglitz reasoned that if he could "put down [his] philosophy of life" by turning his camera skyward, he could demonstrate once and for all that his photographs depended on neither subject matter nor special effects. "Clouds were there for everyone," he noted sardonically.[42] He could and should have also acknowledged the influence of modernist antimaterialistic conceptions of reality, with which he was more than well-acquainted by 1920, but chose not to.

Although Stieglitz frequently insisted that all his photographs were "equivalents," that is that they represented *his* self or *his* vision, the new cloud studies were even more suggestive and personal than any photographs he had yet printed. In their ability to convey abstract feeling, they are indeed "unhampered by anything—not even the negative." Their power (unfortunately largely lost in reproduction) directs the viewer to a transcendental awareness. Stieglitz hoped that his audience would *see* music. "I wanted a series of photographs," he wrote, "which when seen by Ernest Bloch (the great composer) he would exclaim: Music! Music! Man, why that is music!" (To make sure, Stieglitz included the

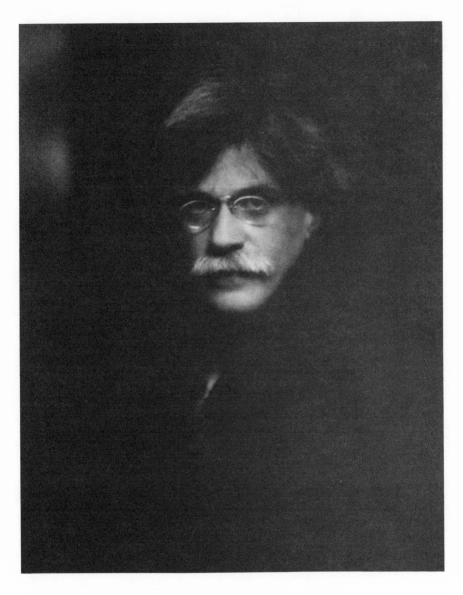

Alfred Stieglitz, *Self-Portrait*, 1910. *(National Gallery of Art, Washington; Alfred Stieglitz Collection)*

word "music" in some of their titles.) Or woman. Ironically, one of the few people who did not see feminine forms in the *Equivalents* was the person whose intense femininity (in Stieglitz's eyes) had inspired them, Georgia O'Keeffe. "Can you find the woman in these?" she asked. "I can never find the woman."[43]

4 Stieglitz's success in "putting photography on the map" did not depend solely on taking pictures of unparalleled distinction. Equally important was his foresight in linking photography's fortune to the emerging European avant-garde, notably to the artistic and social ideals professed by the German and Austrian secessions of the late nineteenth century. The secessionists, whose ranks included such important artists as Edvard Munch and Gustav Klimt, represented a new departure in aesthetic appreciation. Their fin-de-siècle revolt against the realist tradition of the nineteenth century became one of the avenues that later led to abstract expression, the hallmark of the next century. Significantly, it was through secessionism that Stieglitz, whose intellectual roots were after all German, not French, came to understand modernism.

Originally impressed by the secessionists' decision to include photographs in their Munich exhibition of 1898, Stieglitz discovered that he shared the group's basic worldview. In 1899 he called the German and Austrian artists "the most advanced and gifted men of their times." Like them, he was engaged in a generational revolt against the nineteenth century's liberal rational order. His own "secession" from business he had interpreted as a protest against the commercial world of his father. Like the secessionists, he sought a deeper personal identity by creating a new transmaterialistic means of expression that would, he hoped, portray the real nature of modern man. In addition, he believed fervently with the secessionists that the regenerative powers of art could offer an antidote to the growing demands of modern life. Finally, he greatly admired their work, hanging, around 1900, in his Madison Avenue home large reproductions brought back from Germany of *The Sin* (1895) by Franz von Stuck, a painting

Alfred Stieglitz, *Equivalents*, 1927. *(National Gallery of Art, Washington; Alfred Stieglitz Collection)*

that featured a semi-nude woman, a classic femme fatale with a ferocious snake wrapped around her body, *Isle of the Dead* (1880) by Arnold Boecklin, a second symbolist painting, and Franz von Lenbach's portrait of Eleonora Duse, Stieglitz's favorite romantic heroine.[44]

As early as 1902 Stieglitz began to bring the secessionists' new antirational social and personal definitions of art to bear on the world of American photography. By then he had grown increasingly impatient with squabbles in the conservative New York Camera Club, many of whose members objected to Stieglitz's "absolute control" over the Club's journal, *Camera Notes*.[45] As

he saw it, his high standards alienated those who could not meet them and who, in his eyes, were more interested in socializing than in photography. Stieglitz also feared more serious challenges to his self-assumed position as the preeminent patron of American photography from fellow photographers like F. Holland Day, who had arranged an exhibition of American photographs in London and Paris in 1900 and 1901. Day, a Boston photographer whose most famous pictures depicted the Crucifixion, had invited Stieglitz to participate, but he declined, ostensibly on the grounds that Day's standards did not equal his own. In any case, when Charles de Kay of the National Arts Club in New York asked Stieglitz to exhibit his work in its galleries in 1902, Stieglitz decided to organize instead a group show over which he requested and received complete authority. De Kay's generous invitation gave Stieglitz what he was looking for: an occasion to resign as editor of *Camera Notes*, an opportunity to establish his authority among American photographers, and most crucially for the future, a chance to found a new organization which he called the "Photo-Secession."

The new group, having no basis in reality outside of Stieglitz's mind, owed its genesis to the National Arts Club exhibition's need for a title. Wishing to associate the show with something larger than his own domineering will, Stieglitz impulsively labeled it "An Exhibition of American Photography arranged by the Photo-Secession," preferring the European-derived designation to his own name though, for the moment, the two were synonymous. In this manner he announced his withdrawal, or secession, from the salonlike New York Camera Club (though he continued to use its facilities until its members expelled him in 1908) and launched a new, potentially revolutionary movement on New York's staid art scene. Years later Stieglitz recounted what he had told de Kay in 1902. "The idea of secession is hateful to the Americans," he said. "They'll be thinking of the Civil War. I'm not. *Photo-Secession* actually means a seceding from the accepted idea of what constitutes a photograph; besides which, in Europe,

in Germany and in Austria, there've been splits in the art circles
and the moderns call themselves Secessionists, so *Photo-Secession*
really hitches up with the art world."[46]

At its inception, the Photo-Secession, as its name suggested,
assumed an antitraditional position regarding the arts and society.
In keeping with Stieglitz's open-ended approach to life, the or-
ganization stood for anything it might become. Its amorphous
existence was its message. Not surprisingly, many people were
confused. Even those photographers represented in the Photo-
Secession's first exhibition did not have a clear idea of what it
was. One of them, Gertrude Käsebier, asked Stieglitz for an ex-
planation. His reply reflected the values he associated with the
Photo-Secession, particularly the importance of self-definition,
which provided the cornerstone for the new organization. He
asked her if she *felt* she was a secessionist. When told yes, he
said, "Well, that is all there is to it."[47]

Stieglitz's unwillingness or inability to define explicitly his cri-
teria characterized the Photo-Secession from the beginning.
While it needed an organization and resources in order to become
an active body, Stieglitz did not want the Photo-Secession to im-
itate the institutions he set out to oppose. He hoped that his new
group would offer a real alternative to convention. Yet, to remain
revolutionary, the Photo-Secession, as Stieglitz conceived of it,
had simultaneously both to organize and to retain its dynamic
posture. That contradiction, which struck (and strikes) at the heart
of the avant-garde's efforts to challenge effectively the mainstream
culture's forms, was reflected in two documents Stieglitz issued
following the exhibit at the National Arts Club.

The first, a standard constitution for the Photo-Secession which
outlined its objects and established its rules and procedures re-
garding membership, dues, and the like, contrasted sharply with
the second, a broadside, published in a commercial handbook.
In a brief statement of purpose issued only a few months after
the constitution, Stieglitz saw fit to extol "the fanatical enthusiasm
of the revolutionist, whose extreme teaching has saved the mass

from utter inertia." Comparing his fight for self-expression through photography to other revolts, he explained that "this secession from the spirit of the doctrinaire . . . found its expression in the foundation of the Photo-Secession. Its aim is loosely to hold together those Americans devoted to pictorial photography in their endeavor to compel its recognition, not as the handmaiden of art, but as a distinctive medium of individual expression." Elsewhere, an open-minded Stieglitz discarded the constitution he had just completed. "There are no hard and fast rules to which we must adhere," he wrote in 1903. "New conditions will bring with them new changes." By 1910 he exclaimed that the Photo-Secession had "no constitution at all," pointing out that "in art matters . . . organization means gradual and certain stagnation."[48] Stieglitz, in other words, resolved the tension between antistructural ends and institutional means by abrogating the legitimacy, but not the reality, of the latter from the outset.

One of the means Stieglitz chose to advance his cause was to publish a new journal. "An illustrated quarterly magazine devoted to Photography," as its masthead read, Camera Work first appeared in January 1903. Six hundred forty-seven people had subscribed to the periodical, which was issued in an edition of one thousand copies. By insisting on the finest binding, paper, and photographs available, Stieglitz made Camera Work the most beautiful and expensive journal of its kind in the world. He even paid to have it printed in Germany, where publishing standards were superior. The quarterly's reproductions claimed to reflect accurately the featured photographer's original photographs, something that demanded individual attention to every copy of each issue. Having one's prints appear in Camera Work soon became photography's highest accolade.

In addition to enabling Stieglitz to fulfill his favorite role as patron, Camera Work also gave him a new forum, one that he controlled completely, from which to put forward dissenting ideas about photography, art, and, ultimately, American culture as well. In the premier issue Stieglitz stated that it was not his in-

tention to edit another "primer" for amateur photographers. On the contrary, he explained that he planned to open *Camera Work*'s pages to the most advanced writing of the day. And, to maintain critical autonomy for his essayists, he declared that the new quarterly "owes allegiance to no organization or clique." He even claimed that its being "the mouthpiece of the Photo-Secession" would not interfere with its independence.[49] That an organ could be an official voice of an organization and yet remain independent of it was obviously impossible. Stieglitz, nevertheless, assumed that the Photo-Secession's anti-institutional animus would protect *Camera Work*'s freedom. Since he was willing personally to pay the costs subscriptions and advertising did not cover, he did not have to compromise either his standards or his principles.

The Photo-Secession also needed a New York gallery to present its message. Following its exhibition at the National Arts Club, Stieglitz arranged group shows for the Photo-Secession in Chicago, Philadelphia, and Pittsburgh, as well as in Europe. These exhibits, however, did not give it the impact that a permanent home would. Prompted by a large exhibition of popular photographs shown in New York in 1904 that Stieglitz said sarcastically was designed "to save photography" from him and what he represented, he decided to rent rooms to ensure that his anticommercial perspective would also have its outpost. His friend Eduard Steichen had found space on the fourth floor in a building at 291 Fifth Avenue. Both a painter and a photographer, Steichen shared Stieglitz's hope that by founding their own gallery, they could circumvent the establishment's refusal to show photographs and other forms of art in the same place. Within a short time after 1905 when they were first opened, the Little Galleries of the Photo-Secession became America's showplace for the most advanced art in the world.[50]

To make certain that the Photo-Secession would remain "uncorrupted" by the commercial world it aspired to challenge, Stieglitz proposed to eschew all business practices. Consequently, only a small, inconspicuous sign indicated the gallery's presence

on Fifth Avenue, and its shows were rarely advertised to the general public. Stieglitz tried to explain the apparent contradiction between his desire to change society at large and his uncompromising elitism by telling an interviewer in 1908, "I gave up sending out invitations to our exhibitions long ago. Those who are interested in the things we have here will find them, and those who are not interested we don't care to waste time with. This is the only free place in Fifth Avenue." For that reason, he also said that he did not lock the gallery's doors since to do so would violate its spirit. So too, when a secessionist published a business card on which he had printed "Member of the Photo-Secession," he was expelled. Stieglitz wrote him, "To use the Secession for advertising purposes is about the worst offence that can be committed." Perhaps a bit exaggerated, but no more so than Stieglitz's refusal to sell the work he showed unless he felt that the prospective buyer demonstrated (to Stieglitz) that he could not live without the coveted art object. And, if he did sell something, the artist enjoyed all the profits. "The introduction of money," Stieglitz said, remembering his childhood, "always strikes me as unpleasant." Finally, as he told Emma Goldman, in order "to keep the place absolutely free," he kept "no books, or records of any kind."[51] In Stieglitz's mind, everything regarding the gallery was designed to proclaim art's supremacy over the material world.

In 1905, before Steiglitz showed a single modern painting, Roland Rood, a critic and a frequent contributor to *Camera Work*, summed up the Photo-Secession's perception of itself and its position in America: "There probably exists no country of importance in which such work is more necessary than in our land. We are, *par excellence*, a race of big and little shopkeepers; our ideal is the utilitarian, the commonplace our standard, and the conventional our goal. So I feel, and strongly, that any fight against this bourgeoisie is the fight of all fights to be fought."[52] He warned that establishing photography's credibility would be only the beginning of the Photo-Secession's struggle to radicalize American culture, not doubting for a second the efficacy of art to change the world.

As Stieglitz promised, *Camera Work* and the Photo-Secession did not focus on photography as an end in itself. From 1902, he had his eye on a larger goal. Like Randolph Bourne later, Stieglitz wanted to discover and portray a new psychological conception of mankind that he hoped would enhance personal freedom while it promoted social change. His thinking led him through secessionism into the obscure riddles of fin-de-siècle symbolism.

The symbolists argued that the nineteenth century's materialist conception of the world, which held that all nature was subject to rational control and analysis, could neither explain the mystery of an infinite universe nor begin to appreciate the true depths of the human soul. Poets like Stéphane Mallarmé and Paul Verlaine believed that only symbolic suggestions triggering some reaction in the viewer or reader's psyche could do that. Turning to the power of myths and dreams to express their newly discovered emotions, the symbolists sought to portray *numen* and *eros*. Love and death were favorite subjects. Where rationalists analyzed, symbolists synthesized. Where Cartesian scientists categorized, romantic artists sought to unite all into one. As the French writer Joséphin Péladan put it, "Our aim is to tear out love," by which he meant sentimentality, "from the Western soul and replace it with the love of Beauty, the love of the Idea, the love of Mystery. We shall unite the emotions of literature, the Louvre and Bayreuth in a state of harmonious ecstacy."[53] For some symbolists, rejecting materialism and bourgeois society led to socialism; for others, it meant living a life of decadence and nihilism. Suffice it to say, many among the bourgeoisie surrendered their rationalist principles and did not bother to differentiate between the two.

Although by 1902 symbolism was already passé in Europe, well on its way to being tolerated if not accepted by the cultural establishments across the Continent, the rather large lag time that the Atlantic represented permitted cultural radicals in the United States still to see revolutionalry implications in symbolism during the first decade of the twentieth century. With the help of Joseph T. Keiley, a friend and fellow photographer, and Eduard Steichen, Stieglitz made *Camera Work* a symbolist publication

from its first issue. The photographers he featured—Clarence White, Anne Brigman, Gertrude Käsebier, and particularly Steichen—all incorporated symbolist aesthetics in their work. In 1908 *Camera Work* even declared that photography was an art *because* it "expresses itself through symbols."[54] In addition, the two main critics Stieglitz published in the early volumes, Charles H. Caffin and Sadakichi Hartmann, were both devoted to a symbolist vision of a new freedom. What these men shared with Stieglitz, Steichen and to a lesser extent the other Photo-Secessionists was a belief that photography might become a means to break through the rigid constraints of realistic and rational representation. Their main interest was less photography than cultural revolution. It was not by chance that in 1908 the Photo-Secession began introducing modern art in New York.

After Stieglitz, Steichen was the most important figure in helping alter aesthetic awareness in America before 1913. He had been born in Luxembourg in 1879 but emigrated with his parents to Michigan's Upper Peninsula when he was less than two years old. Steichen's mother assumed responsibility for the family after the rigors of mining broke his father's health. The absence of a dominant male figure in the Steichen family helps explain Steichen's subsequent search for substitute father figures, strong men like Stieglitz, whom Steichen later championed as intellectual heroes. Having moved to Milwaukee as a youth, after a few years of school Steichen apprenticed himself to a design company where he worked until 1898. His new job demonstrated in addition to the principles of drawing the uses and possibilities of photography. Intrigued by the new medium, in 1899 and 1900 he submitted romantically suggestive sylvan landscapes to photographic salons in Philadelphia and Chicago. Following success there, the painter-photographer, like most aspiring American artists at the start of the twentieth century, decided to go to Paris.

On his way to Europe, he visited Stieglitz in New York and formed a strong attachment to the older man who, for his part, thought he discovered a disciple in Steichen. Most impressed by

his equal concern for photography and painting, Stieglitz purchased three prints from Steichen for the then handsome price of five dollars a piece. While Steichen was in France, Stieglitz reported his activities in *Camera Notes*, most notably his unsuccessful effort to introduce ten photographs alongside his charcoal drawings at the Champs de Mars.[55] When he returned to the United States in 1902, Steichen was naturally drawn to New York. There he joined Stieglitz in launching *Camera Work* and the Photo-Secession, becoming Stieglitz's main designer in these years responsible for doing the magazine's graphics and hanging the gallery's exhibits.

What made Steichen's support important and—in the future when he returned to Paris and began sending back the work of Rodin, Matisse, and other postimpressionist painters—significant was that he understood and agreed with Stieglitz's secessionist ideas. Like Stieglitz, Steichen wanted to fashion a new identity by expressing his feelings through art. That romantic impulse also led him to discover the fin-de-siècle symbolists in Europe.[56] Incorporating their aesthetics into his photography and view of art generally, Steichen emerged as one of *Camera Work*'s transitional figures between symbolism and modernism, though he himself was reluctant to complete the journey.

One symbolist philosopher who particularly influenced Steichen's thought and art was the Belgian playwright Maurice Maeterlinck. Maeterlinck described the new aesthetic he yearned for in 1885 as one "straining towards invisible truths." Many years later, in 1950, Steichen remarked how moved he had been by the Belgian's ideas regarding the hidden essences of reality and the human unconscious a half century before. "We lived in a romantic era," he recalled. "I was terribly romantic and passionate in my early painting days. I'd become greatly moved by an idea or an experience. I remember, for example, how Maeterlinck's essay, 'Silence,' stirred me, how I went out to paint pictures of night and silence in that mood. I often spoke with Stieglitz about Maeterlinck. We were both moved by him."[57]

Steichen might have added that he tried to photograph night and silence too. In fact, the pictures he took with a camera probably conveyed more successfully his romantic symbolist sentiments than the ones he drew, paintings and sketches he later destroyed. His early prints, *Woods—Twilight* (1898) and *The Pool—Evening* (1899) were derived in part from his reading of Maeterlinck and call attention to the symbolists' favorite motif, nature's impenetrable mystery. Their soft focus, their subtle merging of brownish tones, and their suggestive subject matter, which seems to expand indefinitely past the pictures' borders, evoke a mystical reverence for life beyond the natural world. These murky landscapes mark Steichen's attempt to pierce reality's veil in order to elicit the real meaning of night and silence, death's metaphors. "What a beautiful hour of day is that of the twilight when things disappear and seem to melt into each other, and a great beautiful feeling of peace overshadows all," he wrote in reference to these fin-de-siècle photographs in 1901.[58]

To call attention to symbolist influence on Steichen's photographs, *Camera Work* included a brief introduction by Maeterlinck when it presented them. Stieglitz and Steichen thought that his statement on photography put Steichen's prints into their proper perspective. According to Maeterlinck, photography, for the first time, had given light purposeful expression. Writing especially for *Camera Work*—Stieglitz claimed that "the inspiration for the article was given through Steichen's photographs"—he suggested that in the mechanical medium "thought has found a fissure through which to penetrate the mystery of [light] . . . and compel it to say such things as have not yet been said in all the realm of chiaroscuro, of grace, of beauty and of truth."[59]

Although *Camera Work* published more of Steichen's prints than anyone else's, Steichen was hardly the only Photo-Secessionist who wanted to express grace, beauty, and truth. As noted, symbolist notions influenced most of the pictures Stieglitz published in the early years of *Camera Work*. The Photo-Secessionists particularly liked the blurred images symbolism's dreamy texture

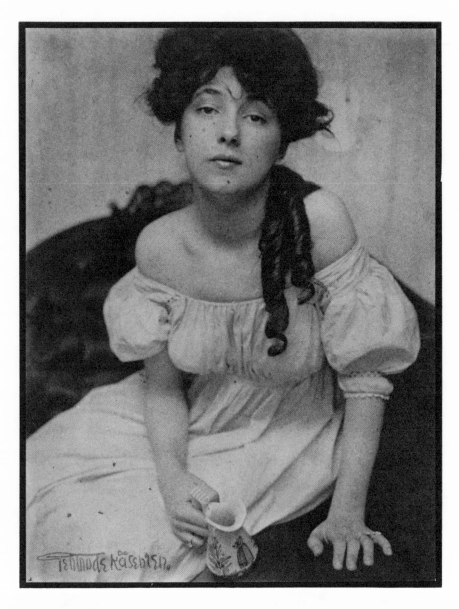

Gertrude Käsebier, *Portrait of Miss N.*, 1902. *(International Museum of Photography at George Eastman House, Rochester, N.Y.)*

seemed to call for, an attribute that in retrospect dates the majority of their photographs.

Portrait of Miss N.(1902) by Gertrude Käsebier is a good example. Appearing in *Camera Work*'s premier issue, it shows in soft shades of brown a beautiful young woman, seated, holding a concave oval pitcher an arm's length below her full breasts. Her long hair falls gracefully over one of her naked shoulders, and her chin, thrust forward slightly, invites the viewer's attention. Sad eyes and taut mouth suggest tragedy, but, like her body and the symbolic pitcher she holds, they are nonetheless enticing. In short, though no snake is wrapped around her, Miss N. is a seductive fin-de-siècle femme fatale. No doubt she succeeded in striking the pose so well because in real life she was no less dangerously ravishing. Four years after the picture was taken, her husband, Harry Thaw, killed Stanford White defending this Miss N[esbit]'s honor.

Camera Work also published symbolist criticism to buttress the radical nature of its photography and to demonstrate the Photo-Secession's departure from established convention in both artistic expression and social perception. One of its leading writers was Charles H. Caffin. An Englishman by birth, Caffin emigrated to the United States in 1892, where he made a living writing about art and photography. One of his books, written partially under Stieglitz's influence, *Photography as a Fine Art* (1901), remains a classic defense of photography's artistic potential.

Caffin believed that the main problem with American society and art was its materialistic bias, suggesting that the answer to bourgeois malaise lay in rediscovering the spiritual basis of the universe. Contrasting East and West, he called for a readjustment in the Americans' emphasis on substance at the soul's expense. "Materialism, rabid, rampant, and insatiable," he wrote, "has about run its course. . . . Possibly the remedy may lie in the return to a fuller recognition of the Spiritual." In painting, for Caffin, that meant rejecting the idea of art for art's sake, abandoning the study of naturalism, and repudiating the notion of

individual aggrandizement. He proposed in their place a Neo-platonic conception of reality that would approximate the ideal rather than define it. Accordingly, the critic said that the artist should not think of nature "as a thing to be imitated, but as a viable embodiment of unseen forces." Nevertheless, Caffin was not optimistic that "our painters" could adopt "this abstract point of view" in the face of "a society that bends every effort, intellectual and otherwise, to concrete gains."[60] With the symbolists, he stopped short of calling for the abandonment of form altogether, though that conclusion followed logically from his argument.

As Caffin's rejection of art for art's sake implied, his aesthetic criticism had a social or political component to it. Writing about Steichen, for example, Caffin explained that he "belonged, with Ibsen's *Hilda*, to the new generation" that was about to redefine society's basic values and ideals. Caffin saw the modern artist as engaged in a lonely battle to maintain "the purity and freshness of his early purpose," an aspiration, he believed, which threatened the bourgeoisie. He, therefore, fully expected traditional society to ridicule or ignore the new generation of artists. America, in particular, according to Caffin, was "the greatest grinder-down of the individual to mediocrity."[61]

Like Randolph Bourne, Caffin sought to defend the integrity of the individual in a new, modern, mass-oriented society. But, also like Bourne, he did not support his radical sentiments with a clearly defined and practical program that might have helped create the kind of world he hoped for. Still, as early as 1903, along with Stieglitz, Caffin was laying the intellectual foundation for the emergence of an avant-garde in the United States by defining the artist's (and the critic's) role in society as one of opposition to the materialist culture.

He was joined by Sadakichi Hartmann, who also challenged traditional ideas about art and society. Hartmann, the younger son of a German merchant and a Japanese mother, was a wide-ranging figure in American cultural life. From roughly 1893,

when he was jailed in Boston for writing a symbolist play called *Christ* about Jesus' love life, until the 1920s, when he lost his way in the illusions of Hollywood, Hartmann defended the activities of the avant-garde.

Only fifteen in 1882 when he was sent to live with relatives in Philadelphia after running away from a German naval academy, Hartmann discovered that his real love was not the regimentation his father preferred for him but the freedom which he found in literature. Within a short time he was writing poems, plays, as well as art and literary criticism. He is even credited with having founded in 1893 the first avant-garde magazine in America, the *Art Critic*, a journal limited to four issues, which borrowed heavily from French symbolism. Among the major figures who influenced his development as a cultural radical was Walt Whitman. Hartmann befriended the aging poet, who did more than anyone to shape the next generation's romantic ideal of an American hero, in Camden in 1884 and continued visiting him until a year before the sage's death in 1892.[62] In addition, he also met, when traveling in Europe in the late 1880s, the French symbolists Verlaine and Mallarmé, even attending the latter's famous Tuesday Evenings where symbolism was discussed and developed. Not one to restrict his energies to thinking and writing, Hartmann was also a marvelous dancer and a redoubtable character in Greenwich Village social circles. During the Village's heyday he became known as "the King of Bohemia," his striking semi-Asiatic appearance and expansive personality no doubt contributing to his recognition.

Hartmann's German and Japanese background combined with his strong interest in photography's future made him a natural ally in Stieglitz's cause. A contributor to both *Camera Notes* and *Camera Work*, he helped articulate the Photo-Secession's goals. Like Caffin, Hartmann argued in one of *Camera Work*'s first issues that "accuracy is the bane of art." He thought that art in the United States would develop only after Americans rejected their strong preference for naturalistic representation. That conclusion,

however, did not lead him to endorse abstraction immediately. Not suprisingly, given his ancestry, he looked to Japan for aesthetic inspiration. In 1903 Hartmann wrote one of the first popular books for the layman on the history of Japanese Art. In it, he implied that the Japanese artist's concern for brevity, concision, simplicity, suggestion, and repetition with slight variation could offer a powerful antidote to "the materialistic shams with which Western civilizations delude themselves."[63]

Eastern sensibility, as it did for Caffin, gave Hartmann an antithetical reference point from which to oppose the dominant cultural trends of his time. His adamant defense of the individual combined with his fierce antagonism toward the social forces that sought to restrict the boundaries of personal expression made him a perfect spokesman for any symbolist cause. "My whole life," he said in 1903, "has been a fight for the nude, for liberty of thought in literature and art."[64] Fighting for the nude, of course, was Hartmann's symbolist metaphor for his belief in the necessity of uncovering the true depths of men and women. By defying cultural convention and authority, he hoped to unleash the emotions he felt art could convey.

In light of the symbolist critical context that Stieglitz had established and in light of his original intention to show all forms of art at the Little Galleries, Pamela Colman Smith's show of seventy-two drawings, which opened at 291 on January 5, 1907, and ran for three weeks, represented, as Stieglitz often claimed, no new departure for the Photo-Secession. In fact, her exhibit formed a bridge, as it were, over which *Camera Work* and 291 moved from symbolism in photography to modernism in painting.

Stieglitz has recounted that Smith came to 291 on her own initiative, imagining that the Photo-Secession might be interested in her work. He was most impressed by one of her smaller drawings, *Death in the House*, a typical symbolist theme, apparently derived from an Icelandic legend. Feeling that it reflected his state of mind at the time, he impulsively decided to give her the show she wanted.[65]

Steichen has complained in his autobiography that Stieglitz "jumped the gun" by showing Smith in 1907 when, according to him, they had agreed that Rodin, who was close to Steichen personally, should have had the honor of inaugurating nonphotographic art at 291. And, because in contrast to most of the great artists Stieglitz later introduced, Pamela Colman Smith has largely been forgotten, his decision to show her has been presented as something akin to a false start.[66] Yet, in retrospect, it made sense to exhibit Smith's primitive symbolist washes before Rodin's advanced postimpressionist sketches, though, of course, that was not the reason Stieglitz did so. He simply decided to sponsor Smith because he sympathized with how she interpreted the world. Her drawings may have surprised many who had become accustomed to seeing only photographs on the Little Galleries' walls, but, given 291's background, they should not have been shocked.

Stieglitz made his point clear in *Camera Work's* first issue for 1907. Writing in typically cryptic symbolist language, he explained that: "The exhibition of drawings in black and color by Miss Pamela Colman Smith . . . marked, not a departure from the intentions of the Photo-Secession, but a welcome opportunity of their manifesting. The Secession Idea is neither the servant nor the product of a medium. It is a spirit." In Stieglitz's mind that spirit represented "honesty of aim, honesty of self-expression, [and] honesty of revolt against the autocracy of convention."[67]

Smith was born in Great Britain, but grew up in Jamaica and the United States. After studying art at the Pratt Institute in Brooklyn, she returned to England and Ireland, where she joined the movement to revive Celtic literature and traditions. Following the influence of Yeats, Maeterlinck and Debussy, all of whom she befriended, Smith sought to express her inner visions through painting. A mystic, she aimed, in the words of one critic, "to pierce the veil that hid the subjective world." She believed that the evocative power of music would unlock her feelings and enable

her to convey graphically hitherto unsuspected glimpses of a magical universe. Listening to music, she painted what she saw. At the opening of her second show at 291, she even recited West Indian nursery tales and chanted Yeats's poetry to provide the correct suggestive atmosphere for appreciating her work.[68]

Smith drew heavily on symbolism. Her assumption that music best provided the imaginative background for her goal of synthesizing art and emotion as well as her feeling that what really mattered was self-conceived reality were clearly symbolist ideas. She believed, moreover, that evocative symbols and ancient legends could potentially recapture precolonial and antirational conceptions of the world, an objective her Jamaican and Irish past no doubt prepared her to value. Despite her antinaturalistic bias, however, Smith never transcended realistic representation. Her watercolors had an intended childlike, albeit enchanting, simplicity about them, a fact that made them popular (Stieglitz sold about half from her first exhibit) but unchallenging. Smith found her most dramatic form of expression not in painting but in the occult. She is best known for her 1909 Rider deck of tarot cards.[69]

Pamela Colman Smith opened a new world at 291, not only by employing a new medium but also by provoking critical comment regarding perception, painting, and society. Writing in *Camera Work*, the critic Benjamin de Casseres, for example, extolled Smith as "the evocatrice of Wonder," exclaiming that her work posed a real challenge to "the scavengers [who] scrape the gutters for coppers and duck in the cesspools of practical life for the rolling dollar." Nor did de Casseres unfairly project his own personal battle against the practical, the utilitarian, and the concrete onto Smith's pictures. In the catalog to her second show at Stieglitz's gallery in 1909, Smith herself pointed out her work's implied criticism of American culture. "It seems to me," she wrote, "that fear has got hold of this land. Each one has a great fear of himself, a fear to believe, to think, to do, to be, to act."

146 In presenting her watercolors to the public, Smith said she was being true to her " better self" and hoped that her audience would respond in kind.[70]

Neither Smith nor de Casseres resolved the apparent contradiction between her symbolist sketches' popularity and their intended implicit attack on the social status quo. Rooted in nineteenth-century realistic techniques, symbolist painting (and photography) proved perfectly acceptable to large bourgeois audiences. Such was not the case, however, of symbolism's offshoot, modern art.

6 Three days after a startling exhibit of revolutionary drawings and prints by Henri Matisse in April 1908 the Little Galleries of the Photo-Secession were forced to close. The landlord, Benjamin Altman, ironically, an art collector but one interested mainly in old masters, doubled the rent, an expense the Photo-Secession could not meet. Stieglitz later said that he thought he could have gone to Altman "hat in hand" and had the lease renewed without charge. But he was too proud for that and insisted, he explained, "on doing things in [his] own way." Rather than compromise the Little Galleries' independence, Stieglitz allowed its rooms, as *Camera Work* put it, to revert to "their original condition of an univiting and dilapidated garret." Within days of vacating the experimental station, a sweatshop occupied the premises.[71]

The transformation of the Little Galleries from a revolutionary outpost into a commercial establishment confirmed, at least in Stieglitz's mind, America's preference for material wealth before spiritual enrichment. Others shared his view. One who did was Paul B. Haviland, a man who could contribute enough financially to prevent Photo-Secession's demise. Haviland's enlistment in Stieglitz's cause just as the Little Galleries began exploring modernism illustrates how some advocates of the new art viewed what they saw. In later years Haviland explained to his daughter that between 1908 and 1916 he felt "he was participating in a move-

ment that was going to change the world." Had it been possible, he told her, he "would have placed the entire Haviland enterprise at Stieglitz's service."[72]

Haviland was born in Paris in 1880. His father headed a family corporation that manufactured china while his mother, a daughter of a famous French art critic, Philippe Burty, no doubt helped educate him to appreciate the importance of art. After taking a liberal arts degree from the University of Paris in 1898, Haviland came to the United States, where he continued his studies at Harvard until 1901. Concluding his formal education that year, he became his father's representative in New York City. But just as Stieglitz's early exposure to life in the arts prevented him from going into business, so too Haviland's growing up in a world of art, literature, and music suggested an attractive alternative to his family's china concern.

In 1908 Haviland attended the Rodin exhibition at the Little Galleries and met Stieglitz. Most impressed by the power of the older man's personality as well as by his impressive confidence that a new art could in fact resolve the cultural contradictions that beset them both, Haviland found a cause to which he could devote himself. He saw Stieglitz's experimental gallery as one that represented "the spring of eternal youth," employing the same metaphor Randolph Bourne did to describe their shared ideal of personal growth leading to social change. Unwilling to see his newly discovered oasis expire for lack of funds, Haviland, with several other enthusiasts, decided to guarantee the Little Galleries' rent of $1,200 a year. The Photo-Secession then moved across the hall to 293 Fifth Avenue, though the Secessionists increasingly referred to their new home by its former address, 293 not having the same magical associations that 291 possessed in their minds. It mattered little that some people who thought that numbers were fixed entities might be confused.

Stieglitz was extremely fortunate that Haviland joined 291's cause just as it was beginning to move into the uncharted territory of modernism. Stieglitz, not being a disciplined thinker—indeed

148 he prided himself on having no fixed conceptions—needed others, like Haviland, to outline his raw notions in print for him. Following the creation of *Camera Work* and the foundation of the Photo-Secession, Stieglitz wrote very little in addition to his voluminous private correspondence. In letters he could uninhibitedly describe evolving thoughts and feelings without subjecting himself to the discipline of expository writing. Instead, he relied on his editorial prerogative to publish or not, and, more importantly, on his position as director of the Photo-Secession to advance his views. Inscribing an issue of *Camera Work* in 1915 for Haviland, Stieglitz described inadvertently how he conceived of his role. "If 291 as it stands today means anything to anyone," he wrote displaying unwittingly his gigantic ego, "it is because Paul B. Haviland at a critical time, then a comparative stranger to me, felt the desire intensely enough to *create* an *opportunity* for me to work."[73]

In many ways, Stieglitz's antipathy toward the rigorous demands of theory became a distinct asset in promoting an art movement whose full dimensions were still unformulated when he took up its cudgels. Rather than elucidating explicitly how the new art would look and explaining exactly what it would do, Stieglitz and his cohorts depended on three interrelated principles they had developed previously as secessionists to present their case. First, they continued to argue in favor of the necessity and legitimacy of self-expression which, as modernization proceeded at an accelerating pace in the social and economic spheres, became more and more personal, idiosyncratic, and subjective. Second, they refused to endorse any single school of thought or mode of expression, preferring to attack the traditional academic conception of art and society by eschewing its cardinal tenet, namely, rigid adherence to certain clearly defined basic cultural standards. That notion led them to adopt a radically new pluralist frame of reference which, in turn, welcomed new forms of art in all fields. And, finally, they believed, as they had since 1902, that they were indeed participating in a movement that was going to change the world.

Stieglitz's own search for an authentic style, one that was self-defined rather than socially determined, persuaded him to support other artists' quests for liberation from the confines of tradition. It was natural, therefore, that he welcomed the new postimpressionists' experiments with line, color, and space. His basic belief that the artist's cultural imperative was to express himself enabled Stieglitz to endorse the modernist revolution in the arts. "Why should you presume to tell an artist what he should do," he asked rhetorically. "When he is working, he is not thinking of you or me, or anybody else; he is only satisfying a need of expressing something which is within him."[74] In short, Stieglitz's appreciation of the richness of individual differences conditioned him to understand that the new modern artists, by looking inward and expressing what they felt, conveyed the nature of the universe more accurately than those who painted realistically what they saw.

Even if Stieglitz had not been predisposed toward a modernist conception of art, his pluralist posture would have led him at least to seriously consider it. He had been experimenting with the tenets of cultural pluralism since 1902 when he arranged the first Photo-Secession exhibit in which he deliberately embraced all methods of photographic printing and development. He insisted then, as later, on giving all forms of expression a chance to be seen. In *Camera Work*, too, he so often published dissenting opinions that he felt it necessary to point out that the journal's "policy . . . consists in printing any point of view or any idea, whether we approve of it or not." In 1915, when modern art seemed to have triumphed in New York's main galleries, Stieglitz noted in jest, "If worst comes to worst and the members of the National Academy of Design can find no other place to exhibit their pictures, I will cheerfully give them the use of No. 291."[75]

Stieglitz, nevertheless, did not consider self-expression an end in itself. Nor did his commitment to pluralism alone make him a modernist. Only the third component—his basic conviction that his efforts in the field of art had revolutionary repercussions in the world at large—provided the linchpin that held his world-

150 view in place. "Our strength has been," Stieglitz often said, "that we have had faith in our work and that we have had a definite goal." Asked to define it, his most frequent response was, "We are striving for freedom of experience and justice in the fullest sense of the word." In Stieglitz's mind the link between freedom and justice lay in his firm belief, as he often put it, that "art and life are synonymous."[76] And if they were indeed the same, then it followed that concentrating one's mind on self-expression was not an indulgent exercise but a noble effort that could make a real difference in the state of human development.

Stieglitz thought he was launching a revolution when he introduced modern art in the United States. Living in an increasingly secular era, he invested in the act of artistic creation the power former generations had reserved for religion. He often noted that he felt out of place in the age of science and technology. In the final analysis, to break through the perceptual barriers of realistic representation required a faith similar to what Stieglitz placed in his pleas of behalf of the artist and modern art. "It is seven years now," he wrote in 1912, "that I have been running the little place at '291' and I have not missed but two days during the whole time. During this period about 160,000 people have come up and they have been shown something which is unique in America or in Europe. Many of them are beginning to see that back of the so-called Exhibitions there is something bigger than just what is hung on the walls; there is an idea, a spirit. But few seem to grasp its meaning, a hand full possibly do."[77]

On that final somber note, Stieglitz pointed to the ultimate failure of his proposed revolution. If he was a prophet leading the way to a new radical culture, he did so in a language not many people could comprehend. And, if they could understand it, they discovered in Stieglitz's passionate rhetoric no clearly conceived way of translating 291's idealistic principles into a program of action that might indeed have resulted in the social change the modernists so desired. Sadly, when the right of artistic self-expression would be fully accepted by society, when cultural

pluralism would turn into a bulwark of the conservative estab-
lishment, and when the paintings of postimpressionist "wild men"
would become hedges against inflation, few would recall the rev-
olutionary promise Stieglitz and other cultural radicals had once
seen in modern art.

"Art is dead," Marius de Zayas announced in 1912. By issuing
that astounding proclamation in *Camera Work*, de Zayas, a Mex-
ican-born caricaturist fast emerging as 291's chief exponent of
modernism, wanted to call attention to what he considered tra-
ditional art's total failure to express the new dimensions of the
modern era. In de Zayas's eyes, however, art's death was not
"absolute but relative"; the expiration of the past, in his view,
would enable the future to be born. "Every end is but the be-
ginning of a new and fresh manifestation," he continued, thereby
linking the avant-garde's promise of rebirth and renaissance to its
proposed break from a legacy of stagnation.[78]

7

The introduction of modern European art, for which Amer-
icans were completely unprepared, required the dramatic met-
aphor de Zayas proposed to make its case. In January 1908 Stieg-
litz hung fifty-eight drawings of Auguste Rodin in the Photo-
Secession galleries. This foray into the world of the Parisian avant-
garde presented an aesthetic and intellectual challenge far sur-
passing that of Pamela Colman Smith's exhibition the previous
year. Georgia O'Keeffe, for example, then an art student in New
York, thought perhaps that her future husband was playing a joke
on the public by showing the Rodin pictures. To her, they seemed
"just a lot of scribbles." Most art critics saw no more in Rodin's
loosely defined studies, predominantly of nude women, than she
did. One wrote that they should not have been permitted outside
the artist's studio. To him, they were "too purely technical to
have much general interest except that of a not very elevating
kind," the latter an oblique reference to the sketches' sensually
evocative nature.[79] Rodin's nudes, for this established critic, not

only defied conventional standards of drawing, they also attacked the cherished sentimental notion that art should either decorate or uplift.

Rodin's defenders interpreted his work along the same lines but from a diametrically opposed point of view. Arthur Symons, an English critic with a strong background in symbolism, wrote in the catalog for the Rodin exhibition at 291 that the artist's drawings "note only movement, expression." Their omission of detail as well as their lyrical nature, he maintained, was conceived to call into being the basic, albeit dangerous, sexual attraction of woman. Although the subjects of these pictures are clearly female figures, the simplicity of their design approaches the barriers of abstraction. These two inseparable attributes—on one hand, Rodin's "challenge to the prurient prudery of our puritanism," in the words of a critic close to 291, and on the other, his experimental approach to the problems of form—made the exhibit the most provocative show in New York, at least until the following spring.[80]

For three weeks in April 1908, 291 displayed watercolors, drawings, lithographs, and etchings by "le roi des fauves," Henri Matisse. Stieglitz had never heard of Matisse when Steichen suggested that the Photo-Secession give him his first one-man show outside of France. Even though Stieglitz did not "understand" all of the pictures Steichen had brought with him from Paris, he decided to mount a retrospective exhibition of Matisse's development "from the beginning until 1908." The innovative idea of demonstrating an artist's transformation from a traditional to an experimental painter was one that appealed to him. Indeed, his organic approach to art (and life), on which the theory of a retrospective appreciation of an artist was based, enabled 291 to pioneer the concept. Stieglitz often said that he was mainly "interested in development. In growth." If he did not grasp Matisse's advanced abstract drawings, he nonetheless wanted to. And, in any case, he reasoned, "the New York 'art-world' was sorely in need of an irritant and Matisse certainly proved a timely one."[81]

Auguste Rodin, *Kneeling Girl—Drawing No. 6*, n.d., drawing,
12⅞" × 9⅞". *(Alfred Stieglitz Collection, © The Art Institute of
Chicago. All rights reserved)*

Indeed they did as Stieglitz made clear by reprinting in *Camera Work*, in keeping with his pluralist policy of giving all sides of a debate a chance to be heard, selective examples of the show's reviews. The conservative art critic James Huneker, for example, claimed that Matisse's "memoranda of the gutter and brothel" made Rodin look "academic." For Huneker, Matisse offered only "the coldness of the moral vivisector," demonstrating again the conservative's inability to separate morality from aesthetics.[82] In this, at least, he agreed with the radicals.

J. E. Chamberlain liked Matisse no more than Huneker did, but, while poking fun at the artist, he also described Matisse's purpose with insight. According to Matisse, Chamberlain wrote, "the artist should paint only abstractions, gigantic symbols, ideas in broad lines, splotches of color that suggest the thoughts that broke through language and escaped, and all that." Obviously, the critic also listened at 291. Still, he remained disturbed by Matisse's portrayal of "subterhuman hideousness." It had so severely taxed him, he said, that he would "try to put Henri Matisse out of [his] mind for the present."[83]

How challenging Matisse's pictures were in 1908 can be seen in Charles Caffin's essay "Henri Matisse and Isadora Duncan." After discussing Matisse's work with the artist, Caffin explained that the painter sought to portray "the feeling which the sight of an object stirs in him." Inevitably, to draw something that does not have a corporeal presence required transcending ordinary description of nature, and Caffin posited that perhaps Matisse had "too completely cut himself off from our traditions" to be "reasonably persuasive." He was not sure. The only way he could understand Matisse was by comparing him to Isadora Duncan, whose free flowing, abstract dances, he said, conveyed to him a similar "primitive elemental feeling."[84] Caffin stopped short of embracing Matisse fully. In 1908 he was not prepared to make the transition from symbolism, which depended on appreciating beauty *through* the real world, to modernism in which beauty (or truth) lay intrinsically within its pure expression.

Two years later, when Stieglitz gave Matisse a second one-man show in which 291 exhibited selected drawings as well as photographs of the artist's larger, more dramatic canvases such as *The Blue Nude* (1907), a slight change had taken place within the minds of some people. Chamberlain, for example, was now ready to tell his readers, "Matisse is a great man." He was no longer so tormented apparently by what another critic still called Matisse's "impossible travesties on the human form." Although most people persisted in considering Matisse a "madman," 291's work was having some impact on aesthetic perception in New York City. Even the staunchly conservative Metropolitan Museum of Art could not entirely ignore the little revolution taking place at the other end of Fifth Avenue. Against its will the museum became the first public institution in the world to collect the French artist's work. Mrs. George Blumenthal, wife of the Metropolitan's future president, told Stieglitz that she wanted to purchase three drawings from the show to give to the museum. At first an arrogant Stieglitz refused to sell them to her, fearing that she would put them in her Gothic home. When she explained her purpose, he laughed, telling her that the Metropolitan would never accept Matisse. Her arrogance apparently outweighed his. She told him, "The Museum will take what I offer it." It did, too, but not without noting in its bulletin that the three drawings were "slight in workmanship."[85]

The third major French artist Stieglitz introduced to the American public was Paul Cézanne. He had first encountered Cézanne's colorful semiabstract watercolors in 1907 on a visit to Bernheim Jeune et Fils in Paris. At the time, he said later, he found the pictures incomprehensible, no more than "pieces of blank paper with a blotch of color here and there." By 1911, though, when Steichen cabled that he could procure the same Cézanne watercolors for 291, Stieglitz was eager to show them. In the interim he had absorbed much. From the Steins in Paris, whom he visited in 1909, but also from the artists at 291, Steichen, de Zayas, and Max Weber, Stieglitz had learned how to see

abstract art. "A new world had been born for me," he explained in 1938, trying in his old age to recapture the excitement he had experienced a quarter century before when, upon discovering Cézanne, everything did seem like it was beginning again.[86]

Although some Cézanne lithographs were included in a group show at the Photo-Secession in 1910 that also featured Renoir, Monet, and Toulouse-Lautrec, his major introduction came in 1911. The combined impact of Cézanne's one-man show in March that year underlined the idea that art was power. For example, Charles Caffin, now willing finally to discard the weight of his symbolist assumptions, declared that the French painter's "scientific" abstractions pointed toward "a completer union of art with life." He even claimed that by emphasizing "simplification" and "organization," Cézanne had resolved the "irreconcilable" tension between "materialism and idealism." It was, of course, easier for Cézanne to dissolve a mountain into multicolored brush strokes than it was to unite, as Caffin apparently hoped to do, the cultural radicals' dream of "expression" with the progressives' concern for "efficiency." Most visitors to the Cézanne exhibition undoubtedly agreed with the critic who wrote that "to ordinary eyes the [Cézanne] landscapes seem to be on the point of disappearing from the paper."[87]

Exponents of modern art at 291 praised Matisse and Cézanne's work for its "primitive" charm. For the same reason, they adored Henri Rousseau's paintings. After attracting the attention of the avant-garde in Paris, le Douanier died in 1910. Max Weber, who had befriended Rousseau three years earlier, persuaded Stieglitz to honor the painter by giving him his first one-man show anywhere. The memorial exhibition of 1910 included six small paintings Weber had acquired in addition to a few drawings. Weber wrote in a statement for the show that Rousseau "was truly naive and personal, a real 'primitive' living in our time." James Huneker, of course, disliked what Weber praised, Rousseau's expression of childlike wonder before the natural world. "As an artist he is a joke," the critic wrote. "There is too much gush

over 'divine awkwardness' and 'inspired amateurship.' " Where
for Weber, Rousseau represented a "rejuvenation of the spirit of
primitive art," essentially religious in its inspiration and expres-
sion, for Huneker, he manifested the decline of standards in
modern civilization.[88]

The last significant European painter whom Stieglitz exhibited
before the Armory Show was Pablo Picasso. In the spring of 1911
the Photo-Secession mounted Picasso's first one-man show in the
United States. With examples drawn from his youthful appren-
ticeship years through his latest, most advanced cubist experi-
ments, it comprised eighty-three watercolors and drawings. Fol-
lowing 291's policy, with Picasso's help Steichen, de Zayas, and
Frank Burty, Paul Haviland's brother, selected the pictures to
"represent the different stages" of the artist's "development."[89]
Only two were sold. Revealingly, they were among the first and
the last. Hamilton Easter Field paid twelve dollars for a realistic
picture Picasso did when he was twelve years old, while Stieglitz
purchased the most controversial drawing in the exhibit, an ab-
stract cubist design entitled Nude for sixty-five dollars.

To aid understanding the Picasso retrospective, Stieglitz parted
from his usual policy of letting the exhibited art speak for itself
and issued an explanatory statement by Marius de Zayas. De Zayas
began, appropriately enough for a discussion of an artist who pro-
posed a whole new way of portraying the world, by disclaiming
the validity of art criticism. Drawing on 291's pluralist and an-
tiauthoritarian principles, he maintained that no person should
pretend "to possess the absolute truth, or even a relative one."
Like Randolph Bourne, he concluded that neither assumed stan-
dards nor conventional wisdom should be allowed to impede self-
expression. Only if one could accept that revolutionary idea, de
Zayas argued, could he then begin to appreciate Picasso. As Caffin
had described Matisse's motivation, so de Zayas, who also based
his conclusions on interviews with the artist, noted that it is not
the spectacle that captures Picasso's attention but rather "the pic-
torial equivalent of the emotion" he feels when looking at nature.[90]

158 Stieglitz recognized that Picasso, to paraphrase Gertrude Stein, was one who was coming. He therefore recommended that the Metropolitan Museum preserve the entire collection in New York by purchasing all eighty-three pictures for $2,000. Bryson Burroughs, the museum's curator of painting, however, said that he "saw nothing in Picasso" and concluded that his "mad pictures would never mean anything to America." In the context of 1911 he seemed less foolish. Most commentators could not even get past de Zayas's introductory repudiation of the tradition of criticism. One compared his "innocence" to that of an "imbecile." Another, Arthur Hoeber, "feared the worst" when he read that de Zayas had rejected the critic's right to arbitrate. Nor did Picasso suprise him. He likened the artist's work to "the gibberings of a lunatic."[91]

8 No significant movement in art, even one that proclaims language's fundamental inadequacy, emerges without offering some statement of its methods and purpose. Modernism was no exception, and Kandinsky's *Concerning the Spiritual in Art* (1912) and Apollinaire's *The Cubist Painters* (1913) have both received their due for developing a rationale for abstract art during its formative years. Some of the essays Stieglitz published in *Camera Work* as well as de Zayas and Haviland's coauthored A *Study of the Modern Evolution of Plastic Expression* (1913), issued by 291, performed the same functions. By offering intellectual guidelines for modern artists, 291 not only gave them a home but a platform as well. That American painters were not as advanced as their European teachers does not lessen the significance of Stieglitz's work in advancing the cause of modern art. Of the 304 people who still subscribed to *Camera Work* in 1912, one third lived outside of the United States.[92]

Perhaps Gertrude Stein was one of them. In any case, when she wanted to publish two abstract sketches that in their idiosyncratic way described Matisse and Picasso, her agent turned to

Stieglitz as the only person possibly bold enough to offer her experimental prose to the public in 1912. Publishers in Paris and London had previously rejected the essays. Stieglitz, in contrast, decided to feature them in a special issue of *Camera Work* after reading only the first forty words of each. Claiming that he did not know the author's identity when he first contemplated the manuscripts, her agent having brought them to him personally, he later said that he accepted the articles *because* he did not understand them. At the time, though, Stieglitz told Stein that for him, at least, she had "succeeded in expressing Matisse and Picasso in words."[93]

To do with words what Matisse and Picasso did with paint was Stein's goal. On Matisse, she wrote: "One was quite certain that for a long part of his being one being living he had been trying to be certain that he was wrong in doing what he was doing and then when he could not come to be certain that he had been wrong in doing what he had been doing, when he had completely convinced himself that he would not come to be certain that he had been wrong in doing what he had been doing he was really certain then that he was a great one and he certainly was a great one."[94] Her "Pablo Picasso" was a variation on the theme.

Stein reasoned that Matisse and Picasso demanded a new context to explain the significance of their work. Where they aspired to paint pure spirit, she focused on language's structure in order to evoke the meaning of her subjects' art. "You will be very careful," she wrote Stieglitz, "will you not, that no punctuation be introduced into the things. . . . I have put in all of it that I want and any that is introduced will make everything wrong."[95] As a symbolist might, she intended her prose to suggest the essence of her subject, not to become its unchallenging substitute which, in her view, would have distorted understanding by proposing a linear analysis of a new, antirational art form.

In introducing Stein's portraits, *Camera Work* editorialized that "the Post-Impressionist spirit is found expressing itself in literary form." Many were as appalled by her writing as they were by

Matisse and Picasso themselves. After John Galsworthy, an English writer with liberal inclinations, read the Stein pieces, he asked Stieglitz to withdraw an essay he had previously given *Camera Work* permission to publish. Ironically, his article, which had already been set up and which came out in the next issue, argued in favor of pluralism. "Art," he wrote, "demands of us an essential tolerance of all its forms. Shall we, then, waste breath and ink in condemnation of artists because their temperaments are not our own?" Like many other progressives, Galsworthy apparently answered his own question affirmatively. If artists went beyond the rational limits which he felt he had defined judiciously enough, he would not tolerate their work. Walter Weyl, too, thought that Stein's essays were absurd; he taunted the experimental painter and photographer Morton Schamberg, who considered them magnificent, to try to unscramble her sentences after he had rearranged them.[96] More significant than Schamberg's failure to decipher Stein was the cultural divide that separated an exponent of the new art form from one who espoused the new order.

If Stein suggested much, she explained very little, however. The first sustained defense and analysis of modern art in the United States was offered by Marius de Zayas. Like the other critics at 291, his roots were also foreign. De Zayas came to New York from Mexico as a young man of twenty-seven in 1907. He had been forced to flee his native country with his family after his father's Veracruz newspapers opposed Diaz's dictatorial regime. Beginning his career in art by drawing caricatures for his father's papers, he found employment doing the same for the *Evening World*. His witty drawings caught the attention of Stieglitz who, in 1909, gave de Zayas his first of three shows at 291. Both men believed that caricature, not unlike photography, had the ability to penetrate character. For de Zayas, it represented an entrée into modern art, and, in turn, the lessons of modernism enabled him to design the most advanced caricatures ever attempted.

Considering himself a serious student of art, de Zayas left New York for Paris in 1910. He spent about a year there, viewing the latest experiments at the Salon d'Automne, talking to artists, and writing. Among his first pieces was an exposé written for a popular audience, "The New Art in Paris." In order to dramatize the point that one could and should learn to appreciate new ways of seeing, de Zayas exaggerated his own shock when he first encountered a modern painting. "I could not understand anything," he wrote. "I looked, but did not see." Within a very short time, however, he understood much, and answered his own rhetorical question, "What are these people aiming at?" with unrivaled insight. A year before Kandinsky wrote *Concerning the Spiritual in Art*, de Zayas noted the metaphyscial basis for the abstract artist's search "to find the truth."[97]

Having grown up in a land where Aztec and Mayan ruins provided the imaginative background for contemporary perception, de Zayas recognized that painters like Picasso sought inspiration in primitive art. Because it was "less conventional" and "more spontaneous," the modern artists regarded it, he said, as "more truthful," that is, closer to the source of human consciousness. De Zayas maintained that modernism represented "a new form of the primitive." Like its natal root, it attempted to relate directly to the viewer's feelings. For ancient as well as modern man, he suggested, art's object was both sacred and emotive. "It makes me feel, and that is all I ask of it."[98]

But modern art also made de Zayas think. He realized, with the avant-garde in Paris, that realistic representation had reached a dead end in its ability to express the artist's newly discovered inner life. In an age of science, which emphasized the primacy of facts at the expense of spirit, advanced artists had to find some way of staying ahead of what society considered beautiful in order to challenge the civilization from which they felt alienated. Modernists did so, de Zayas explained, by proclaiming the power of autonomous forms to convey sensation without imitating nature and without resorting to "fanciful symbolism."[99] Where fin-de-

siècle secessionism's promise to unveil the authentic identity of modern man sank under the weight of its fantastic imagery, abstraction's relative freedom would, in fact, enable modern artists to examine the true nature of the human soul.

Stieglitz often said that 291 was "a splendid laboratory to study psychology practically." By that he meant that the modern artists who congregated there were interested chiefly in realizing a new conception of the individual and of the community. Drawing on both Darwin and Freud, de Zayas and Haviland's A *Study of the Modern Evolution of Plastic Expression*, 291's handbook published during the Armory Show, argued that art developed through time. In its view the artist expressed society's organizing systems of belief, which, of course, were constantly subject to change. By 1913 the authors argued that it was imperative to bring the new forays into the unconscious to bear on the way artists intepreted the world. "We firmly believe," they wrote, "that the modern evolution of plastic expression has . . . brought to reason and conscience many unconscious feelings of man." And they no less firmly believed that "the more analyzed the feelings are the more abstract is their representation."[100]

De Zayas illustrated the point in his own drawings. By 1913 he had decided to differentiate between concrete and abstract caricatures. In the first group of sketches, which were easy to understand and which the artist sometimes called "relative," he exaggerated his subjects' personal attributes in order to compose satirical portraits. De Zayas soon grew bored with the genre's limitations, however, and, desiring to make a more universal statement about an individual's "psychological representation," turned to drawing abstract caricatures. In these sketches, which he referred to as "absolute," he relied only on geometrical forms and algebraic formulas. They attempted, he said, not only to define a personality but also to suggest the subject's relationship to the world and his place in evolution. Since de Zayas now wanted to portray nonmaterial characteristics of the depicted person, he reasoned that his interpretations had to be abstract. Picabia called them "the psychological expression of man's plurality."[101]

De Zayas tells the story, probably apocryphal but nonetheless illustrative, of how he conceived his theory of abstract caricatures after seeing in the British Museum a primitive wooden stick to which a South Pacific shaman had attached a group of nets. He used the stick, de Zayas explained, to catch souls. The cult object reminded him of Stieglitz's "physical" and "spiritual" presences, and he decided then, he said, to base an abstract caricature of his friend on the forms he had seen.[102] In telling the anecdote, de Zayas wanted to underline modernism's link to primitive art, an idea he had been exploring since at least 1911.

During his Parisian sojourn of 1910–11, de Zayas pointed out in a letter to Stieglitz the extraordinary "influence of african negro art among this revolutionists [sic]" in France. "Some," he said, "have merely copied it, without taking the trouble to translate it into French." Three years later his suggestion that 291 mount an exhibition of African sculpture came to fruition. It represented the first occasion that "Negro statuary" was displayed as art.[103] The outbreak of war combined with Stieglitz's open-minded, pluralistic approach to what 291 might show led to the exhibit. De Zayas, who happened to be in Paris in September 1914, per-suaded Paul Guillaume, an avant-garde art dealer who collected African art, to let him take whatever pieces he wanted to New York, the market for them in Paris having evaporated.

De Zayas considered the exhibition crucial, and he wrote an introductory essay for the catalog which again summarized the raison d'être of abstract expression as it was understood at 291. Living in a racist era, de Zayas believed that the African's supposed lack of cognitive development precluded his portraying the world objectively. To do so, he said, required powers of analysis the black man did not possess. Consequently, not without envy, de Zayas argued that the "savage," as he was sometimes called at 291, conveyed only pure emotion. De Zayas was less interested in anthropology, however, than in using the lessons of primitive art to counter bourgeois society's increasingly positivistic definition of the individual. "Negro art," he explained, by renewing ap-preciation for expressive forms, "has made us conscious of a sub-

jective state, obliterated by objective education." In the battle for the mind, de Zayas, along with Stieglitz, wanted modern artists to preserve "the subjective truths that give us the reality of ourselves."[104]

For the same reason, on four occasions between 1912 and 1916, 291 showed children's art to the public. Just as modernism's proponents believed that African sculptors conveyed their emotions in an uninhibited fashion, so too they thought that children, not yet influenced by social conventions, expressed their true feelings and authentic selves. For romantic painters like Abraham Walkowitz, who first suggested showing children's pictures at 291, the child's natural spontaneity represented a marvelous quality, one worth striving for in the modern era. Stieglitz articulated the philosophy that supported exhibiting drawings by children in the context of an art gallery, something he claimed had never been done before. "Give a child a brush and a paint box and leave him alone," he told an interviewer in 1912. "Don't bother him with theories, don't attempt to confine his genius within established limits. The great geniuses . . . are those who have kept their childlike spirit and have added to it breadth of vision and experience."[105] His belief that society conspired to squelch a child's creativity as he or she grew up matched Bourne's views exactly.

Stieglitz's conception of childhood innocence, derived in large part from Rousseau, proved no less controversial than 291's other provocative ideas. A reviewer of the first children's show, not persuaded by the argument that institutionalized education limits growth and stifles freedom, used the exhibit, which he believed ridiculous, to attack American modernism. "One of the young artists," he suggested, "saw a painting by Mr. Max Weber and made one just like it—only better." A mother of one of the children whose pictures had been selected forced Stieglitz to withdraw them when she saw the Matisse exhibit which preceded the children's show. That her child should be associated with an artist like Matisse dismayed her immensely. She wrote to Stieglitz, "I have seen the Matisse and was not amused, but disgusted with

them, and feel in consequence that I would prefer not to show Jean's paintings at 291. . . . They are beyond art, and I do not regret my ignorance." And, when a teacher, influenced by Stieglitz's ideas regarding art education, attempted to introduce them into her class, according to the press, the "school authorities intervened on the grounds that the new method fostered anarchy in art and necessarily would lead to anarchy in politics."[106]

They also did not regret their ignorance. On the contrary, those school authorities understood precisely what Stieglitz was aiming at. Underlying Stein's stream-of-consciousness approximations of abstract art, de Zayas's appreciation of the religious and irrational roots of modernism, and 291's frequent exhibits of primitive and children's art was Stieglitz's firm belief that he did not live in an artistic vacuum, that *Camera Work* and the Photo-Secession did make a difference to the real world, and that his "experimental laboratory" was, in fact, engaged in opening up what really mattered: perception, expression, and consciousness. That modernism's opponents feared anarchy was not unnatural, even if it was unrealistic. Stieglitz frequently pointed out that his was a "revolt against all authority in art, in fact against all authority in everything, for art," as he often said, "is only an expression of life."[107]

Stieglitz linked, at least in his mind, his efforts to radicalize American culture during the Progressive Era with "the social unrest that pervade[d] the whole country" at the time. Many sympathetic admirers, in fact, liked to compare 291 with the I.W.W., the syndicalist labor movement that terrorized conservative as well as liberal public opinion before World War I. As the painter and critic Guy Pène du Bois exclaimed, "Since we have an I.W.W. in our streets, it is fine that we have one in our galleries to complete . . . the connection of art with life." Hutchins Hapgood, a radical columnist for the *New York Globe*, also felt compelled to point out what he believed were the common goals of "all the real workers of our day." Writing that "Post-Impressionism is as disturbing in one field as the I.W.W. is in another," he concluded

that what joined such figures as Alfred Stieglitz and Big Bill Haywood was their common desire to "dynamite the baked and hardened earth so that fresh flowers can grow." Agnes Ernst Meyer, one of the regulars at 291, has written that not only Haywood but also Emma Goldman "dropped in occasionally," both having assumed apparently that, like themselves, Stieglitz was engaged in a struggle to emancipate American society.[108]

The social critic at 291 who carried the fight against the cultural status quo furthest into the realm of traditional politics was Benjamin de Casseres. Declaring himself a "secessionist," de Casseres ran for mayor of New York City in 1915 on the "Smash It" ticket. Antedating Norman Mailer's similar suggestion by over half a century, he called for "the erection of the State of Manhattan," no doubt hoping that his pun would shock as much as his proposal. The remainder of de Casseres's libertarian platform advocated the legalization of prostitution and gambling, the sale of liquor twenty-four hours a day, seven days a week, as well as the mayor's immediate impeachment should he attempt to "regulate private morals." Elsewhere, he wrote that his platform contained only two planks: "Do as thou good-and-goddamned wilt! Do it in public."[109]

De Casseres was one of Camera Work's more irrepressible essayists. Like other cultural radicals at 291, he considered art a weapon to be wielded against the "giant conspiracy of mediocrity" which the United States represented to him. He particularly disliked the progressives' notions of a planned society, writing that "all economical, political and religious programmes fail because of the belief in a rational, ordered future." Like Bourne, de Casseres believed that irony should be used as a wedge to undermine the stolid foundations of what both men considered insidious attempts to control people's lives. He also favored the unleashing of the unconscious in a "renaissance of the irrational" as an antidote to planned sterility. "Long live Socialists, Anarchists, Nihilists, Communists, Diabolists, Impressionists, and anybody anywhere who is in favor of upsetting something somehow somewhere

sometime," he wrote in an effort to sum up the multivaried an- 167
tagonistic posture of the American avant-garde before the First
World War.[110]

Eventually de Casseres's anarchism pushed him even beyond
the pale of 291. Early in 1915 he asked Stieglitz, "Can *Camera
Work* (meaning you) stand for an article called 'A Plea for the
Obscene'? . . . It would create something of a *stink*, just what
we need in this country— a real, healthy stink!" At the heart of
Stieglitz's dream, however, was not a stink but a vision of a cul-
tural renaissance based on principles he now felt de Casseres no
longer shared. "It is not easy for me to say no," he wrote back,
but "you have lost touch with what is really going on at
'291.' "[111] Interestingly, de Casseres was really ahead of Stieglitz
in his toying with the absurd. During the next two years 291 was
to see the spirit of dada emerge with increasing intensity.

For cultural conservatives who opposed everything 291 was
trying to accomplish, de Casseres personified their greatest fears.
In their minds he was the consummate anarchist whose aim was
to set society on its edge. Considering art a bastion of social sta-
bility, conservative cultural critics decried the new experiments
in art, interpreting them as serious threats to civilization itself.
Like Stieglitz and others at 291, they too regarded art not only
an integral part of society but its directing genius. If essays in
Camera Work had a utopian thrust to them, opinion offered by
the leading academic critics and painters, more often than not,
had a hysterical edge to it. So, for example, Royal Cortissoz com-
pared modernism to "Ellis Island art" which he thought, not un-
like the new immigrants, imperiled the foundations of the re-
public. In language similar to de Casseres's, he warned that the
modern artists' chief goal was "to turn the world upside down."[112]

The debate about art, which reached unprecedented peaks fol-
lowing the Armory Show in 1913, was not mainly a contest be-
tween the avant-garde represented by Stieglitz and the reactionary
forces of the past represented by the establishment. Most critics,
in fact, who considered, say, cubism, as one did, "war against

all law and order," did not, like Cortissoz, call themselves conservatives. Rather, influenced by the governing spirit of the Progressive Era, they considered themselves, with Kenyon Cox, an influential teacher and writer in New York, "believers in progress." Although Cox thought that "our golden age" lay in the future, he still could not tolerate art that transcended traditional boundaries outlined by authorities like himself. In his view, by challenging rational representation of reality, modernists attacked progress itself. "Believing, as I do," he concluded, "that there are still commandments in art as in morals . . . I have no fear that this kind of art will prevail, or even that it can long endure."[113]

Because the modernist controversy related so directly to issues that were central to the broader fabric of culture — self-definition, perception, and social values, for example — it attracted the critical, if uneducated, attention of people whose concerns normally did not fall within the realm of art. Randolph Bourne's nemesis, Walter Lippmann, for example, lambasted the modernists for claiming that they had "usurped the avenues of human expression." In a satirical portrait of a patron of abstract painting who ignores pictures of "pretty girls, dancers, Eve and Venus, affectionate dogs, moonlight on the snow, mermaids, and motherly old women by the fireside," preferring instead to contemplate "torsos, fragments of arms, and sketches consisting of not more than a dozen lines," he accused modern artists of turning their major failure, an inability to communicate simply and rationally, into an assumed virtue. Lippmann argued that modernism not only fragmented the public's standards but that it also threatened its values.[114]

A man no less concerned with preserving social order, Theodore Roosevelt, agreed with the progressive theorist about art's purpose. In a review of the Armory Show, the former president likened abstract painters to "a lunatic fringe." Not realizing the close connection, he said that he preferred his Navajo rug to Marcel Duchamp's *Nude Descending a Staircase* (1912), the exhibition's most provocative painting. For Roosevelt, the Indian design was

a "far more satisfactory and decorative picture."[115] To decorate 169
and uplift, the former president agreed with the established art
critics, were art's sole functions. To deviate from them in order
to suggest another view of reality, to express some irrational part
of one's self, or to propose a revolutionary transformation of con-
sciousness and thereby of society as well, in the conservative and
progressive minds alike, meant joining, quite literally, a lunatic
fringe.

Even as late as 1921, when the Metropolitan Museum, re-
luctantly and belatedly, recognized modern art by organizing an
exhibition of post-1880 European painting, a group of anonymous
supporters of the museum issued "A Protest against the Present
Exhibition of Degenerate 'Modernistic' Works in the Metropolitan
Museum of Art." Like other concerned critics who believed that
art and society were organically interrelated, their chief objection
was not aesthetic but political. Maintaining that modern art was
"Bolshevistic," they wrote, "We believe that these forms of so-
called art are merely a symptom of a general movement through-
out the world having for its object the breaking down of all law
and order and the Revolutionary destruction of our entire social
system." Thirteen years previously, when Stieglitz first began
showing modern paintings, the Metropolitan's director, Sir Casper
Purdon Clarke, was inclined to agree that the new art was terribly
unsettling. "There is a state of unrest all over the world in art as
in all other things," he noted. " And I dislike unrest."[116]

If art could revitalize society, as Stieglitz thought, it followed 9
logically that American artists could not simply imitate European
styles and expect their work to express and, in turn, shape life in
the United States. Just as Bourne had demanded that Americans
reject their "cultural humility" and devise in its place "a new
American nationalism," Stieglitz also became an ardent cultural
nationalist. One of the paradoxes in Stieglitz's life was that, after
introducing the most advanced European art, he then decided

to promote American artists on the assumption, derived from Whitman, that an artist's work should be rooted in the place he lived and on the theory that his new forms of expression would in fact radicalize American culture. As Stieglitz explained to his German printer in 1914, "My whole life in this country has really been devoted to fighting the terrible poison which has been undermining the American nation. As an American, I resented the hypocrisy, the short sightedness, the lack of construction, the actual stupidity in control everywhere."[117]

During the depression, advocacy of an indigenous American art presupposed an extremely conservative cast of mind, both stylistically and politically. Following the emergence of the American regionalists' view, as Thomas Hart Benton so forcefully expressed it in both painting and criticism, that American artists ought to paint unmistakably native images for a broadly-based but also naive public, cultural nationalism ceased to support either experimental art or radical social ideas. Twenty years previously, however, cultural nationalism had galvanized the avant-garde, a fact Benton himself was not unaware of. During his youth he had been a modernist and a frequent visitor to 291. In 1934, however, when Steiglitz's friends issued a testimonial to honor the seventy-year-old Stieglitz, Benton felt compelled to ridicule both the man and the book. He wanted to dissociate the metaphysically inclined Stieglitz from the American heritage which he now wanted to define in exclusively conservative terms. "I am certain that no place in the world ever produced more idiotic gable [sic] than '291'," Benton wrote in a review he sardonically called "America and/or Alfred Stieglitz," not mentioning the fact, as Stieglitz reminded him after the essay's publication, that he had once begged Stieglitz to give him a show there.[118]

In contrast to Benton, Stieglitz's admirers—Waldo Frank, Lewis Mumford, Dorothy Norman, Paul Rosenfeld, and Harold Rugg, the editors of America and Alfred Stieglitz—emphatically believed that Stieglitz's interpretation of cultural nationalism had had an important place in American intellectual life, one worth

remembering in the new, antimodernist era of the thirties. They sought to call attention to Stieglitz's quarter century struggle to give *American* artists a place and a chance to express themselves, to transplant an *American* variant of modernism in the United States with all that that implied, and, finally, to make New York City an international art capital not only by supporting modern art but also by protraying the city's emerging vitality.

Around 1913 Stieglitz discovered that he could satisfy more easily his personal desire to be a leader by sheltering and showing a few outstanding modern American painters than by promoting European artists exclusively. The Armory Show that year demonstrated that 291 was more akin to modernism's outpost in the hinterlands than its nucleus, and Stieglitz did not enjoy being on the periphery of anything. After the International Exhibition, which Stieglitz often referred to as a "circus," he gave only three more one-man shows to major European painters, Francis Picabia, who came to New York and joined 291, Constantin Brancusi, and Gino Severini. American artists, he felt, would appreciate his efforts more that their European counterparts, who obviously needed him less. Following a trip to Europe in 1911, Stieglitz never again traveled outside of the United States, finally determining his own identity by proclaiming himself, as his friend Paul Strand put it, "an American in America."[119] The label pointed to a perennial outsider's great need to be accepted.

Although Stieglitz never told an artist how or what to paint, his preference for lyrical and abstract expression was clear. The American painters closest to 291—John Marin, Arthur Dove, Marsden Hartley, and Georgia O'Keeffe—were all actively engaged in experimenting with new, modern forms. Unlike the ashcan school, whose paintings were also unacceptable to the academy, their work was neither sentimental nor rooted in realistic portrayal of subject matter. Stieglitz said that he was not "interested" in the Eight, who already had a patron in Robert Henri, "except in an indirect way."[120] Although his photographs bore some superficial resemblance to the urban scenes the ashcan

school painted, Stieglitz as well as the American painters considered themselves far more revolutionary than the Eight. Marin, Dove, Hartley, and O'Keeffe were, moreover, like the *Camera Work* critics, fervent cultural radicals who wanted to transform American culture by teaching new modes of perception. Both figuratively and literally, they were engaged in a revolt against the world of their fathers, a fact that gave their relationships with the elderly Stieglitz, "the old man," as he was referred to, an interesting and complicated twist. When 291 became a haven for American artists, Stieglitz finally succeeded in establishing the "family" he had desired for so long. Its members, with the ironic exception of the only woman in the group, Georgia O'-Keeffe, all emphasized the soft sides of their personalities.

The first Americans who showed their work at 291 were Alfred Maurer and John Marin. Members of the New Society of American Artists in Paris, a secessionist organization Eduard Steichen established for experimental painters from the United States, Maurer and Marin mounted a joint exhibit in the spring of 1909. Of the two, Maurer was the more innovative. Under Matisse's influence, he had begun experimenting with color and form, and, unlike Marin, who received generally favorable notices, was therefore ridiculed in the press. "Another 'wild man,' " J. E. Chamberlain called him. The public, according to Stieglitz, generally assumed that Maurer had "gone red."[121]

It was, however, with Marin that Stieglitz formed a close, life-long relationship. The two men met in Paris during the summer of 1909. Steichen took Stieglitz to visit Marin's studio where he discovered that Marin, fearing his more experimental work would prove unacceptable, had not sent his most interesting etchings to New York the previous spring. Stieglitz, in response, assumed his favorite role as patron and encouraged the younger man to express himself regardless of the consequences. Then thirty-nine years old, Marin was torn between following his own artistic impulses and producing conventional drawings of Parisian tourist attractions in order to earn a living.

Marin's background helps explain the significant role Stieglitz played in his life. Marin's mother died when he was nine days old, and his father, an accountant, left his son to be brought up by his maternal grandparents. His family, especially his father, were never enthusiastic about Marin's choice of careers. To them, becoming an artist represented a rejection of middle-class values, virtues accountants usually depend on, notably the denial of self-expression and the general acceptance of conventional society's pecuniary nature. Consequently, they helped him only reluctantly and only after he demonstrated, by failing as an architect, that he could do nothing else but paint. Stieglitz recognized a kindred soul in Marin and decided, therefore, to guarantee him a minimal income so that he could paint the way he wanted. By featuring and, in Marin's case, selling his work, by securing loans from interested benefactors, and by reaching into his own pocket when necessary, Stieglitz gave Marin the financial independence and emotional support he needed to develop.[122]

Although both Marin and Stieglitz de-emphasized the European roots of Marin's art in order to suggest that it was an authentic expression of American culture, the lessons the artist learned in France aided him enormously when he returned to the United States in 1911. Without utilizing the principles of abstraction, Marin would have been unable to convey the emotions the environment stimulated, as he wanted, instead of what it looked like, something he preferred leaving to photographers. Accordingly, his statement for the one-man show he presented at 291 in 1913 combined modernist aesthetics with a nationalist, environmental ethic. In language reminiscent of Whitman, whom Marin also much admired, he explained the "point of view" that imbued his Manhattan watercolors. "You cannot create a work of art," he wrote, "unless the things you behold respond to something within you. Therefore if these buildings move me they too must have life. . . . It is this 'moving of me' that I try to express."[123] The scenes Marin painted—Fifth Avenue, the Brooklyn Bridge, the new Woolworth Building, or a seascape in Maine,

174

all representations of an early twentieth-century romantic vision of America—possessed personal as well as social significance for him.

Marin's deliberate search for country and self assumed a transcendental quality that, in turn, had not only religious but also social connotations. Just as his watercolors challenged traditional conceptions of painting, so Marin sought in his personal life to attain greater freedom. In keeping with 291's general philosophy of opposing authoritarian order and rational stability, he wrote metaphorically, "May the man who invented barbed wire fences be eternally damned. That's my main occupation, that of going through barbed wire fences."[124] Although, like Stieglitz, Marin had no idea how he could translate his utopian dreams into a realistic political program, he knew that he wanted to replace American culture's rigid and didactic definitions of right and wrong with antirational, nonmaterialistic, and procommunal interpretations of art and life. Because, in his mind, art and life were synonymous, he naively believed, at least in 1913, that his paint brush could be an effective weapon in the war against social convention.

Clearly, 291, which Marin (employing both suggestive free verse and matching irregular margins) thought of as

> a place
> where reason halts
> in season and out of season

provided the catalyst for his development as a modern American artist. Arthur Dove, too, believed that Stieglitz's "super-encouragement" enabled him to become the painter he did.[125] Like Marin, he saw Stieglitz as a father figure who supported the artistic experiments his own father abhorred. And, like Marin, too, he mined the veins of modernism in order to express his even more abstract appreciation of the American landscape.

Born in 1880, Dove discovered an innate talent for drawing

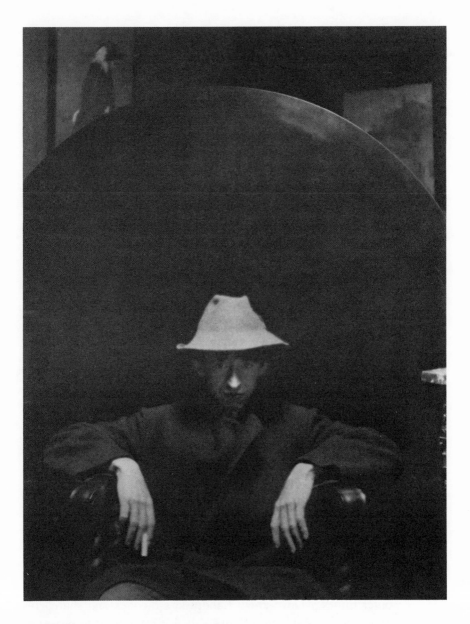

Alfred Stieglitz, *John Marin*, 1911. *(National Gallery of Art,
Washington; Alfred Stieglitz Collection)*

at an early age. His father, a prosperous contractor in upstate New York, did not encourage Dove to pursue it, however, hoping instead that he would become a lawyer. Law bored Dove, and so, against his father's wishes, he embarked upon a career in commercial design. Although financially successful as an illustrator, Dove's compelling desire to express himself as an artist drove him to France in 1908. Upon his return to the United States the following year, he looked up Stieglitz, who was impressed enough with Dove's work to include it in the "Younger American Painters" show of 1910. Following Stieglitz's advice, Dove decided to devote himself completely to his art. Philosophically and temperamentally unable to draw commercially anymore, he moved to Westport, Connecticut, where he supported his wife and son by farming and fishing, tasks that grated less on his artistic sensibility. During the next two years, between 1910 and 1912, while working full time on the farm, he painted a series of the most abstract drawings yet produced in America. These pastels, called the *Ten Commandments* to emphasize the religious impulse that inspired them, formed the nucleus of his "First Exhibit Anywhere," a one-man show at 291 in 1912. Dove's father's reaction paralleled Marin's. According to Stieglitz, he claimed no one would ever buy his son's work.[126]

Modernism represented something much larger than a new style of painting for Dove. Along with the European abstract painters Kandinsky, Mondrian, and Malevich, he felt that abstract images could convey more powerfully the deeper meanings many modern artists looked for in nature. Kandinsky was especially close to the 291 circle. *Camera Work* even published extracts from the Russian artist's seminal book *Concerning the Spiritual in Art* in 1912, the same year Kandinsky issued his revolutionary tract. Modern painters, he wrote, "are the seekers of the inner spirit in outer things." Dove knew Kandinsky's theories and shared his desire to use abstraction (Dove called it extraction) to penetrate reality, as if the world were an orange, its juicy essence hidden inside. Like Marin, Dove translated his religious feelings into a

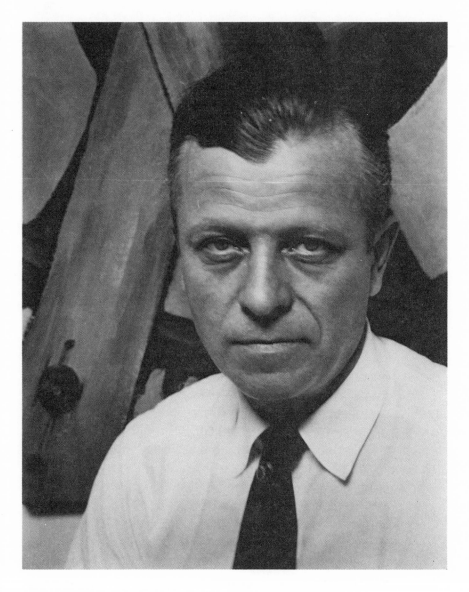

Alfred Stieglitz, *Arthur Dove*, 1914 or 1916. *(National Gallery of Art, Washington; Alfred Stieglitz Collection)*

178 celebration of the American landscape, though the connection is less obvious because his forms are more abstract. Still, Paul Rosenfeld, Bourne's old friend and, after the war, a cultural critic who attached himself to 291's legacy, could write, "Dove begins a sort of *Leaves of Grass* through pigment."[127]

Dove's work did not sell, however, and, after 291's demise in 1917, he returned to commercial illustration in order to make a living. Only after the death of his father in 1921 was he able to take up painting again, executing later in the decade a series of innovative natural collages. Believing that Dove's father had undermined the artist's confidence, Stieglitz called his death a "fortunate thing."[128]

Like Marin and Dove, Marsden Hartley also discovered "an utterly new world" at 291. "It let a few personalities develop in the way they were believed in," he wrote nostalgically in 1934, recalling the time between 1909, when he gave his first one-man show at 291, and 1917, eight years that marked his most dramatic period of creativity.[129] With both Marin and Dove, Hartley freely acknowledged Stieglitz's role as a financial benefactor and intellectual instigator in enabling him to join the ranks of America's first modernists. Hartley's life and art, in fact, repeated the dominant theme that characterized the other American artists who congregated at 291: a lonely childhood, a search for "the mystical necessity" through abstract art, and finally, as the decade progressed, a quest for an identity as a distinctly American painter.

Hartley, the youngest of nine children, only five of whom survived childhood, was born in 1877 in Lewiston, Maine. When he was only eight, his mother died, an event that marked the beginning of a lonely life of rootlessness and frustration. "From the moment of my mother's death," he wrote in his unpublished biography, "I became in psychology an orphan."[130] Like the severe loneliness of so many other cultural radicals of the era, Hartley's led to a search for a community that could help him alleviate the pain of the alienation he experienced as a homosexual. After rejecting the priesthood as a possible solution to his problems, the mystically inclined Hartley turned to painting.

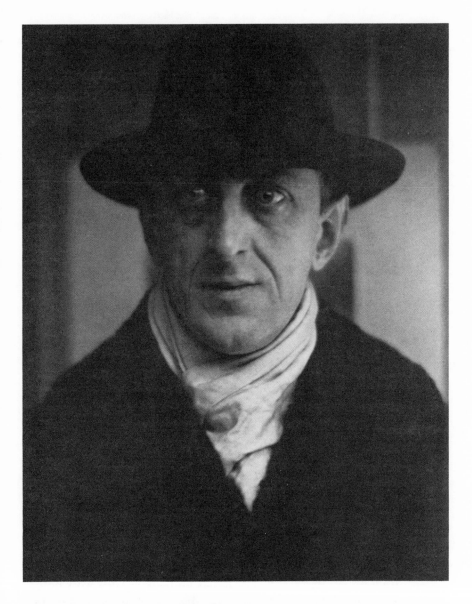

Alfred Stieglitz, *Marsden Hartley*, 1915–16. *(National Gallery of Art, Washington; Alfred Stieglitz Collection)*

By 1909 Hartley's portfolio included enough impressive paint-ings that Stieglitz agreed to give him a show at 291 even though the season had already ended. No doubt Stieglitz was moved by Hartley's urgent desire to communicate his feelings as well as by his commitment to art. Perhaps, too, the fact that members of the ashcan school had previously criticized Hartley's mystical landscapes influenced Stieglitz's impulsive decision to exhibit them. Following the show, Hartley became an active member of 291 while he continued to search for a way to paint spirit. "I feel as if I were standing continually at a sort of Maeterlinckian threshold waiting my life out for the door to open," he wrote Stieglitz in 1911.[131]

The following year Stieglitz made financial arrangements, again by securing loans based on the artist's future production of work, which enabled Hartley to go to Europe. Like other American painters in Paris, he gravitated towards twenty-seven rue de Fleu-rus, Gertrude Stein's domicile. "I have somewhat the same feeling toward the number 27 that I have toward 291," Hartley told Stein. "They both have a magic of their own." As his cabalistic comment indicated, Hartley did not give up his spiritual search when he arrived in France. Under the influence of the Parisian avant-garde, he moved a step further toward relating abstract feelings through abstract representation. Hartley's earlier New England landscapes had exaggerated nature's forms in an effort to convey the artist's perception of the environment's sublime intensity. Once in Paris, he eschewed the physical world altogether as he began experimenting with what he called "cosmic cubism," a style of painting he derived from Bergson's philosophy that the artist should allow his intuition to guide his insights toward the truth, and from Kandinsky's new manual, *Concerning the Spir-itual in Art*. In 1914, when Hartley brought his latest work home for an exhibition at 291, he wrote that his art summoned up his "sense of devotion."[132]

Hartley felt more comfortable in Germany, whose artists were more receptive to his mystical bent if not his sexual preference,

than in France, and, in 1913, moved from Paris to Berlin. Still, he continued to face the plaguing question of his real identity. Realizing that by living in Europe he risked becoming a derivative artist cut off from his national roots, Hartley exclaimed, "I could never be French. I could never become German—I shall always remain The American—the essence which is in me is American mysticism."[133] While living in Germany, just before the outbreak of the war, Hartley executed a group of abstract paintings based upon Indian motifs and symbols, a series he labeled *Amerika*. Like the other American artists at 291, he identified strongly with Whitman's plea for a native American culture. In Hartley's mind, as in Stieglitz's, to create art was to create a new nation.

Not all of the artists who frequented 291 established constructive relationships with Stieglitz. One who did not was Max Weber, a leading experimental painter born in Russia in 1881. Weber studied art in France from 1905 through 1908, where with the avant-garde he learned to appreciate spontaneity, the primitive, and the importance of expressing the unconscious in his work. Upon returning to the United States, he went to 291 and asked for an exhibit. After an initial rebuff, Stieglitz included him in the "Younger American Painters" show and promised the artist a one-man exhibit later on. For two years Weber became an active member of 291, contributing articles to *Camera Work*, hanging an important photographic retrospective for the Photo-Secession in 1910, and even sleeping at the gallery when he could not afford to live elsewhere. But, unlike other artists around Stieglitz, Weber, a highly strung, easily slighted individual, intensely resented the older man's patronage. He frequently quarreled with Stieglitz while minimizing the significance of other artists' work. In the process he made himself very unpopular. After an angry dispute regarding how much he could legitimately ask for the paintings he featured in his one-man show of 1911, Weber left 291, vowing he would not return.

Although Weber's association with 291 lasted only two years, he nevertheless made important contributions to the Stieglitz cir-

cle and later to the making of the American avant-garde. A significant painter, he was an integral member of 291 during the crucial years when the Photo-Secession made its transition from photography to abstract art. In his unpublished memoirs, Weber maintained that "Stieglitz knew nothing about modern art" before he had "brought him the first information that was authentic." While Weber's comment reflects the rift that separated the two men as well as his rather grandiose view of himself, it is true that he did advance Stieglitz's understanding of the Parisian avant-garde. Weber's *Essays on Art*, lectures delivered in 1914 and published two years later, explored the same modernist values for which the Stieglitz group also fought. With his former cohorts, Weber interpreted culture as an area of contention between radicals and those "practical" people, unnamed progressives mainly, "whose minds are filled with contracts, measures, weights, prices, profits, [and] war maps."[134] For Weber, as for Stieglitz and Bourne, the future of American society, perhaps even the issue of war and peace, hung in the balance of a debate over man's nature and art's function.

Georgia O'Keeffe, the last artist to join 291's orbit, became the closest to Stieglitz. In the thirty years between 1916, when they first met, and 1946, the year Stieglitz died, the two formed the most creative association in the history of American art, each stimulating the other to do his or her best work. Unfortunately, because their massive correspondence is closed, only the outlines of their relationship are perceptible. Like "the men," as she referred to Marin, Dove, and Hartley, O'Keeffe received her first solo show at 291, after having her work included in two previous group exhibits at the gallery. As a struggling young artist, first in Virginia and South Carolina and then in Texas, she found that 291 gave her a focus and a reference, and responded by expressing many of its modernist ideas in her art and life. In 1918 Stieglitz asked O'Keeffe to come to New York, and sent Paul Strand to Texas to fetch her. Within a short time O'Keeffe and Stieglitz were living together, Stieglitz leaving his wife the year O'Keeffe arrived in New York. In 1924 they married.

The second of seven children, O'Keeffe was born in Sun Prairie, Wisconsin, in 1887. She grew up on her family's large dairy farm where she developed a fierce sense of independence and self-awareness, attributes she shared with her future husband. As a young girl she did not suffer the personal frustrations nineteenth-century society usually visited upon females, and at a very early age decided to be an artist. Although her parents supported her wish, they must have expected their eldest daughter to have become an art teacher, an acceptable profession for young women, and certainly not a painter. Before her, the lone American woman who had established herself as an artist was Mary Cassatt. Cassatt, of course, unlike O'Keeffe, had to go to France to achieve success.

After attending a boarding school in Virginia, where her family moved in 1902 for health reasons, O'Keeffe studied art first at the Art Institute in Chicago and then at the Art Students League in New York. Later she claimed that she learned nothing from the latter institution's conservative, if renowned, faculty and decided therefore to quit painting because she had nothing to contribute. Although her decision rested on a rationalization of her disappointment that her family could no longer afford to pay for her education, it also reflected accurately her need to express herself, something professors like Kenyon Cox did not see the necessity for. By 1912, however, she was again studying art, this time at the University of Virginia. Her teacher, Alon Bement, introduced her to new conceptions of painting which he, in turn, had learned from his colleague at Columbia Teachers College, Arthur Wesley Dow. Impressed by the talented O'Keeffe, Bement made arrangements for her to teach summer school in Texas and, in 1914, to study under Dow himself. Dow, who was influenced by the Orientalist Ernst Fenollosa, taught that it was more important to fill space beautifully than to imitate nature. His innovative principles of design, which were based on Japanese aesthetics, opened a new world for O'Keeffe, who later said she did not need to travel to France in order to learn how to express her feelings or to become an American painter.

Although Dow supported "modernism in art," his main interest

184 was composition, not cultural revolution. In contrast to her teacher, O'Keeffe felt that she required other sources of stimulation in addition to the new technical experiments in art. Living in New York in 1914, she soon found them in the city's cultural avant-garde. Following the example of her close friend Anita Pollitzer, O'Keeffe became a radical feminist, joining the militant National Women's Party, which advocated not only suffrage but also complete social and economic equality. She subscribed to the *Masses*, and her boyfriend, Arthur Macmahon, a graduate student at Columbia and a former roommate of Randolph Bourne's, gave her a copy of *Youth and Life*. Its call for uninhibited self-expression delighted her. More importantly, she was a frequent visitor to 291 and an avid reader of its publications. The following year, teaching in Columbia, South Carolina, she depended on it for her intellectual lifeline. "Then *291* came and I was so crazy about it that I sent for Number 2 and 3," she exclaimed in a letter. "I think they are great—They just take my breath away—it is almost as good as going to 291."[135]

Living in South Carolina, cut off from friends, relatives, and social distractions, O'Keeffe allowed the modernist ideas that she had been exploring to express themselves in her work. In her autobiography she described how she realized what cultural freedom meant when she created her first abstract charcoals. "I said to myself," she wrote, "'I have things in my head that are not like what anyone had taught me—shapes and ideas so near to me—so natural to my way of being and thinking that it hasn't occurred to me to put them down.' I decided to start anew—to strip away what I had been taught—to accept as true my own thinking. . . . I was alone and singularly free, working into my own, unknown—no one to satisfy but myself."[136]

While O'Keeffe was the first American artist to develop an intensely subjective, abstract style of painting without going first to Europe, thus supporting her claim of being a pioneer of native modern American art, she nevertheless did have models. During the time that she was working on her new charcoals, she wrote

Alfred Stieglitz, *Georgia O'Keeffe*, 4 June 1917. *(National Gallery of Art, Washington; Alfred Stieglitz Collection)*

186 to Anita Pollitzer, "I believe I would rather have Stieglitz like something—anything I had done—than anyone else I know of— I have always thought that—If I ever make anything that satisfies me even ever so little—I am going to show it to him to find out if it's any good." Then, as if realizing that she was surrendering her powerful will to another person, something she never did, she continued, "I don't see why we ever think of what others think of what we do—no matter who they are—isn't it enough just to express yourself." She added for good measure, "Let them all be damned—I'll do as I please."[137]

Within days, O'Keeffe sent her new drawings to Pollitzer without explicit instructions. "They are at your mercy," she wrote, "do as you please with them." Reading her friend's mind perfectly, Pollitzer did not take long to show O'Keeffe's work to Stieglitz. She recounted his reaction in a letter to O'Keeffe. "They're the purest, finest, sincerest things that have entered 291 in a long while," he said, suggesting that he would like to show them some day.

Looking at O'Keeffe's long curved lines and oval shapes, forms the artist extracted both from nature and from within herself, Stieglitz claimed that he would have known that a woman had done them had he not been so told. "She's got the sensitive emotion," he commented.[138]

Stieglitz believed that women experienced the world differently from men. If they were unafraid to convey what they felt, he thought, their art, according to him, could create new dimensions of expression that might in turn liberate a male-dominated society. Committed completely to the idea of self-liberation, Stieglitz applied the logic of his argument to women as well as men. His attitudes toward feminism were very similar to Bourne's. Both wanted women to help emancipate American culture, not by being more like men, but by being more completely feminine.

At first, O'Keeffe did not reject the idea that her paintings, in the words of Marsden Hartley, were "full of utterly embedded femininity." Referring to them in 1916, she wrote, "It is essentially

a woman's feeling" that she wanted to convey. Later, she tired of such theories about her art, particularly the hackneyed Freudian interpretations of the series of large flowers she did in the twenties and thirties. In keeping with her anti-intellectual attitude toward her work, an attitude incidentally that she shared with Stieglitz, O'Keeffe felt that analysis in general and Freudian analysis in particular prevented immediate appreciation of her paintings. Still, the idea that she was reaching into herself as a woman— and as an American—was what originally attracted Stieglitz to her. When he introduced O'Keeffe's drawings in 1916, *Camera Work* noted that they "were of intense interest from a psycho-analytical point of view. '291' had never before seen woman express herself so frankly on paper."[139]

Having met Stieglitz after the Forum Exhibition of Modern American Painters, O'Keeffe did not participate in the show though its governing principles also inspired her. Held at the Anderson Galleries in March 1916, the Forum Exhibition represented cultural nationalism's apotheosis, at least its modernist version. It sought to offer an antidote to the prevailing public impression which followed the Armory Show that modernism was an exclusively European phenomemon. By selecting the latest and best paintings of America's leading avant-garde artists, seventeen painters including all of Stieglitz's protégés as well as such future outstanding figures as Thomas Hart Benton, Man Ray, and Charles Sheeler, the exhibition's organizers aspired to promote native modern American art on a grand scale. O'Keeffe's future work notwithstanding, the show manifested the zenith of Stieglitz's imagined ideal of a community of American artists regenerating culture in the United States. He wrote suggestively in one of the six forewords to the exhibition's catalog, "No public can help the artist unless it has become conscious that it is only through the artist that it is helped to develop itself."[140] After 1917 no one, not even the wishful Stieglitz, would ever again so optimistically propose such a lofty, perhaps conceited, role for the artist in society.

10 In 1915 Stieglitz's "laboratory" was still working in full force. After the outbreak of war in Europe, *Camera Work*, published in Germany, began to appear irregularly. The gallery then issued a new periodical it named after itself. An experimental sheet, *291* incorporated the latest expressions of the American and European avant-gardes. By helping put out the new journal, Stieglitz suggested that the Photo-Secession's original commitment to pluralism had not lost its capacity to tap the creative potential of modernism. Stieglitz's position had been that 291 was not devoted to modern art but to the ideas that made it possible. Following that logic, he claimed that he supported any form of expression that stimulated a new way of seeing or experiencing the world. The new publication, its brief successor, the *Blind Man*, as well as Stieglitz's continued devotion to photography corroborate his insistence that 291 remained a source of innovative cultural experimentation until its demise in 1917.

Nevertheless, apart from Steichen, most of the original Photo-Secessionists did not share Stieglitz's appreciation of nonphotographic art. As sketches by postimpressionists replaced their prints both in *Camera Work* and on 291's walls, they deserted the gallery and canceled their subscriptions. Stieglitz, who considered Camera Work "all too personal—like a work of art," was not about to let others deter him from pursuing his larger purpose, however. As the prophet of the avant-garde, he saw his main responsibility to himself, or rather to his vision of the importance of art in society, and certainly not to what he viewed as a band of uneducated, narrow minded, and commercially inclined pictorial photographers, some of whom established a counterorganization to represent their interests. "I am exceedingly sorry if subscribers are not satisfied with what I am doing," he wrote to one unhappy patron. "But the only person who interests me to satisfy, is myself." Time and again, he pointed out to readers who misunderstood his intention, *"Camera Work* is more than a picture book of beautiful photographs: it is a vital force."[141]

Stieglitz never lost his interest in photography despite the Photo-

Secessionists' accusations that he had abandoned their cause. Occasionally he tried to explain why *Camera Work* featured few photographs after introducing Rodin and Matisse and why, with the exception of Adolph de Meyer's show in 1912, 291 gave only two photographic exhibits after 1910, one to himself in 1913 and another to Paul Strand in 1916. Following his discovery of modernism's ability to induce new levels of consciousness and to create new forms of expression, Stieglitz began to see most photographers as mere "picture takers," men and women who were largely unaware of art's deeper meanings and its potential social significance. For photography to maintain its position as a viable art form, he argued, it had to compare favorably with the best work done in painting and sculpture. As his mouthpiece Paul Haviland wrote in 1910, "Those photographers who hope and desire to improve their own work can derive more benefit from following the modern evolution of other media than by watching eternally their own bellies like the fakirs of India."[142]

While Stieglitz still insisted that photographers should emphasize the intrinsic qualities of their medium—that is, that they not try to make prints which looked like paintings—he nonetheless believed that photography should embody the goals of modern art. Photography's relation to modernism, however, was not easy to comprehend, particularly in 1912. When his friend the German photographer Heinrich Kühn complained that he could not see any possible connection between postimpressionism and photography, Stieglitz retorted, "You don't understand what Picasso & Co. have to do with photography!"

> With *Camera Work* I will strive that once and for all one may get some idea of what has been accomplished artistically in photography; secondly, whatever struggle it costs, to compel the world to respect art-photography (I hate that word); and, thirdly, what photography essentially means ethically — whether employed through the camera (photography in the purest sense) or through

> *a painter with his brush (photography in an intellectual*
> *sense just as much as though a camera were used). Now*
> *I find that contemporary art consists of the abstract*
> *(without subject) like Picasso etc. and the photographic.*

In other words, Stieglitz argued that since photography had freed painting from literal or metaphorical representation, in order to keep pace, photography, in turn, had to reflect the creativity which the camera had unleashed in the graphic arts. "Just as we stand before the door of a new social era," he concluded on the revolutionary note he was fond of stressing, "so we stand in art too before a new medium of expression—the true medium (Abstraction)."[143]

To underline the link between "art-photography" and modern painting, Stieglitz offered his first and only solo exhibit at 291 while the Armory Show was in progress. Proclaiming the International Exhibition of Modern Painting the culmination of 291's previous efforts, he pointed out that his "own photographs were shown while the Big International Show was being held. It was the only logical thing for me to do. It was really remarkable how well they stood the test."[144]

The only other photographer whose work Stieglitz felt bore comparison to modern painting was Paul Strand. Strand shared Stieglitz's aesthetic values and outlook on life, and his early photographs incorporated the new trends in art that 291 had been presenting. Late in life Strand recalled how he had purposely borrowed the new sensibility the modernists had been experimenting with in order to develop the most strikingly original photographs that had yet been printed. "I was learning from these people what photography was," he noted; "all the abstract things I did were consciously directed at finding out what these fellows were talking about, and seeing what relationship it had to photography." From cubism, he explained, he learned techniques of composition based not on subject matter but on the inherent ability of form by itself to convey emotion. In addition, following

a painter like John Marin, he sought to portray the dynamic energy he associated with the city, to capture, as it were, "the movement in New York" on still pictures.[145] And finally, influenced by the cultural nationalism at 291, he attempted to express the nobility of the city's commonfolk by taking completely candid shots of New York's poor.

In 1915 Strand took his latest photographs to 291 for Stieglitz to criticize, as he had been doing for years. Stieglitz was immediately impressed and recognized them for what they were: breakthroughs in modern photography. He told Strand that he had "done something new" and that he wanted both to present the prints at 291 and to reproduce them in *Camera Work*. Just as he had exhibited his own work during the Armory Show in order to demonstrate that photography and painting could contribute complementary components to a modernist conception of the world, so he displayed Strand's photographs while the Forum Exhibition was in progress. In addition, Strand's new prints gave Stieglitz cause to publish the first issue of *Camera Work* since 1914. "I feel now, in view of Strand's work and in view of 291's record," he wrote to a friend in England, "the necessity of getting out another Number." *Camera Work's* final two issues did in fact feature Strand's hard-edged, modernist photographs, pictures like *Abstraction, Bowls* (1915), *Fifth Avenue* (1915), and *Blind Woman* (1916). In contrast to most of the softly focused, impressionist prints *Camera Work* had previously published, Strand's incorporated the future hallmarks of modern photography. His work was, as the journal pointed out, "pure," "direct," and of "real significance."[146]

Supporting Strand's ability to translate modernist values into photography was his understanding of and sympathy with the avant-garde's cause. Like his mentor, Stieglitz, and with his friend, Randolph Bourne, Strand also wanted to open up society so that individuals could be free. Moreover, he was confident that his camera was the perfect instrument for contributing to that objective. Writing for the *Seven Arts* in 1917, he explained that in

his mind photography was "a new road from a different direction, but moving toward the common goal, which is Life." According to his reasoning, since "Life" involved community and community meant country, photographs could enrich the nation, if not the world, by expressing America "in terms of America."[147] He assumed, in other words, that Stieglitz's photographs of New York, or his own he might have added, made life fuller and more intense.

Stieglitz not only desired to carve out new forms, he also wanted to create multiple and varied opportunities to express them. When, therefore, members of the 291 circle proposed publishing a new journal to supplement *Camera Work*, Stieglitz agreed to lend his gallery's name and help guarantee the sheet's cost. In March 1915 de Zayas, Haviland, Agnes Ernst Meyer, who later, with her husband, Eugene Meyer, bought the *Washington Post*, and Katherine Rhoades, an avant-garde painter with feminist interests, began putting out *291*. A portfolio issued monthly for one year, it was printed on large, high quality paper, usually included not more than four pages, and cost a dime. One hundred people subscribed. "The whole thing," Stieglitz remarked, "is nothing more than an experiment." He expected it to be "fun."[148]

Like any avant-garde publication, *291* adopted an antagonistic posture toward established society, its values, and its pretenses. Indeed, iconoclastic satire provided the journal's original raison d'être. Among its favorite targets, not suprisingly, given his ardent campaign at the time to promote engineering as the solution to all social problems, was "the American Business Man." Recalling a similar use of irony by Randolph Bourne, *291* asked:

> If we wish to find the greatest imaginative powers of
> our country, do we think of our artists? The question
> is almost ludicrous when we compare the realized
> imaginations of the artistic and the business world.
> Where is our most effective, our most adventurous

thought? Who creates and guides and supports our universities, our charitable and artistic and scientific endeavors of every sort? In short who is the only man without whom we could not get along, politicians, social workers and college presidents notwithstanding? Finally, if wrong has been done, who has been and will continue to be the only man with sufficient knowledge to remedy those wrongs? The answer to all these questions is too obvious. Our social structure may be a machine that is clumsy, inefficient, antiquated, but verily it hath its god.[149]

But *291* was not the *Masses*. Where that organ offered socialism as an answer to a business-dominated civilization and published realistic cartoons to sell the magazine's ideas, *291* suggested that the road to liberation ran through the contours of the mind. While its humor may have been satiric, its point of view was extremely sophisticated. In keeping with *291*'s avant-garde roots, the new sheet sought to delve into the mysteries of consciousness along modernist lines. Its first cover, which featured a semiabstract, geometrically designed caricature of Stieglitz, contained the caption "291 throws back its forelock." The intended message was implicit, namely, that *291* was going to explore uncharted psychological territory, and, to do so, would draw on the new advances in the modern arts and in psychology.

The editors of *291*, following the example of Apollinaire's *Soirées de Paris*, decided to combine poetry and abstract design. They believed that the two art forms together could invoke new states of consciousness as Apollinaire had previously done, though *Soirées de Paris* was less spectacular and, in the end, less successful than *291* in joining modernist ideas about art, literature, and society. But the French poet and critic had shown the way. "He is doing in poetry what Picasso is doing in painting," de Zayas wrote in 1914. "He uses actual forms made up with letters." Less

than a year later, *291* featured one of Apollinaire's "ideogrammes" in its first issue, just above three transcribed dreams which explore Stieglitz's unconscious fears of the femme fatale. In their layout the editors suggested that a common purpose—to force words to yield the nonrational truths that pervaded the modernist universe—provided the framework for both experiments. For the same reason, *291* published de Zayas's "psychotypes." These, as Agnes Meyer, who collaborated on some of the stream-of-consciousness portraits recalled, were "supposed to weld together the plastic and literary arts in a depiction of various levels of a total state of mind."[150]

Also included were Picabia's machinist drawings, sketches he composed of various members of the 291 circle based on machine-derived motifs. Thus, he presented Stieglitz as a broken camera, Haviland as a powerless lantern, and himself as a car horn. These pictures, *291*'s antirational outlook, and its experimental typography have given the sheet a reputation for having helped instigate dada. Whether or not Picabia's pictures are "anti-art," and therefore should be considered dada's predecessor, they were stimulated by the French artist's fascination with the United States' new mechanistic civilization. Picabia thought that machines perpetrated modernism's new forms, and, in an ironic reversal of their opinions, most people at 291 now agreed that the new mechanical environment was exciting. De Zayas, for example, wrote in an essay that accompanied Picabia's sketches, "All genuine American activities are entirely in accord with the spirit of modern art." For de Zayas, who also wanted to "discover America," Picabia had "burned his ship behind him," in order to portray accurately life in the United States.[151] The irony of a Mexican's underlining the ability of a Frenchman to uncover America's roots was not discussed or explored.

Although neither Stieglitz nor 291 was directly involved with its publication, dada and cultural nationalism also combined to create *291*'s brief successor, the *Blind Man*. The product of Marcel Duchamp's rich imagination, the *Blind Man* was a small

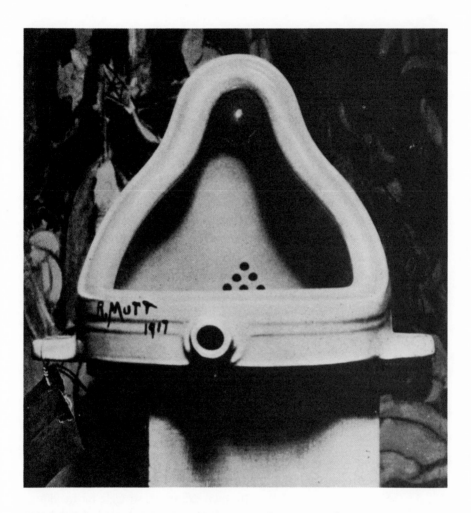

Alfred Stieglitz, Marcel Duchamp's *Fountain by R. Mutt* from
The Blind Man. *(Philadelphia Museum of Art, Louise and
Walter Arensberg Collection)*

magazine that appeared only twice, in 1917. Duchamp, who came to New York following his scandalous success at the Armory Show, felt, like his friend Picabia, that the United States represented the future. Desiring therefore to cultivate "an American art which shall truly represent our age," as a letter in the *Blind Man* put it, he decided to issue his magazine.[152]

The *Blind Man* looked forward to the upcoming exhibition of the Society of Independent Artists at which Duchamp, under the pseudonym R. Mutt, planned to show a urinal entitled *Fountain*. Though it had promised to exhibit any work submitted to it, the society's committee rejected the readymade, and "The Richard Mutt Case," as the *Blind Man's* second issue called it, soon became a cause célèbre of American art. Duchamp contended that because "Mutt" had "created a new thought for that object," he had contributed a work of value. In submitting his *Fountain*, Duchamp, who later claimed that "the concept of the Readymade" may have been "the most important single idea to come out of [his] work," pressed pluralism to its furthest limits.[153] With a single imaginative act he abolished any distinction between life and art, rejected completely criticism's legitimacy, and called attention to his own self-proclaimed right of determination. Duchamp was in effect saying that there were no standards, values, or customs outside of his own choosing to which he would adhere.

Stieglitz was one of the few people at the time who recognized the significance of Duchamp's statement. Seeing the connection of Duchamp's assertion to his own existential struggle for freedom, he had *Fountain* removed to 291 where in April 1917 he exhibited the readymade and photographed it for posterity. His pictures, as Carl Van Vechten wrote to Gertrude Stein in Paris, "make it look like anything from a Madonna to a Buddha."[154]

11

If Duchamp's *Fountain* represented the extreme limit of the avant-garde's reach, the urinal was appropriately among the last works shown at 291. Within a month of its unheralded exhibition, 291

closed its doors and *Camera Work* ceased publication for good, thus ending a chapter in the history of American art.

The immediate cause for their demise was the beginning of prohibition in August 1917. Financial support for Stieglitz's gallery and publications had depended in large part on his wife's steady income from her family's brewery in Brooklyn. When, following the United States' entry into the First World War, the government forbade the use of valuable foodstuffs to manufacture alcoholic beverages, Stieglitz was forced to terminate his experiments. "My family and I," he wrote to the publisher Mitchell Kennerley in May, "have been badly hit. So badly, that I am compelled to give up 291 and *Camera Work*."[155]

The letter was one of the few times Stieglitz acknowledged the importance of money in running 291 and in putting out his publications. It would be inaccurate, however, to suggest that prohibition alone dried up the support for America's artistic avantgarde. Had Stieglitz's financial position not deteriorated, it would have been inconceivable for him to have continued as he had before April 1917 after America joined the war. The faith, or now more clearly the fiction, on which 291 and *Camera Work* were based—that art could determine society's future—could no longer be sustained once the aims of war defined the nation's social purpose. In the face of a universal conflagration, modernism, which had been predicated upon both social confidence and the most extreme definitions of freedom, seemed like a spent force. Until midcentury, in America at least, it also looked like a false start. Most of the artists associated with 291 stopped experimenting with abstract expression. With some individual variations, Marin, Dove, Hartley, and O'Keeffe all rediscoverd the virtues of realistic representation. Even Stieglitz himself, though he had great difficulty comprehending what the war was really about, recognized that 1917 marked the end of his dream. Only months after Wilson's declaration of war, he lamented, "Of course the War as a background emphasizes all the weaknesses which I tried to overcome all these years—in which I failed."[156]

When the war had broken out in Europe two and a half years before, Stieglitz's views had been slightly different. In sharp contrast to Bourne, he assumed that the international conflict would have a beneficial influence on an overmaterialistic world. With most people in August 1914, he had no idea what war really was. The same romantic illusion that had enabled him to exalt the artist's role in society led Stieglitz to exclaim on September 1, "The war was inevitable and perhaps it will have the one redeeming feature to bring the human race a little closer together." Enamored by the collective unity and false idealism that war at first imposes on divided peoples, he welcomed the struggle that later resulted in the death of his cause. "Thank heaven," he wrote on September 28, before reports of the reality of trench warfare reached the United States, "there is at least something real and alive, even if it takes the form of death. To me the War, terrible as it may seem to others, is a most wonderful thing."[157]

It has been suggested that Stieglitz's German background prepared him to favor Germany's cause. The truth is more complicated. Stieglitz wrote that if his "sympathies are with any of the nations, they may be with Germany," leaving open the possibility that he rejected the conventional interpretation of the war as one between feuding countries. "I am pro nothing," he explained to *Camera Work*'s German printer. "I don't believe in governments as governments exist today . . . [though] I tell the people if they insist that I be for one nation or another, that I am for Germany." Instead, he imposed his own conception on the conflict even though it bore no relation to reality. Accordingly, the war became a "natural thing," whose "outcome can only be for good." Believing, as he had argued since his student days in Berlin, that everything, even war, encompassed a spiritual essence, Stieglitz saw in Germany's struggle a "vision combined with faith."[158] For him "vision" and "faith," even if derived from a world war, redeemed whatever personal suffering the conflict imposed.

Because it provides a final insight into Stieglitz's inability to

differentiate between the worlds of art and politics, his view of the war is significant. For an artist, vision and faith may open the doors of perception; for a country fired by nationalism, they usually lead to bloodshed and destruction. In time even Stieglitz came to see, albeit reluctantly, that his goals were not applicable outside the cultural realm though, when he did, his importance as a patron of the avant-garde was reduced to recalling the promise of a previous era.

As far as the United States was concerned, Stieglitz hoped the country would remain neutral. And yet he could not resist applying his apocalyptic yearnings to America as well. "What will the country come to?" he asked in 1916. "It is a wonderful country, but it needs an earthquake or two. Some terrible calamity to bring the people to a realization of what life really means." By February 1, 1917, however, the day Germany announced that it would resume unrestricted submarine warfare, Stieglitz began to take the ominous possibility of America's joining the war more seriously, writing as if he were an ignored prophet, "The United States has been living in a fool's paradise for a great many years. Pointing out that fact has really been my work for the past twenty-five years. But the voice was not understood."[159] As America mobilized, Stieglitz regretted the decision to go to war. In a repressive atmosphere of enforced patriotic unity, however, he kept his dissent to himself while quietly making plans to close 291.

In addition to leading to the termination of 291's finances, the war also divided the gallery's supporters. The outbreak of fighting between France and Germany persuaded Haviland to answer the call of his native colors. He wrote Stieglitz, "I have just decided to sail for France . . . to enlist in the french [sic] army." Haviland interpreted the war in terms his former mentor could understand if he saw the other side's point of view. "This war," Haviland wrote in 1915, "has brought out the best elements in the French people and they are really a nation to be admired without reserve." Whatever else it did for him, his return to France marked the end of Haviland's interest in modernism as well as his career in

photography and criticism. He spent the final twenty-five years of his life as a gentleman farmer in the French countryside. Steichen too was a Francophile, writing in his autobiography that "France had become another mother country" to him. Living in Voulangis when the war began, Steichen bid a hasty retreat to New York, only to return to France in 1917 as an officer in the United States Army. Following his homecoming, he quarreled bitterly with Stieglitz about the war and about 291's future plans. De Zayas, on the other hand, who was also in France in September 1914, recognized clearly from the start what the war would do to the world he had lived in. "I left France and especially Paris in a very bad condition," he wrote. "Since the war *started* it seemed that all intellectuality had been wiped out. I believe that this war will kill many modern artists and unquestionably modern art. It was time, otherwise modern art would have *killed* humanity."[160] De Zayas's final note still reflected the formidable potency he and Stieglitz assumed modernism possessed.

The idea that art could kill (even metaphorically) was becoming increasingly more difficult to believe in, however, as the war demonstrated conclusively how little power artists really had. Perhaps realizing that the end was near, Stieglitz issued an edition of *Camera Work* in January 1915 that, in retrospect, assumed the quality of a valedictory. He had asked a selected group of individuals to write brief comments on "What '291' means to me." Sixty-five people, the majority of whom were associated in some way with New York's Lyrical Left, responded. For the most part, their remarks summarized the views Stieglitz had been discussing for the past decade. Hutchins Hapgood, for example, wrote: " '291' to me is a 'Salon,' a laboratory, and a refuge." De Zayas listed a few key words: "Liberty, Freedom, Individualism, Self-Expression, To-live-one's-life-in-one's own way." Hodge Kiron, the Jamaican elevator operator for the building, said of 291: "It has taught me that our work is worthy in proportion as it is the honest expression of ourselves."[161]

Since Stieglitz believed that only a collective, pluralistic portrait

could possibly capture 291's elusive essence, he also invited and published alternative viewpoints. The critic Arthur Hoeber, who said that he felt Stieglitz had entered "the enemy's camp to request an opinion as to what was thought of the campaign just waged," still maintained that 291 represented "chaos." The more significant dissent, one that augured 291's demise, was offered by its cofounder, Eduard Steichen. Steichen objected first of all to the issue's underlying concept, calling the volume "impertinent, egotistic, and previous." He wrote that it seemed like an "obituary" and suggested, in fact, that it was symptomatic of 291's "marking time." For Steichen, the war represented a watershed, one he claimed 291 unfortunately did not transcend. "It failed," he wrote, recalling Walter Lippmann's similar argument about war and society, "to grasp the necessity of making of itself a vast force instead of a local one." Just what Steichen thought 291 could have done to join the great tidal wave of change that was coming over the world remained unspecified. He did believe in August 1914, however, that "an art movement such as futurism [should be] relegated to the scrap heap—History." Like de Zayas, he did not think that modernism and war were compatible. But Steichen favored the struggle against Germany, and the passion he had once invested in modern art found a new outlet in a nationalistic militarism after 1914. On August 27, he told Stieglitz that Germany's "crime is against Humanity. But she will pay—the dearest—and ultimately humanity will win out."[162]

Steichen accused Stieglitz of turning his back on reality, and, in a way, he was correct. Where Stieglitz fiercely resisted altering his thinking, Steichen changed drastically both his outlook and his way of life. He made personal decisions during the war that enabled him to adjust to new social conditions in a manner Stieglitz was incapable of. First, he enlisted in the army, volunteering to command the aerial reconnaissance unit in General Billy Mitchell's incipient airforce. By necessity, Steichen discarded his preference for impressionistic pictures, not to mention his assumption regarding photography's ability to discover new meta-

physical truths. He told Mitchell, who became a new hero for the formerly romantic Steichen, "that a soft-focus print [ought to] be considered a court-martial offense."[163] After the war, Steichen, unlike Stieglitz, having experienced real poverty in his youth, had no difficulty turning to commercial photography in order to make a very good living. He soon became the best in the field, though his postwar photographs do not match the vitality of the ones he took before 1914.

In recognition of the new direction of his life after the war, Steichen symbolically Americanized the spelling of his first name as if to call attention, at least unconsciously, to his personal metamorphosis. In addition, he burned all of his paintings in a massive bonfire, a destructive act that signified the end of his belief that the camera and the brush were simply different tools that enabled the artist to convey a universal vision. Indeed, both changes were prefigured in Steichen's final contribution to *Camera Work* in 1915. His essay on 291 revealed not only the break between himself and Stieglitz but also the fissure that had developed in the brave new world the two photographers had jointly set out to create in 1905.

By April 1917 Stieglitz understood that Steichen was right. Under the pressure of O'Keeffe's arrival in New York, his marriage was breaking up. He no longer had access to sufficient funds. The regulars of 291 were irrevocably divided. And, finally, in the face of war's urgency, art no longer seemed as central as it previously had. Only days after the United States joined the Great War, with an eye now on history rather than on the future, Stieglitz sought to ensure that 291's record was intact. He wrote to both the New York Public Library and the Library of Congress offering to complete their respective sets of *Camera Work*. He confidently told each institution that he *knew* "that in a very short time *Camera Work* will be priceless," though then he was desperately trying to get someone to buy at greatly reduced rates the numerous editions he had on hand. He proposed selling Wan-

amaker's one thousand copies for $425, threatening otherwise to burn them.[164]

Destroying *Camera Work* appealed to Stieglitz. He felt that he needed to proffer some sign of a symbolic suicide in April 1917 to indicate the end of the life he had led since 1905. He chose not *Camera Work* for the object of his wrath, but picked instead the magazine that bore his movement's name for annihilation. An innocuous letter in the Alfred Stieglitz Archive bears witness to *291*'s dadaesque end:

> *291 Fifth Ave., New York*
> *April 12, 1917*

> *American Waste Paper Co.*
> *70 Greene St., New York*

> *Gentlemen:*

> *Under separate cover we are sending you a copy of a paper called '291'. We have several hundred pounds of this paper which we wish to dispose of. What could you give us per pound for this paper?*
> *Awaiting your reply, very truly yours,*

> *[signed] Alfred Stieglitz*[165]

In keeping with primitive ritual, Stieglitz undoubtedly hoped that his destruction of *291* would lead to the rebirth of his vision. Following the war, he did open other galleries and, to be sure, he did do some of his most outstanding photography after 1917. Still, no magical rite, however bold, could restore the unfulfilled, and, in the final analysis, unfounded promise of modern art creating a new society.

4 EPILOGUE

It has been observed that a contemporary poet publishing a volume of verse is like a person dropping a feather into the Grand Canyon and then waiting for the echo. While such in fact may be the case today, at least in the United States, people like Randolph Bourne and Alfred Stieglitz, not to mention the conservative defenders of the cultural status quo, hardly thought so some seventy-five years ago. For them man's fate did seem to hang on the character of a poem or the properties of a painting. As James Oppenheim, reviewing Bourne's life in 1919, remarked sadly, their prewar generation had shared a distinctive, "new vision" of the world. At its center, he wrote, lay "the Russian mixture of art and revolution, the one a change in the spirit of man, the other a change in his organized life."[1] Though the spirit came first, for Oppenheim and the Lyrical Left, the two were indivisible.

In the thirties Marxist critics like Michael Gold and Joseph Freeman criticized the previous generation's radical artists and writers for being interested solely in art-for-art's sake. Their censure of the Greenwich Village cultural radicals reveals the fissure that opened in the intellectual world following World War I. The change is even recorded in the thinking of someone like Oppenheim who, in 1930, looking back on the remote era of "America's Coming-of-Age," wrote, "That we should have thought that the arts and the criticisms could rule business appears so ludicrous now as to be beyond laughter."[2] But the Marxists' critique was unfair, even if it was not unfounded; Bourne, Stieglitz, and Oppenheim, like the rebels of Greenwich Village generally, never

206 advocated art-for-art's sake. On the contrary, they considered art and life synonymous. Their chief aspiration was to link modernist culture and radical politics in order to free the individual and liberate the entire society. It would be more accurate to say that they believed romantically in art for life's sake.

The exigencies of the Great Depression killed any lingering hope that modernist expression could join political opposition to the social and economic status quo. The Marxists' view that cultural radicalism was essentially a bohemian manifestation of the worst excesses of individualism has had an enduring impact on American thought about culture. Although their own prescription for "social realism" is no longer a vital idea in even the Communist nations, the truth behind the Marxists' (and the progressives') view that the economy and politics, not art and criticism, determine the course of history shattered the cultural radicals' belief that an individual artist or writer, acting alone, can affect the world order by creating new paths in human consciousness. Only in Communist countries, paradoxically, do developments in the realm of culture seem threatening to the established political and economic systems.[3]

Bourne of course had been dead for over a decade by 1930, but Stieglitz's experience during the depression indicates how antiquated cultural radicalism seemed after the years of its genesis. Unable to adjust to the altered climate of opinion, Stieglitz discovered that the new era's insistence upon an unidealistic and objective mode of expresssion reduced the impact of his work and ideas. When intellectuals began redefining radicalism, linking its cultural concomitant to a dispassionate representation of the American Scene as, for example, in the paintings of Ben Shahn or the photography of Walker Evans, Stieglitz, refusing to desert a metaphorical and self-derived form of art, found himself more and more isolated, embittered, and alone. At the end of his life he opposed not only the cultural establishment but the intellectual vanguard as well.

In contrast to someone like his former disciple Paul Strand, who wanted to lend his camera's eye to the cause of social justice, Stieglitz continued to explore the same photographic themes he had been examining for years. Until 1937, when he stopped taking pictures at the age of seventy-three, he steadfastly portrayed the artist as a sensual, mystically aware being. He continued to represent the urban landscape as a new, if now also slightly inhuman, frontier. And, most dramatically, he underlined in photograph after photograph nature's equivalences of his own personal feelings. Strand, on the other hand, had little use for the photographic aesthetic he had once helped pioneer and broke with Stieglitz in part because his new political orientation contrasted so dramatically with Stieglitz's. Where Strand joined the Communists in spirit if not in name, Stieglitz opposed the New Deal because it was based upon the authority and intervention of the government in human affairs. Referring to the W.P.A.'s financing of public murals, Stieglitz said, "I don't mind them looking at pictures, but don't destroy the walls."[4]

An American Place, Stieglitz's third and last gallery, also manifested his stubborn refusal to alter his assumptions or change his point of view during the thirties. Unlike 291, the new exhibition room introduced almost no new artists or concepts, concentrating instead on providing a showcase for Stieglitz's old protégés, Marin, Dove and O'Keeffe.

But ideas and visions, particularly ones as powerful as the Lyrical Left's dream of a cultural renaissance that changes the economic and social organization of American society, never really fade away completely. They possess half-lives of sorts, and can re-emerge long after their reported deaths. In the sixties many radicals, increasingly frustrated by the old Left's inability to transcend the narrow confines of orthodox Marxist thought, reevaluated the significance of cultural expression as an instrument of social change.

Writers like Paul Goodman, Theodore Roszak, and Charles

208 Reich analyzed and explored the theses and hopes outlined earlier by the Lyrical Left. Paul Goodman's *Growing Up Absurd* (1957) celebrated individuality while lamenting societal pressures to conform. Theodore Roszak's *The Making of a Counter Culture* (1969) pitted a "youthful opposition" against a "technocratic society." And Charles Reich's *The Greening of America* (1970) discovered revolutionary promise in new forms of consciousness. Although these books and the ideals they represented found a much larger audience than Bourne or Stieglitz ever did, their message was similar in many ways. The younger generation's romantic celebration of youth, its principled opposition to the war in Vietnam, its rejection of the aggrandizing claims of science, technology, and pragmatic politics, its flirtation with mystical, antimaterialist conceptions of the universe, its desperate search for community and individual redemption, and, finally, its belief that "imagination is revolution" demonstrated the vitality of the Lyrical Left's legacy.

America had in fact had a usable past. Randolph Bourne, who had so poignantly described the issues and problems that this new generation of cultural radicals faced, was rediscovered. In 1964 his essays were republished, and, even more remarkably, stayed in print and were read widely by students seeking answers to questions he had asked over fifty years before. Although Stieglitz did not enjoy a similar reemergence as a cultural critic, in part because his message was less accessible, in the sixties critics like Harold Rosenberg and Clement Greenberg picked up where he left off in defining and supporting modern art's place and importance in American society.

In the last anaylsis, however, Randolph Bourne's and Alfred Stieglitz's success in defining cultural radicalism before the First World War remains their most important contribution. Although they failed to bring about the revolution they hoped for, they did create a revolution in the mind and the arts. Their faith that their work and criticism had a real impact on society made it possible.

The belief, even if unfounded, that one well-placed blow to the establishment could bring it down certainly contributed more than a small share to the development and diffusion of modernism. If today it seems like a spent force, modernism's death has left a vacuum at the center of our cultural life as a nation. Such was not the case for a brief moment around 1913.

Notes

Selected Bibliography

Index

NOTES

Abbreviations

AG Alyse Gregory
AS Alfred Stieglitz
CW *Camera Work*
NR *New Republic*
RB Randolph Bourne
SA *Seven Arts*

Chapter 1 MANNAHATTA

[1]Eduard Steichen to AS, Nov. 1913, Alfred Stieglitz Archive, Collection of American Literature, Beinecke Rare Book and Manuscript Library, Yale University, New Haven.

[2]Quoted in Van Wyck Brooks, *America's Coming-of-Age* (New York: B. W. Huebsch, 1915), 161; quoted in John P. Diggins, *The American Left in the Twentieth Century* (New York: Harcourt Brace Jovanovich, 1973), 74.

[3]Brooks, *America's Coming-of-Age*; Henry F. May, *The End of American Innocence* (Chicago: Quadrangle Books, 1959); James B. Gilbert, *Writers and Partisans* (New York: John Wiley and Sons, 1968); Diggins, *The American Left in the Twentieth Century*; and Arthur Frank Wertheim, *The New York Little Renaissance* (New York: New York Univ. Press, 1976).

[4]For discussions of the Armory Show, see Meyer Schapiro, "The Introduction of Modern Art in America," in *Modern Art* (New York: George Braziller, 1978), 135–78, and Milton W. Brown, *The Story of the Armory Show* (Greenwich, Conn.: Joseph H. Hirshhorn Foundation, 1963). Christopher Lasch *(The New Radicalism in America* [New York: Vintage Books, 1965], xiv) and Robert E. Humphrey *(Children of Fantasy* [New York: John Wiley and Sons, 1978], 18) argue that cultural radicals confused art and politics. Curiously, because Lasch does not consider their ideas seriously, focusing instead on the social history of intellectuals, he himself confuses radicals, progressives, and liberals. Thus, in separate chapters, such different and frequently antagonistic thinkers as Jane Addams, Randolph Bourne, and Herbert Croly all become examples of the rise of a new "social type" when, in fact, what they mainly had in common was little more than the time and inclination to write. Mabel Dodge to Gertrude

Stein, Jan. 24, 1913, in Donald Gallup, ed., *The Flowers of Friendship* (New York: Octagon Books, 1979), 70–71; *New York Times*, Mar. 16, 1913, pt. 4, 6.

[5]Mabel Dodge, *Movers and Shakers* (New York: Harcourt Brace, 1936), 188; Hutchins Hapgood, "Creative Liberty," clipping, Hutchins Hapgood Papers, Collection of American Literature, Beinecke Rare Book and Ms. Lib.

[6]*New York Panorama* (New York: Random House, 1938), 73.

[7]George Santayana, *Winds of Doctrine* (New York: Charles Scribner's Sons, 1913), 4–5. Although historians disagree about the nature of the progressive movement, my understanding of it relies heavily upon the general interpretations offered by Samuel P. Hays, *The Response to Industrialism, 1885–1914* (Chicago: Univ. of Chicago Press, 1957) and Robert H. Wiebe, *The Search for Order, 1877–1920* (New York: Hill and Wang, 1967). In addition, William E. Akin, *Technocracy and the American Dream* (Berkeley: Univ. of California Press, 1977), Samuel Haber, *Efficiency and Uplift* (Chicago: Univ. of Chicago Press, 1964), David W. Noble, *The Paradox of Progressive Thought* (Minneapolis: Univ. of Minnesota Press, 1958), idem, *The Progressive Mind* (Chicago: Rand McNally, 1970), and James Weinstein, *The Corporate Ideal in the Liberal State* (Boston: Beacon Press, 1968) all note the conservative underpinnings of progressive reform, something contemporary cultural radicals pointed out at the time. For intelligent discussions of the *New Republic*, see David W. Noble, "The *New Republic* and the Idea of Progress, 1914–1920," *Mississippi Valley Historical Review*, 38 (Dec. 1951), 387–402, Charles Forcey, *The Crossroads of Liberalism* (New York: Oxford Univ. Press, 1961), and John P. Diggins, "The *New Republic* and Its Times," *NR*, 191 (Dec. 10, 1984), 23–73.

[8]See John Higham, *From Boundlessness to Consolidation* (Ann Arbor: William L. Clements Library, 1969) for a fascinating overview of American cultural history.

[9]Anna Alice Chapin, *Greenwich Village* (New York: Dodd Mead, 1917), 176.

[10]Floyd Dell, *Homecoming* (New York: Farrar and Rinehart, 1933), 271; *Le Dernier Cri*, 2 (Jan. 1917), 36; John Reed, *The Day in Bohemia* (New York: Privately printed, 1913), 14; quoted in Fred W. McDarrah, *Greenwich Village* (New York: Corinth Books, 1963), 32. John Sloan's sketch of the event, *The Arch Conspirators* (1917), is reproduced in Wertheim, *The New York Little Renaissance*, 66.

[11]Dell, *Homecoming*, 250; Van Wyck Brooks, *An Autobiography* (New York: E. P. Dutton, 1965), 155.

[12]Quoted in Egmont Arens, *The Little Book of Greenwich Village* (New York: E. Arens, 1918), 14.

[13]Jack McGrath as told to Arthur M. Row, "The Legend of Greenwich Village," typescript, New York Public Library, n.d., 28; quoted in Allen

Churchill, *The Improper Bohemians* (New York: E. P. Dutton, 1959), 110; *Mother Earth*, 9 (Feb. 1915), back cover.

[14]*Le Dernier Cri*, 2 (Jan. 1917), 65.

[15]Quoted in Guido Bruno, *Bruno Chap Books*, No. 6, "Anarchists," (N. p.: Privately printed, 1915), 8; quoted in Carl Zigrosser, *My Own Shall Come to Me* (N. p.: Casa Laura, 1971), 74.

[16]RB to AG, n.d., Alyse Gregory Papers, Collection of American Literature, Beinecke Rare Book and Ms. Lib. Although Robert E. Humphrey in *Children of Fantasy* studies different figures from those selected here, I think that he underrates the intellectual and cultural achievements of Hapgood, Cook, Reed, Eastman, and Dell in order to demonstrate his thesis that Greenwich Village became "the playground of utopia."

[17]May, *The End of Innocence*, 322.

[18]Walter Lippmann, "Legendary John Reed," *NR*, 1 (Dec. 26, 1914), 16. For an interesting discussion of *Drift and Mastery*, see David A. Hollinger, "Science and Anarchy: Walter Lippmann's *Drift and Mastery*," *American Quarterly*, 29 (Winter 1977), 463–75. Hollinger notes that while both Theodore Roosevelt and Randolph Bourne loved the book, each did so for opposite reasons. Where Roosevelt saw in the treatise a recipe for order, Bourne thought that Lippmann's argument supported the unleashing of anarchic impulses.

[19]Reed, *The Day in Bohemia*, 42.

[20]Hutchins Hapgood to Mabel Dodge, n.d., Mabel Dodge Luhan Papers, Collection of American Literature, Beinecke Rare Book and Ms. Lib.; Herbert Croly, *Willard Straight* (New York: Macmillan, 1924), 472, 473.

[21]Herbert Croly, *The Promise of American Life* (New York: Macmillan, 1909), 139, 333, 22 (emphasis added). Charles Forcey points out that Croly, writing at the beginning of the twentieth century, underestimated the totalitarian implications of his argument (*Crossroads of Liberalism*, 45).

[22]*NR*, 1 (Nov. 14, 1914), 4; *NR*, 1 (Dec. 26, 1914), 10–11.

[23]*NR*, 5 (Nov. 13, 1915), addendum (emphasis added); "The Control of Immigration," *NR*, 6 (Apr. 8, 1916), 254.

[24]John R. Commons, *Races and Immigrants in America* (New York: Macmillan, 1907), 20; Edward A. Ross, *The Old World in the New* (New York: Century, 1914), 230, 279.

[25]*Americanism: Addresses by Woodrow Wilson, Franklin K. Lane, Theodore Roosevelt* (N.p.: Americanization Department, Veterans of Foreign Wars of the United States, n.d.), 15, 2. For a different view of progressivism and its relation to immigration, see John Higham, *Strangers in the Land* (New York: Atheneum, 1975), 117–23.

[26]*NR*, 4 (Sept. 18, 1915), 164; *NR*, 3 (June 26, 1915), 185; "Free Speech for Teachers," *NR*, 3 (June 26, 1915), 193; Walter Lippmann, "Hyphens and

Frontiers," *NR*, 5 (Dec. 4, 1915), 116; idem, "Integrated America," *NR*, 6 (Feb. 19, 1916), 62. In *Crossroads of Liberalism*, 214, Charles Forcey maintains that the *New Republic* had a "strong concern for civil liberties," but his documentation relies exclusively on citations preceding December 1915.

[27]Lippmann, "Integrated America," 64.

[28]RB, *History of a Literary Radical*, ed., Van Wyck Brooks (New York: B. W. Huebsch, 1920), xxiii–xxiv (emphasis mine).

[29]AS to Marsden Hartley, July 10, 1914, AS Archive.

[30]Walter E. Weyl, *The New Democracy* (New York: Macmillan, 1912), 203.

[31]The description of modernism comes from Renato Poggioli, *The Theory of The Avant-Garde*, trans. Gerald Fitzgerald (Cambridge: Belknap Press of Harvard Univ. Press, 1968), 136. RB, *Youth and Life* (Boston: Houghton Mifflin, 1913), 232–33; Marius de Zayas and Paul B. Haviland, *A Study of the Modern Evolution of Plastic Expression* (New York: "291," 1913), 7.

Chapter 2 RANDOLPH BOURNE

[1]James Oppenheim, "The Story of the Seven Arts," *American Mercury*, 20 (June 1930), 164; RB, *Untimely Papers*, ed., James Oppenheim (New York: B. W. Huebsch, 1919), 5. For sympathetic portraits of Bourne's life and goals written by cultural radicals after 1918, see Van Wyck Brooks, "Randolph Bourne," in *Fenollosa and His Circle* (New York: E. P. Dutton, 1962), 259–321, Edward Dahlberg, "Randolph Bourne," in *Alms for Oblivion* (Minneapolis: Univ. of Minnesota Press, 1964), 79–86, John Dos Passos, "Randolph Bourne," in *Nineteen-Nineteen* (New York: Modern Library, 1937), 103–6, Theodore Dreiser, "Appearance and Reality," in *The American Spectator Yearbook* (New York: Frederick A. Stokes, 1934), 204–9, and Paul Rosenfeld, "Randolph Bourne," in *Port of New York* (New York: Harcourt Brace, 1924), 211–36.

[2]*Dial*, 66 (Jan. 11, 1919), 41.

[3]RB, "An Autobiographical Chapter," *Dial*, 68 (Jan. 1920), 1.

[4]Dreiser, "Appearance and Reality," 205; quoted in AG, "Randolph Bourne: Life and Selected Letters," 103, Ms., Collection of American Literature, Beinecke Rare Book and Manuscript Library, Yale University, New Haven.

[5]Agnes De Lima to AG, n.d., Randolph Bourne Papers, Rare Book and Manuscript Library, Columbia University, New York; AG, "Randolph Bourne: Life and Selected Letters," 6. Biographical details are in John Adam Moreau, *Randolph Bourne* (Washington, D.C.: Public Affairs Press, 1966).

[6]RB, "An Autobiographical Chapter," 5–6.

[7]RB to AG, May 20, 1914, Alyse Gregory Papers, Collection of American Literature, Beinecke Rare Book and Ms. Lib.

[8]Natalie Fenniger to Esther Cornell, Jan. 17, 1919–Feb. 10, 1919, RB Papers; RB, *Youth and Life* (Boston: Houghton Mifflin, 1913), 343–44.

[9]Alfred Adler, *The Neurotic Constitution*, trans. Bernard Glueck (New York: Moffat Yard, 1917), 24. See, for example, Bourne's essay "The Puritan's Will to Power," *SA*, 1 (Apr. 1917), 631–37. Quoted in AG, "Randolph Bourne: Life and Selected Letters," 104.

[10]RB, *Youth and Life*, 344, 345–46; RB to AG, Nov. 15, 1915, AG Papers.

[11]RB, *Youth and Life*, 341; RB to Prudence Winterrowd, Mar. 2, 1913, RB Papers; Beulah Amidon to AG, Oct. 4, 1948, RB Papers; RB to AG, Jan. 19, 1914, AG Papers.

[12]RB to AG, Jan. 21, 1916, AG Papers; RB to Simon Barr, Jan. 19, 1914, RB Papers.

[13]RB, *Youth and Life*, 345; Amidon to AG, Oct. 4, 1948, RB Papers; RB to Elizabeth Shepley Sergeant, June 9, 1915, Elizabeth Shepley Sergeant Papers, Collection of American Literature, Beinecke Rare Book and Ms. Lib.

[14]RB, *Youth and Life*, 346, 347.

[15]RB, "What Is Exploitation?" *NR*, 9 (Nov. 4, 1916), 14.

[16]RB to Winterrowd, Jan. 16, 1913, RB Papers.

[17]Frederick Keppel, *Columbia* (New York: Oxford Univ. Press, 1914), 276. A typical progressive administrator, Dean Keppel defended Columbia against the charge that it was "overrun with European Jews" by noting the university's capacity to assimilate them. See pp. 179, 181.

[18]RB to Dorothy Teall, Oct. 23, 1913, RB Papers; RB, "College Life Today," *North American Review*, 196 (Sept. 1912), 371.

[19]AG, "Randolph Bourne: Life and Selected Letters," 104; RB to Winterrowd, Jan. 16, 1913, RB Papers; RB to AG, June 14, 1913, AG Papers; RB, "College Life Today," 369.

[20]RB to Winterrowd, Mar. 2, 1913, RB Papers; Harry Dana to RB, Mar. 21, 1914, RB Papers; Dana to AG, June 30, 1948, RB Papers.

[21]RB to AG, June 1, 1913, and July 24, 1915, AG Papers.

[22]Christopher Lasch cites Bourne's urgent desire to participate in a cause larger than himself to support his thesis that American intellectuals responded more to their social isolation than to any commitments or ideals they may have had. He overlooks the fact that Bourne rejected both his enemies as well as his friends when he felt that they compromised principles he held inviolable. See Lasch, *The New Radicalism in America* (New York: Vintage, 1965), 100–103. RB to Winterrowd, Mar. 2, 1913, RB Papers; RB to AG, n.d., AG Papers.

[23]See, for example, Lasch, *The New Radicalism in America*, 80, and Charles Forcey, *The Crossroads of Liberalism* (New York: Oxford Univ. Press, 1961), 280.

[24]*Nation*, 96 (May 26, 1913), 550.

[25]*Atlantic Monthly*, 107 (Feb. 1911), 149.

[26]RB, *Youth and Life*, 41.

[27]Ibid., 27. In his revisionist study "The Rebels of Greenwich Village," *Perspectives in American History*, 8 (1974), 335–77, Kenneth Lynn has discovered that the average age of 131 cultural radicals in 1912 was 30, and he therefore concludes that generational conflict played little part in the rebellion. By overlooking how the participants interpreted their actions—they indeed saw themselves as "marvelously young"—he has exaggerated the importance of his quantitative evidence.

[28]RB, *Youth and Life*, 291, 295, 297, 308.

[29]RB, "Sabotage," *Columbia Monthly*, 2 (Nov. 1913), 1; RB to Carl Zigrosser, Dec. 13, 1913, Carl Zigrosser Papers, Van Pelt Library, University of Pennsylvania, Philadelphia.

[30]RB, "John Dewey's Philosophy," NR, 2 (Mar. 13, 1915), 154; RB, "No Place for Wilson," *Bloomfield Citizen*, Sept. 7, 1912.

[31]RB, *Youth and Life*, 86. For a critique of progressive reform similar to Bourne's, see Samuel P. Hays, "The Politics of Municipal Reform," *Pacific Northwest Quarterly*, 55 (Oct. 1964), 157–69.

[32]RB, "The Next Revolution," *Columbia Monthly*, 10 (May 1913), 224; RB, "In the Mind of the Worker," *Atlantic Monthly*, 113 (June 1914), 381.

[33]RB, "Law and Order," *Masses*, 3 (Mar. 1912), 14; Theodore Roosevelt, *Outlook*, 98 (May 6, 1911), 13.

[34]RB, "Socialism and the Catholic Ideal," *Columbia Monthly*, 10 (Nov. 1912), 18; RB, "The Next Revolution," 226; RB to Mary Messner, Feb. 7, 1914, RB Papers.

[35]RB to AG, Mar. 13, 1914, AG Papers.

[36]RB, *Youth and Life*, 180, 245.

[37]Ibid., 229; RB to Winterrowd, Mar. 2, 1913, RB Papers; RB to AG, Mar. 13, 1914, AG Papers.

[38]RB, "Maeterlinck and the Unknown," NR, 1 (Nov. 21, 1914), 26.

[39]RB to Winterrowd, Jan. 16, 1913, RB Papers. See RB, "The Fortress of Belief," NR, 4 (Oct. 16, 1915), 283–84, an essay Bourne wrote based on the life of a friend who was a Christian Scientist, Mary Messner.

[40]RB, *Youth and Life*, 286–87.

[41]RB to AG, Sept. 8, 1913, A.G. Papers.

[42]RB to Arthur Macmahon, Dec. 23, 1913, RB Papers.

[43]RB, "Impressions of Europe, 1913–1914," *Columbia University Quarterly*, 17 (Mar. 1915), 112. See also Bourne's review of Philip Van Ness Myers's *History as Past Ethnics* in which he criticizes the author's static conception of culture, particularly his insistence that all people's ideas, beliefs, and prejudices

can be interpreted from "the standpoint of the Spencerian Protestant" (*Journal of Philosophy*, 10 [Nov. 6, 1913], 641–42).

[44]RB, "Continental Cultures," *NR*, 1 (Jan. 16, 1915), 15.

[45]RB to Henry Elsasser, Oct. 10, 1913, RB Papers; RB to Zigrosser, Dec. 13, 1913, Zigrosser Papers; RB to AG, Dec. 13, 1913, AG Papers.

[46]RB, "Holy Poverty," *NR*, 1 (Nov. 14, 1914), 25; RB to Zigrosser, Nov. 16, 1913, Zigrosser Papers; RB to AG, Oct. 11, 1913, AG Papers; RB to Winterrowd, Nov. 3, 1913, RB Papers.

[47]RB to AG, Nov. 1, 1913, AG Papers; RB to Zigrosser, Nov. 3, 1913, Zigrosser Papers.

[48]RB to Zigrosser, Dec. 13, 1913, Zigrosser Papers; RB to Frederick Keppel, Jan. 9, 1914, RB Papers; RB, "Impressions of Europe, 1913–1914," 116–17; RB to AG, Jan 19, 1914, AG Papers.

[49]RB, "Impressions of Europe, 1913–1914," 117.

[50]RB to Zigrosser, Nov. 3, 1913, Zigrosser Papers.

[51]RB, *Atlantic Monthly*, 114 (Sept. 1914), 397, 399.

[52]RB to AG, July 30, 1914, AG Papers.

[53]RB, "Impressions of Europe, 1913–1914," 125.

[54]RB, "Berlin in War Time," *Travel*, 24 (Nov. 1914), 9.

[55]RB to AG, Aug. 25, 1914, AG Papers.

[56]RB to AG, Feb. 16 and July 5, 1914, AG Papers.

[57]RB to AG, Apr. 10, 1914, AG Papers; Ellery Sedgwick to RB, May 9, 1914, RB Papers.

[58]Herbert Croly to RB, Oct. 5, 1914, RB Papers; RB to AG, July 24, 1915, AG Papers.

[59]For a contemporary radical critique of progressive education which argues that it was designed mainly to meet the needs of a modernizing industrial society, see Joel Spring, *Education and the Rise of the Corporate State* (Boston: Beacon Press, 1972).

[60]RB, "An Autobiographical Chapter," 21; RB, "Diary for 1901," RB Papers.

[61]RB, "Individuality and Education," *Columbia Monthly*, 9 (Jan. 1912), 89.

[62]John Dewey, *The School and Society* (Chicago: Univ. of Chicago Press, 1916), 26–27; idem, *Democracy and Education* (New York: Macmillan, 1916), 357.

[63]RB, *Education and Living* (New York: Century, 1917), 47, 48, 10.

[64]RB, *The Gary Schools*, ed. Adeline and Murray Levine (Cambridge: M.I.T. Press, 1970), 113, 130, 157; RB, *Education and Living*, 152; quoted in RB, *The Gary Schools*, xlii. For a discussion of the Jewish opposition to

introduce the Gary Plan in New York City, see Irving Howe, *World of Our Fathers* (New York: Harcourt Brace Jovanovich, 1976), 278–80.

[65]RB to Sergeant, Sept. 23, 1915, Sergeant Papers.

[66]RB, *Youth and Life*, 326; RB, "College Life Today," 371, 370, 372.

[67]RB, "One of Our Conquerors," *NR*, 4 (Sept. 4, 1915), 122–23; RB to Sergeant, Oct. 10, 1915, Sergeant Papers.

[68]RB, *Education and Living*, 220–21; RB, "The Idea of a University," *Dial*, 63 (Nov. 22, 1917), 510.

[69]Quoted in RB, *History of a Literary Radical*, ed. Van Wyck Brooks (New York: B. W. Huebsch, 1920), xxxiv; "Pageantry and Social Art," in RB, *The Radical Will*, ed. Olaf Hansen (New York: Urizen Books, 1977), 516 (emphasis added).

[70]RB, "Paul Elmer More," *NR*, 6 (Apr. 1, 1916), 246.

[71]Paul Shorey, "The Bigotry of the New Education," *Nation*, 105 (Sept. 6, 1917), 256.

[72]RB, *Education and Living*, 53, 63–64.

[73]RB, "Our Cultural Humility," *Atlantic Monthly*, 114 (Oct. 1914), 506,507.

[74]RB, "Sociological Fiction," *NR*, 12 (Oct. 27, 1917), 359–60.

[75]RB and Van Wyck Brooks, "Traps for the Unwary," *Dial*, 64 (Mar. 28, 1918), 277–79; idem, "The Retort Courteous," *Poetry*, 12 (Sept. 1918), 342; Harriet Monroe, " 'Aesthetic and Social Criticism,' " *Poetry*, 13 (Oct. 1918), 41. Brooks's views on art and society during the depression are outlined in James Hoopes, *Van Wyck Brooks* (Amherst: Univ. of Massachusetts Press, 1977), 201–10.

[76]RB, "The Art of Theodore Dreiser," *Dial*, 62 (June 14, 1917), 509.

[77]RB, "The History of a Literary Radical," *Yale Review*, 8 (Apr. 1919), 468–84. Although published six months after Bourne's death, "The History of a Literary Radical" was placed in the *Yale Review* by Bourne himself.

[78]William James, *A Pluralist Universe* (London: Longmans Green, 1909), 321–22.

[79]John Dewey, "Universal Service as Education," *NR*, 6 (Apr. 22, 1916), 310; idem, "Nationalizing Education," in *National Education Association Addresses and Proceedings*, 54 (1916), 185; idem, "The Principle of Nationality," *Menorah Journal*, 3 (Oct. 1917), 205, 206.

[80]Amidon to AG, Oct. 4, 1948, RB Papers. For discussion of the settlement workers' attitudes toward immigrants, and Jane Addams's personification of lost American values, see, respectively, Allen F. Davis, *Spearheads for Reform* (New York: Oxford Univ. Press, 1967), 84–94, and idem, *American Heroine* (New York: Oxford Univ. Press, 1973), 198–211.

[81]Horace Kallen to RB, Feb. 14 and Aug. 25, 1917, RB Papers.

[82]RB to Edward Murray, Dec. 26, 1913, RB Papers; RB, "Trans-National America," *Atlantic Monthly*, 118 (July 1916), 90.

[83]RB, "Trans-National America," 93.

[84]Sedgwick to RB, Mar. 30 and July 27, 1916, RB Papers.

[85]RB, "The Jew and Trans-National America," *Menorah Journal*, 2 (Dec. 1916), 278, 282.

[86]*Columbia Monthly*, 9 (Nov. 1911), 32; RB to Sergeant, Dec. 21, 1916, Sergeant Papers.

[87]RB to AG, Jan 19, 1914, AG Papers.

[88]RB to Zigrosser, Apr. 2, 1912, Zigrosser Papers; RB to AG, Oct. 11, 1913, and Apr. 10, 1914, AG Papers.

[89]The information on Patchin's here and below comes from Carl Zigrosser, *My Own Shall Come to Me* (N.p.: Casa Laura, 1971), 99–103. See my "Randolph Bourne on Feminism and Feminists," *Historian*, 43 (May 1981), 365–77 for greater detail. Katherine Anthony, *Feminism in Germany and Scandinavia* (New York: Henry Holt, 1915), 230. Anthony later became a celebrated biographer of famous women.

[90]S.B.R. [RB], "Sophronisba," *NR*, 5 (Nov. 13, 1915), 43. A descendant of John Alden, Hopkins became an eighteenth-century historian. "The most delightful bohemians," Bourne wrote, "are those who have been New England Puritans first." She was 84 when she died in 1960, 44 years older than "Sophronisba," who was 40 in 1916.

[91]Zigrosser, *My Own Shall Come to Me*, 94–120, 133–34.

[92]AG to Zigrosser, Sept. 21, 1964, Zigrosser Papers; quoted in Carl Zigrosser, *A World of Art and Museums* (Phildelphia: Art Alliance Press, 1975), 128.

[93]Zigrosser to AG, n.d., Zigrosser Papers; RB to AG, Jan 21, 1916, AG Papers.

[94]AG to Zigrosser, Sept. 21, 1964, Zigrosser Papers; RB to AG, Nov. 19, 1916, AG Papers.

[95]Zigrosser to AG, n.d., Zigrosser Papers.

[96]Max Coe [RB], "Making One's Contribution," *NR*, 8 (Aug. 26, 1916), 91–92.

[97]RB, "Suffrage and Josella," in *The Radical Will*, 453–56.

[98]RB, "Karen: A Portrait," *NR*, 8 (Sept. 23, 1916), 187–88.

[99]RB, "The Vampire," *Masses*, 9 (June 1917), 38.

[100]RB, "The Later Feminism," *Dial*, 63 (Aug. 16, 1917), 103–4.

[101]RB, *Youth and Life*, 283. In the literature on Bourne there is an ahis-

torical debate on what his position regarding the Communists might have been had he not died in 1918. If Bourne was dismayed by the radical feminists' demands for conformity, he would certainly have found the principle of democratic centralism abhorrent.

[102]RB to AG, Jan. 21, 1916, AG Papers.

[103]Herbert Croly, *The Promise of American Life* (New York: Macmillan, 1909), 307; idem, "The Effect on American Institutions of a Powerful Military and Naval Establishment," *Annals of the American Academy of Political and Social Science*, 66 (July 1916), 171.

[104]"The Great Decision," *NR*, 10 (Apr. 7, 1917), 280; "Who Willed American Participation?" *NR*, 10 (Apr. 14, 1917), 308, 309.

[105]"Morale," *NR*, 10 (Apr. 21, 1917), 338; "The Morality of Conscription," *NR*, 11 (May 5, 1917), 8; "Economic Dictatorship in War," *NR*, 11 (May 12, 1917), 38.

[106]*NR*, 11 (June 9, 1917), 146.

[107]John Dewey, "The Future of Pacifism," *NR*, 11 (July 28, 1917), 359; idem, "A New Social Science," *NR*, 14 (Apr. 6, 1918), 294.

[108]See John Dewey, "Conscription of Thought," *NR*, 12 (Sept. 1, 1917), 128-30, and idem, "In Explanation of Our Lapse," *NR*, 13 (Nov. 3, 1917), 17-18.

[109]RB, "Those Columbia Trustees," *NR*, 12 (Oct. 20, 1917), 328-29; *NR*, 14 (Feb. 23, 1918), 93; *NR*, 15 (June 8, 1918), 158; *NR*, 16 (Aug. 24, 1918), 88. Bourne's letter to the editor criticizing Columbia was the only item he published on a war-related issue after 1916 in the *New Republic*. The question of academic freedom greatly concerned him. When his alma mater created a committee of inquiry to determine the faculty's political views, he said that its "intellectual terrorism" would turn the university into a "sheep corral or an adjunct to the American army" (RB to the editor of the *New York Tribune*, Mar. 7, 1917).

[110]RB, *Arbitration and International Politics* (New York: American Association for International Conciliation, no. 70 [Sept. 1913]), 14; RB, "A Glance at German 'Kultur'," *Lippincott's Monthly*, 95 (Feb. 1915), 22–27; RB, "American Use for German Ideals," *NR*, 4 (Sept. 4, 1915), 117–19; RB, "Mental Unpreparedness," *NR*, 4 (Sept. 11, 1915), 143–44; RB to Sergeant, Oct. 10, 1915, Sergeant Papers.

[111]RB, "Magic and Scorn," *NR*, 9 (Dec. 2, 1916), 130; RB, "A Moral Equivalent for Universal Military Service," *NR*, 7 (July 1, 1916), 218.

[112]RB to Sergeant, Sept. 20, 1916, Sergeant Papers.

[113]RB, "The War and the Intellectuals," *SA*, 2 (June 1917), 136, 141–42, 145.

[114]RB, "Twilight of Idols," *SA*, 2 (Oct. 1917), 695–96; RB, "Conscience and Intelligence in War," *Dial*, 63 (Sept. 13, 1917), 193.

[115]RB, "A War Diary," SA, 2 (Sept. 1917), 542, 543; RB, "International Dubieties," Dial, 62 (May 3, 1917), 387; RB, "A War Diary," 546.

[116]RB, "The State," in The Radical Will, 359.

[117]RB to AG, Jan. 5, 1914, AG Papers; RB, "The State," in The Radical Will, 372; RB, "Old Tyrannies," in Untimely Papers, 18.

[118]RB, "The State," in The Radical Will, 365–66; RB, "The Disillusionment," in The Radical Will, 405, 404.

[119]RB to Van Wyck Brooks, Mar. 27, 1918, RB Papers; RB, "A War Diary," 547.

[120]RB to Sarah Bourne, Nov. 4, 1918, RB Papers; RB to Cornell, n.d., RB Papers; RB to Everett Benjamin, Nov. 26, 1917, RB Papers.

[121]RB to Paul Strand, Aug. 16, 1917, Paul Strand Archive, Center for Creative Photography, University of Arizona, Tucson.

[122]RB to Brooks, Nov. 12, 1918, RB Papers; RB to Bourne, Nov. 21, 1918, RB Papers.

[123]NR, 17 (Dec. 28, 1918), 232–33.

[124]Floyd Dell, "Randolph Bourne," NR, 17 (Jan. 4, 1919), 276 (emphasis added).

[125]Bourne to Cornell, Feb. 18, [1919], RB Papers; RB to AG, Nov. 10, 1916, AG Papers; Harold Laski, "The Liberalism of Randolph Bourne," Freeman, 1 (May 19, 1920), 237.

[126]J. S. Watson to Charles Allen, May 25, 1943; quoted in Frederick J. Hoffman et al., The Little Magazine (Princeton: Princeton Univ. Press, 1946), 198–99.

[127]Lewis Mumford, "The Image of Randolph Bourne," NR, 64 (Sept. 24, 1930), 152.

[128]AS to Strand, Jan. 4, 1919, Alfred Stieglitz Archive, Collection of American Literature, Beinecke Rare Book and Ms. Lib.

Chapter 3 ALFRED STIEGLITZ

[1]AS, "Who Am I," Twice-A-Year, 5– 6 (Fall-Winter 1940, Spring-Summer 1941), 160-61.

[2]"Alfred Stieglitz Replies to 'Officialdom,' " Twice-A-Year, 8-9 (Spring-Summer 1942, Fall-Winter 1942), 174.

[3]Waldo Frank, Our America (New York: Boni and Liveright, 1919), 186. See also Frank's study of Stieglitz "The Prophet" in Time Exposures (New York: Boni and Liveright, 1926), 175–79. Paul Rosenfeld, Port of New York (New York: Harcourt Brace, 1924), 260, 258.

[4]AS to Waldo Frank, July 6, 1935, Waldo Frank Papers, Van Pelt Library,

University of Pennsylvania, Philadelphia. To soften the impact of his rejection of Frank's wishes, Stieglitz added a postscript to the letter which in retrospect assumes an unintended irony. "The artist there [in Russia]," he wrote, "is looked upon as the supreme cultural force and is treated accordingly." For Frank's views during the depression, see "How I Came to Communism," *New Masses*, 8 (Sept. 1932), 6–7.

[5]Quoted in Dorothy Norman, *Alfred Stieglitz: An American Seer* (New York: Random House, 1973), 15. See also Paul Rosenfeld, "The Boy in the Dark Room," in *America and Alfred Stieglitz*, ed. Waldo Frank et al. (New York: Doubleday Doran, 1934), 59–88, William Innes Homer, *Alfred Stieglitz and the American Avant-Garde* (Boston: New York Graphic Society, 1977), and Sue Davidson Lowe, *Stieglitz* (New York: Farrar, Straus & Giroux, 1983) for additional biographical details.

[6]Rosenfeld, "The Boy in the Dark Room," 61; *Georgia O'Keeffe: A Portrait by Alfred Stieglitz*, intro. by Georgia O'Keeffe (New York: Metropolitan Museum of Art, 1978), n.p.

[7]Quoted in Norman, *Alfred Stieglitz: An American Seer*, 16, 17.

[8]Ibid., 17; AS to R. Child Bayley, Oct. 9, 1919, Alfred Stieglitz Archive, Collection of American Literature, Beinecke Rare Book and Manuscript Library, Yale University, New Haven.

[9]I would like to thank Frank Proser of Lake George, N.Y., for kindly sending me a copy of Stieglitz's "Mental Photographs." Quoted in Norman, *Alfred Stieglitz: An American Seer*, 16; AS, "The Scissors Grinder," *Twice-A-Year*, 10–11 (Fall-Winter 1943), 260.

[10]Rosenfeld, "The Boy in the Dark Room," 59; Georgia O'Keeffe, "Stieglitz: His Pictures Collected Him," *New York Times Magazine* (Dec. 11, 1949), 24. O'Keeffe also said that Stieglitz "had been spoiled by his family in early life. If he felt he was not getting enough attention, he would get sick in order to attract notice and feed on emotions" (Carl Zigrosser, *A World of Art and Museums* [Philadelphia: Art Alliance Press, 1975], 195). Sadakichi Hartmann to AS, Sept. 2, 1904, AS Archive. Hartmann continued, "We are not all jews [*sic*], and look upon life from the patriarchal point of view." Hartmann's opinion did not prevent him nevertheless from turning to Stieglitz for aid, financial and otherwise, many times in the future. Frank to AS, July 31, 1923, AS Archive. Frank explained, "This is why you have had a 'series' of friends. . . . And this is why the friends who remained, in most cases of course persons of great value, have been of a type which one could justly term Fixated adolescents, or passive or feminine (in that classic use of the word). These associates, true disciples, have lived to almost perfect extent in an atmosphere of your determining."

[11]*Georgia O'Keeffe: A Portrait by Alfred Stieglitz*, n.p.

[12]AS, "Thoroughly Unprepared," *Twice-A-Year*, 10–11 (Fall-Winter 1943), 249.

[13]AS, "Is It Wastefulness or Is It Destruction?" *Twice-A-Year*, 10–11 (Fall-Winter 1943), 254.

[14]AS to My dear cousin, Oct. 15, 1881, AS Archive.

[15]Quoted in Norman, *Alfred Stieglitz: An American Seer*, 25; AS, "Thoroughly Unprepared," 245.

[16]Quoted in Dorothy Norman, *Alfred Stieglitz: Introduction to an American Seer* (New York: Duell, Sloan and Pierce, 1960), 6.

[17]Quoted in Norman, *Alfred Stieglitz: An American Seer*, 33.

[18]AS, "Thoroughly Unprepared," 252; quoted in Norman, *Alfred Stieglitz: An American Seer*, 31.

[19]AS, "Why I Got Out of Business," *Twice-A-Year*, 8-9 (Spring-Summer 1942, Fall-Winter 1942), 106.

[20]Dorothy Norman to author, in conversation. Later in life Stieglitz wrote, "I never much thought of myself as a Jew or any other particular thing—but I'm beginning to feel that it must be *the Jew* in me that is after all the key to my impossible makeup. But Jew or no Jew—I know Life is terribly hard" (AS to Frank, Apr. 3, 1935, Waldo Frank Papers). Quoted in Norman, *Alfred Stieglitz: An American Seer*, 34. Stieglitz was not alone in equating the Brooklyn Bridge and America. See Alan Trachtenberg, *Brooklyn Bridge: Fact and Symbol* (Chicago: Univ. of Chicago Press, 1979).

[21]Quoted in Norman, *Alfred Stieglitz: An American Seer*, 35.

[22]AS, "Why I Got Out of Business," 109, 113, 114.

[23]AS to Heinrich Kühn, Mar. 10, 1907, AS Archive; AS, "The Origin of the Photo-Secession and How It Became '291,' " *Twice-A-Year*, 8–9 (Spring-Summer 1942, Fall-Winter 1942), 125.

[24]Quoted in Norman, *Alfred Stieglitz: An American Seer*, 13; AS to R. C. Bayley, Dec. 11, 1913, AS Archive.

[25]Paul Strand, "Alfred Stieglitz and a Machine," *MSS*, 2 (Mar. 1922), 6.

[26]Quoted in Aaron Scharf, *Art and Photography* (Baltimore: Penguin, 1974), 145–46. Baudelaire's contention that photography damages not only art but society as well still has its adherents. Susan Sontag, for example, argues that photography has, in fact, had a pernicious effect on modern culture and expression. She asserts that today "all art aspires to the condition of photography," which, according to her, accepts without distinction both the popular taste and the material world. In Sontag, Baudelaire's fear, which she cites to support her thesis, becomes an accusation that contemporary society's reliance on photographs has "consumed" our sense of reality (*On Photography* [New York: Farrar, Straus & Giroux, 1977], 149, 179).

[27]"Art Notes," *New York Evening Post*, Dec. 1, 1907, and J. Nilsen Laurvik, "Alfred Stieglitz, Pictorial Photographer," *International Studio*, 44 (Aug. 1911), XXII. When Stieglitz retold the story in 1940, he changed some of its details

for illustrative purposes. See "Photography and Painting," *Twice-A-Year*, 5–6 (Fall-Winter 1940, Spring-Summer 1941), 144–47.

[28]AS, "A Plea for Art Photography," *Photographic Mosaics*, 28 (1892), 136.

[29]AS, "Modern Pictorial Photography," *Century*, 62 (Oct. 1902), 825.

[30]Joseph Pennell, "Is Photography among the Fine Arts?" *Contemporary Review*, 72 (1897), 836; AS, "The Joint Exhibition at Philadelphia," *American Amateur Photographer*, 5 (May 1893), 203.

[31]AS, "The Joint Exhibition at Philadelphia," 203.

[32]"Some Impressions of Foreign Exhibitions," *CW*, 8 (Oct. 1904), 35; quoted in Charles H. Caffin, *Photography as a Fine Art* (New York: Doubleday Page, 1901), 36.

[33]*Georgia O'Keeffe: A Portrait by Alfred Stieglitz*, n.p.; quoted in Norman, *Alfred Stieglitz: An American Seer*, 19, 13.

[34]Laurvik, "Alfred Stieglitz, Pictorial Photographer," XXII. For discussion of Stieglitz's advancements in photographic technology, see AS, "The Hand Camera—Its Present Importance," *American Annual of Photography* (1897), 18–27, and James B. Carrington, "Unusual Uses of Photography, II, Night Photography," *Scribner's Magazine*, 22 (Nov. 1897), 626–28.

[35]"On Plagiarism and Imitation," in Sadakichi Hartmann, *The Valiant Knights of Daguerre*, ed. Harry W. Lawton and George Knox (Berkeley: Univ. of California Press, 1978), 66–67; AS, "My Favorite Picture," *Photographic Life*, 1 (1899), 12.

[36]Quoted in Norman, *Alfred Stieglitz: An American Seer*, 37.

[37]Quoted in W. E. Woodbury, "Alfred Stieglitz and His Latest Work," *Photographic Times*, 28 (Apr. 1896), 161.

[38][Theodore Dreiser], "A Remarkable Art," *The Great Round World*, 19 (May 3, 1902), 434.

[39]AS, "Photograph the Flat-Iron Building—1902–03," *Twice-A-Year*, 14–15 (Fall-Winter 1946–47), 188–90.

[40]AS, "How the Steerage Happened," *Twice-A-Year*, 8–9 (Spring-Summer 1942, Fall-Winter 1942), 127–31; quoted in "American Photography Honored," *Outlook*, 136 (Feb. 20, 1924), 298; Marius de Zayas to AS, June 11, 1914, AS Archive; AS to de Zayas, June 22, 1914, AS Archive.

[41][Dreiser], "A Remarkable Art," 434.

[42]Waldo Frank, "A Thought Hazarded," *MSS*, 4 (Dec. 1922), 5; AS, "How I Came to Photograph Clouds," *Amateur Photographer and Photography*, 56 (Sept. 19, 1923), 255.

[43]AS, "How I Came to Photograph Clouds," 255; quoted in Laurie Lisle, *Portrait of an Artist: A Biography of Georgia O'Keeffe* (New York: Seaview Books, 1980), 102.

[44]AS, "Pictorial Photography," *Scribner's*, 26 (Nov. 1899), 534. For a de- 227
scription of the secessionists' aims, see Carl E. Schorske, *Fin-de-Siècle Vienna*
(New York: Alfred A. Knopf, 1980), 213–19. Eduard Steichen recalls the pictures
Stieglitz had on his walls in his autobiography, *A Life in Photography* (Garden
City, N.Y.: Doubleday, 1963), n.p.

[45]"Valedictory," *Camera Notes*, 6 (July 1902), 4.

[46]AS, "The Origin of the Photo-Secession and How It Became '291,'"
117. For the interesting story of Stieglitz's relations with the New York Camera
Club written from the club's point of view, see Dennis Longwell, "Alfred Stieglitz
vs. the Camera Club of New York City," *Image*, 14 (Dec. 1971), 21–23.

[47]AS, "The Origin of the Photo-Secession and How It Became '291,'"
117–18.

[48]"The Photo-Secession," in *Bausch and Lomb Lens Souvenir* (Rochester,
N.Y.: Bausch and Lomb, 1903), 3; AS, "The Photo-Secession—Its Objects,"
Camera Craft, 7 (Aug. 1903), 83; *Photo-Secessionism and Its Opponents: Five
Recent Letters* (New York: N.p., 1910), 12.

[49]"An Apology," *CW*, I (Jan. 1903), 16.

[50]AS, "The Origin of the Photo-Secession and How It Became '291,'"
118. William Homer argues that showing avant-garde art was "far from [Stieg-
litz's] original intention" in 1905 (*Alfred Stieglitz and the American Avant-
Garde*, 39). My reading of the evidence, notably his choice of names for the
group, his personal background, and his belief that photography, like all art,
was an expression of an inner vision suggests that he was predisposed toward
modernism.

[51]"Alfred Stieglitz, Artist, and His Search for the Human Soul," *New York
Herald*, Mar. 8, 1908, pt. 3, 5; AS to Mr. Stephany, Feb. 7, 1907, AS Archive;
AS to William F. Gable, Feb. 9, 1915, AS Archive; AS to Emma Goldman,
Jan. 6, 1915, AS Archive.

[52]"The Photo-Secession Galleries and the Press," *CW*, 14 (Apr. 1906), 36.

[53]Quoted in Philippe Jullian, *The Symbolists*, trans. Mary Anne Stevens
(London: Phaidon, 1973), 31.

[54]"Is Photography a New Art?" *CW*, 21 (Jan. 1908), 22.

[55]See "Postscript—May 10th," *Camera Notes*, 6 (July 1902), inserted be-
tween pp. 51–52. The jury had originally accepted the photographs, but the
hanging committee intervened.

[56]Dennis Longwell's beautiful book *Steichen: The Master Prints, 1895–
1914* (New York: Museum of Modern Art, 1978) perceptively studies Steichen's
symbolist inclinations.

[57]Quoted in Jullian, *The Symbolists*, 19; quoted in Joseph Shiffman, "The
Alienation of the Artist: Alfred Stieglitz," *American Quarterly*, 3 (Fall 1951),
249–50.

[58]Eduard J. Steichen, "The American School," *Camera Notes*, 6 (July 1902), 23.

[59]AS to Alvin Langdon Coburn, Dec. 12, 1911, AS Archive; Maurice Maeterlinck, "Supplement," *CW*, 2 (Apr. 1903), 6 (reprinted in *CW*, Special Steichen Supplement [Apr. 1906], 1).

[60]Charles H. Caffin, "Of Verities and Illusions," *CW*, 12 (Oct. 1905), 29; idem, "Of Verities and Illusions—Part II, *CW*, 13 (Jan. 1906), 45.

[61]Charles H. Caffin, "Progress in Photography," *Century*, 75 (Feb. 1908), 491; idem, "Eduard J. Steichen's Work—An Appreciation," *CW*, 2 (Apr. 1903), 24.

[62]See Sadakichi Hartmann, *Conversations with Walt Whitman* (New York: E. P. Coby, 1895).

[63]Sadakichi Hartmann, "The Value of the Apparently Meaningless and Inaccurate," *CW*, 3 (July 1903), 17; idem, *Japanese Art* (Boston: L. C. Page, 1903), 276.

[64]Sadakichi Hartmann, "A Visit to Steichen's Studio," *CW*, 2 (Apr. 1903), 28.

[65]Dorothy Norman, "From the Writings and Conversations of Alfred Stieglitz," *Twice-A-Year*, 1 (Fall-Winter 1938), 82.

[66]Steichen, *A Life in Photography*, n.p. See, for example, Homer, *Alfred Stieglitz and the American Avant-Garde*, 43.

[67]"The Editor's Page," *CW*, 18 (Apr. 1907), 37.

[68]M. Irwin MacDonald, "The Fairy Faith and Pictured Music of Pamela Colman Smith," *Craftsman*, 23 (Oct. 1912), 33; "Drawings by Pamela Colman Smith," *CW*, 27 (July 1909), 27.

[69]See Melinda Boyd Parsons, *To All Believers: The Art of Pamela Colman Smith* (Wilmington: Delaware Art Museum, 1975).

[70]Benjamin de Casseres, "Pamela Colman Smith," *CW*, 27 (July 1909), 20; Pamela Colman Smith catalog, AS Scrapbook, no. 4, 64, AS Archive.

[71]AS to Gertrude Stein, Nov. 3, 1913, AS Archive; "The Little Galleries of the Photo-Secession," *CW*, 23 (July 1908), 13.

[72]Quoted in Homer, *Alfred Stieglitz and the American Avant-Garde*, 52.

[73]Quoted in *Photo-Secession*, Lunn Gallery Graphics International Catalog, 6 (Washington, D.C.: 1977), 11.

[74]Quoted in Marius de Zayas and Paul B. Haviland, *A Study of the Modern Evolution of Plastic Expression* (New York: "291," 1913), 17.

[75]AS, "The Photo-Secession at the National Arts Club, New York," *Photograms of the Year 1902*, 20; "Editorial," *CW*, 14 (Apr. 1906), 17; quoted in Marius de Zayas, "How, When, and Why Modern Art Came to New York," *Arts Magazine*, 54 (Apr. 1980), 112.

[76]AS to George Davidson, Apr. 10, 1909, AS Archive; Agnes Ernst, "New School of the Camera," *New York Sun*, Apr. 26, 1908; AS to Spencer Kellogg, Dec. 17, 1913, AS Archive.

[77]AS to R. C. Bayley, Apr. 29, 1912, AS Archive.

[78]Marius de Zayas, "The Sun Has Set," *CW*, 39 (July 1912), 17, 21.

[79]*Georgia O'Keeffe: A Portrait by Alfred Stieglitz*, n.p.; "W. B. McCormick in the *Press*," *CW*, 22 (Apr. 1908), 39.

[80]"The Rodin Drawings at the Photo-Secession Galleries," *CW*, 22 (Apr. 1908), 35; "J. N. Laurvik in the *Times*," *CW*, 22 (Apr. 1908), 36.

[81]Norman, "From the Writings and Conversations of Alfred Stieglitz," 83; AS to John G. Bullock, Mar. 26, 1917, AS Archive; "Henri Matisse at the Little Galleries," *CW*, 23 (July 1908), 10.

[82]"James Huneker in the N.Y. *Sun*," *CW*, 23 (July 1908), 11–12.

[83]"J. E. Chamberlain in the N.Y. *Evening Mail*," *CW*, 23 (July 1908), 10.

[84]Charles H. Caffin, "Henri Matisse and Isadora Duncan," *CW*, 25 (Jan. 1909), 17–20.

[85]"J. E. Chamberlain in the N.Y. *Mail*," *CW*, 30 (Apr. 1910), 51; "Arthur Hoeber in the N.Y. *Globe*," *CW*, 38 (Apr. 1912), 45; quoted in Alfred H. Barr, Jr., *Matisse: His Art and His Public* (New York: Museum of Modern Art, 1951), 115; "Drawings by Matisse," *Bulletin of the Metropolitan Museum of Art*, 5 (May 1910), 126.

[86]Norman, "From the Writings and Conversations of Alfred Stieglitz," 80, 83.

[87]Charles H. Caffin, "A Note on Paul Cézanne," *CW*, 34/35 (Apr.-July 1911), 51; "Mr. Rockwell in the *Brooklyn Eagle*," *CW*, 36 (Oct. 1911), 48.

[88]"Photo-Secession Notes," *CW*, 33 (Jan. 1911), 46; Ibid., 47–48; quoted in Sandra E. Leonard, *Henri Rousseau and Max Weber* (New York: Richard L. Feigen, 1970), 47–48.

[89]Paul B. Haviland, "Photo-Secession Notes," *CW*, 38 (Apr. 1912), 36.

[90]Marius de Zayas, "Pablo Picasso," *CW*, 34/35 (Apr.-July 1911), 65, 66.

[91]AS to E. A. Jewell, Dec. 19, 1939, AS Archive; "Mr. Fitzgerald, 'The New Art Criticism' in the N.Y. *Evening Sun*," *CW*, 36 (Oct. 1911), 68; "Mr. Arthur Hoeber in the N.Y. *Globe*," *CW*, 36 (Oct. 1911), 48, 49. See also "An Opportunity Missed," *291*, 2 (Apr. 1915).

[92]AS to Kühn, May 22, 1912, AS Archive.

[93]AS, "Camera Work Introduces Gertrude Stein to America," *Twice-A-Year*, 14–15 (Fall-Winter 1946–47), 192–95; Carl Van Vechten, ed., *Selected Writings of Gertrude Stein* (New York: Vintage, 1972), 328; AS to Stein, Feb. 26, 1912, AS Archive.

[94]Gertrude Stein, "Henri Matisse," *CW*, Special Number (Aug. 1912), 23.

[95]Stein to AS, Mar. 6, 1912, AS Archive.

[96]"Editorial," *CW*, Special Number (Aug. 1912), 3; AS to John Galsworthy, Oct. 8, 1912, AS Archive; John Galsworthy, "Vague Thoughts on Art," *CW*, 40 (Oct. 1912), 26; cited in Ben Wolf, *Morton Livingston Schamberg* (Philadelphia: Univ. of Pennsylvania Press, 1963), 26.

[97]Marius de Zayas, "The New Art in Paris," *Forum*, 45 (Feb. 1911), 181, 182.

[98]Ibid., 183, 185.

[99]Marius de Zayas, "Modern Art in Connection with Negro Art," *CW*, 48 (Oct. 1916), 7.

[100]AS to Kühn, Jan. 14, 1912, AS Archive; de Zayas and Haviland, *A Study of the Modern Evolution of Plastic Expression*, 33, 34.

[101]"Exhibition Marius de Zayas," *CW*, 42/43 (Apr.-July 1913), 20-22; quoted in Paul B. Haviland, "Marius de Zayas—Material, Relative, and Absolute Caricatures," *CW*, 46 (Apr. 1914), 34. Conservative critics were less kind. One wrote, "And now Marius de Zayas has got it, quite the worse case on record. By this we mean an attack of the prevailing disease for the fantastically obscure in art" ("Wm. B. McCormick in the *N.Y. Press*," *CW*, 42/43 [Apr.-July 1913], 51).

[102]De Zayas, "How, When, and Why Modern Art Came to New York," 114.

[103]De Zayas to AS, Apr. 21, 1911, AS Archive; de Zayas, "Modern Art in Connection with Negro Art," 7.

[104]Marius de Zayas, *African Negro Art: Its Influence on Modern Art* (N.p.: M. de Zayas, 1916), 41.

[105]"Some Remarkable Work by Very Young Artists," *New York Evening Sun*, Apr. 21, 1912.

[106]"Mr. Harrington in the *N.Y. Herald*," *CW*, 39 (July 1912), 48; Kate Simpson to AS, Mar. 1912, AS Archive; "Some Remarkable Work by Very Young Artists."

[107]"Some Remarkable Work by Very Young Artists."

[108]"Some Remarkable Work by Very Young Artists"; "René Guy DuBois [sic] in *Arts and Decoration*," *CW*, 45 (June 1914), 43; Hutchins Hapgood, "Art and Unrest," *CW*, 42/43 (Apr.-July 1913), 43–44; Agnes Ernst Meyer, *Out of These Roots* (Boston: Little, Brown, 1953), 102. In 1940 Stieglitz claimed that Haywood visited his gallery only once, did not look at the pictures on the walls, and pronounced 291 "a dinky little place" of no importance. The story, however, better reflects Stieglitz's misgivings during the depression regarding the split that divided political issues from cultural concerns than it does the

intellectual climate of the Progressive Era, when the various radical forces did join hands in common cause. By 1913 the I.W.W. had in fact forged supportive links with the cultural radicals of New York, the Paterson Pageant being the most dramatic product of that connection. Also, Stieglitz's wife's charge that his "associations with the I.W.W's" contributed to their marital problems, silly as it is, indicates that his tale of 1940, like most of Stieglitz's stories, was more illustrative than true. "Bill Heywood [sic] at 291," Twice-A-Year, 5–6 (Fall-Winter 1940, Spring-Summer 1941), 137; Emmeline Stieglitz to AS, Sept. 2, 1914, AS Archive.

[109]"Platform of Benjamin de Casseres, Candidate for Mayor of New York," in Benjamin de Casseres to AS, n.d., AS Archive; de Casseres to Arthur Burton Rascoe, n.d., Arthur Burton Rascoe Papers, Van Pelt Library.

[110]Benjamin de Casseres, "American Indifference," CW, 27 (July 1909), 24; idem, "The Renaissance of the Irrational," CW, Special Number (June 1913), 23; de Casseres to Theodore Dreiser, n.d., Theodore Dreiser Papers, Van Pelt Library.

[111]De Casseres to AS, n.d., AS Archive; AS to de Casseres, Jan. 21, 1915, AS Archive.

[112]Royal Cortissoz, American Artists (New York: Charles Scribner's Sons, 1923), 18; idem, "The Post-Impressionist Illusion," Century Magazine, 85 (Apr. 1913), 813.

[113]Quoted in Marius de Zayas, "Cubism?" Arts and Decoration, 6 (Apr. 1916), 308; Cortissoz, American Artists, 3; Kenyon Cox, Artists and Public (New York: Charles Scribner's Sons, 1914), 77; idem, "The Modern Spirit in Art," Harper's Weekly, 57 (Mar. 15, 1913), 10.

[114]Walter Lippmann, "The Lost Theme," NR, 6 (Apr. 8, 1916), 258-60.

[115]Theodore Roosevelt, "A Layman's View of an Art Exhibition," Outlook, 103 (Mar. 29, 1913), 719.

[116]"Clarke Talks about Art," CW, 26 (Apr. 1909), 25.

[117]AS to Fritz Goëtz, Dec. 23, 1914, AS Archive.

[118]Thomas Hart Benton, "America and/or Alfred Stieglitz," Common Sense, 4 (Jan. 1935), 22; AS to Thomas Hart Benton, Dec. 29, 1934, AS Archive. For more detail on Stieglitz's relationship with Benton, see my "Alfred Stieglitz and/or Thomas Hart Benton," Arts Magazine, 55 (June 1981), 108–13.

[119]Paul Strand, "Photography and the New God," Broom, 3 (Nov. 1922), 255.

[120]AS to Israel White, Mar. 18, 1913, AS Archive.

[121]"The Maurers and the Marins at the Photo-Secession Gallery," CW, 27 (July 1909), 43; quoted in Norman, Alfred Stieglitz: An American Seer, 97.

[122]Marin's father still thought that his son should commit at least half his time to doing commercial work. Stieglitz responded by asking the elder Marin

232

if he believed a woman could be a prostitute and a virgin simultaneously ("Marin's Father," *Twice-A-Year*, 8–9 [Spring-Summer 1942, Fall-Winter 1942], 158).

[123]"Notes on '291,'" *CW*, 42/43 (Apr.-July 1913), 18.

[124]John Marin to AS, July 22, 1913, AS Archive.

[125]John Marin, *CW*, 47 (Jan. 1915), 74; Arthur Dove, "A Different One," in Frank et al., eds., *America and Alfred Stieglitz*, 245.

[126]Norman, *Alfred Stieglitz: An American Seer*, 101.

[127]Kandinsky, "Extracts from 'The Spiritual in Art,'" *CW*, 39 (July 1912), 34; Rosenfeld, *Port of New York*, 169.

[128]Quoted in Ann Lee Morgan, "An Encounter and Its Consequences: Arthur Dove and Alfred Stieglitz, 1910–1925," *Biography*, 2 (Winter 1979), 44.

[129]Marsden Hartley, "291—and the Brass Bowl,"in Frank et al., eds., *America and Alfred Stieglitz*, 239, 242.

[130]Quoted in Barbara Haskell, *Marsden Hartley* (New York: Whitney Museum of American Art, 1980), 10.

[131]Marsden Hartley to AS, Aug. 20, 1911, AS Archive.

[132]Hartley to Stein, late 1912 or early 1913, Gertrude Stein Papers, Collection of American Literature, Beinecke Rare Book and Ms. Lib.; Hartley to AS, Dec. 20, 1912, AS Archive; Marsden Hartley, *CW*, 45 (Jan. 1914), 17.

[133]Hartley to AS, Feb. 1913, AS Archive.

[134]Quoted in Leonard, *Henri Rousseau and Max Weber*, 47; Max Weber, *Essays on Art* (New York: William Edwin Rudge, 1916), 34.

[135]Arthur Wesley Dow, "Modernism in Art," *American Magazine of Art*, 8 (Jan. 1917), 113–16; Georgia O'Keeffe to Anita Pollitzer, Aug. 25, 1915, AS Archive.

[136]Georgia O'Keeffe, *Georgia O'Keeffe* (New York: Viking Press, 1976), n.p.

[137]O'Keeffe to Pollitzer, Oct. 11, 1915, AS Archive.

[138]O'Keeffe to Pollitzer, Oct. 1915, AS Archive; Pollitzer to O'Keeffe, Jan. 1, 1916, AS Archive.

[139]Hartley, "291—and the Brass Bowl," 240; O'Keeffe to Pollitzer, Jan. 4, 1916, AS Archive; "Georgia O'Keeffe—C. Duncan—René Lafferty," *CW*, 48 (Oct. 1916), 12.

[140] *The Forum Exhibition of Modern American Painters* (New York: Mitchell Kennerley, 1916), 35.

[141]AS to Kühn, May 22, 1912, AS Archive; AS to L. B. Manly, Jan. 14, 1915, AS Archive; AS to George D. Pratt, Dec. 7, 1912, AS Archive.

[142]Paul Haviland, "The Photo-Secession and Photography," *CW*, 31 (July 1910), 42.

[143]AS to Kühn, Oct. 14, 1912, AS Archive.

[144]AS to Schumacher, Apr. 7, 1913, AS Archive.

[145]Quoted in Paul Hill and Thomas Cooper, eds., *Dialogue with Photography* (New York: Farrar, Straus & Giroux, 1979), 5. Charles Sheeler and Morton Schamberg, both painters and photographers, followed Strand's lead in experimenting with abstract photography. Impressed by Schamberg's results, Stieglitz invited him to join the circle at 291 (AS to Morton Schamberg, Dec. 4, 1916, AS Archive). *Paul Strand* (Millerton, N.Y.: Aperture, 1976), 144.

[146]Quoted in Hill and Cooper, eds., *Dialogue with Photography*, 3; AS to R. C. Bayley, Apr. 17, 1916, AS Archive; "Photographs by Paul Strand," *CW*, 48 (Oct. 1916), 11–12.

[147]Paul Strand, "Photography," *SA*, 2 (Aug. 1917), 525.

[148]AS to Hartley, May 4, 1915, AS Archive.

[149]"Ave Caesar Imperator!!! Morituri Te Salutant!" *291*, 3 (May 1915).

[150]De Zayas to AS, July 9, 1914, AS Archive; Meyer, *Out of These Roots*, 102.

[151]Marius de Zayas, *291*, 5–6 (July-Aug. 1915). Picabia shared de Zayas's interpretation. Referring to his abstract paintings which were shown at 291 in 1915, he told a reporter, "Because of your extreme modernity . . . you should quickly understand the studies which I have made since my arrival in New York. They express the spirit of New York as I feel it, and the crowded streets of your city as I feel them, their surging unrest, their commercialism, and their atmospheric charm" (Francis Picabia, "How New York Looks to Me," clipping, AS Archive).

[152]*Blind Man*, 2 (May 1917), 10.

[153]Ibid., 5; quoted in Arturo Schwarz, *The Complete Works of Marcel Duchamp* (London: Thames and Hudson, 1969), 39.

[154]Carl Van Vechten to Gertrude Stein, April— of a Thursday [1917], in Donald Gallup, ed., *The Flowers of Friendship* (New York: Octagon Books, 1979), 116. Although Duchamp wrote in the *Blind Man* that his *Fountain* "disappeared" after he submitted it, such was not the case, as Van Vechten's letter, which notes its current exhibition at 291, makes clear. Duchamp also wrote to Dorothy Norman years later that Stieglitz showed and photographed the readymade. See Norman, *Alfred Stieglitz: An American Seer*, 128.

[155]AS to Mitchell Kennerley, May 17, 1917, AS Archive.

[156]AS to Strand, Aug. 18, 1917, AS Archive.

[157]AS to Abraham Walkowitz, Sept. 1, 1914, AS Archive; AS to Anne Brigman, Sept. 28, 1914, AS Archive.

[158]AS to Goëtz, Dec. 23, 1914, AS Archive.

[159]AS to R. C. Bayley, Nov. 1, 1916, AS Archive; AS to Paul Haviland, Feb. 1, 1917, AS Archive.

[160]Haviland to AS, Sept. 4, 1914, AS Archive; Haviland to AS, Dec. 11, 1915, AS Archive; Steichen, *A Life in Photography*, n.p.; de Zayas to AS, n.d., AS Archive.

[161]Hutchins Hapgood, "What 291 Is to Me," *CW*, 47 (Jan. 1915), 11; Marius de Zayas, "291," ibid., 73; Hodge Kiron, "What 291 Means to Me," ibid., 16. When Sadakichi Hartmann read the "What 291 Means to Me" issue of *CW*, to which he had not contributed, he wrote Stieglitz, "I must confess I never expected to see such an accumulation of balderdash, bombast, rodomontade, gallimaufry, salmagundi, and 'I scratch you on the back if you tickle me' rant and prattle under one cover" (Hartmann to AS, May 20, 1915, AS Archive).

[162]Arthur Hoeber, "What 291 Means to Me," *CW*, 47 (Jan 1915), 49; Eduard Steichen, "291," ibid., 65–66; Steichen to AS, Aug. 27, 1914, AS Archive.

[163]Quoted in Matthew Josephson, "Commander with a Camera—II," *New Yorker*, June 10, 1944, p. 34.

[164]AS to New York Public Library, May 16, 1917, AS Archive; AS to Library of Congress, Apr. 23, 1917, AS Archive; AS to John Wanamaker Co., May 21, 1917, AS Archive. In 1929 Stieglitz did burn two thousand editions of *Camera Work* at Lake George. The destruction of the magazines followed O'Keeffe's decision to take up a summer residence in New Mexico.

[165]Stieglitz received $5.80 for eight thousand copies of *291* (AS, "The Magazine *291* and the Steerage," *Twice-A-Year*, 8–9 [Spring-Summer 1942, Fall-Winter 1942], 135).

4 EPILOGUE

[1]Stephen Spender, *The Struggle of the Modern* (London: Hamish Hamilton, 1963), 5; RB, *Untimely Papers*, ed. James Oppenheim (New York: B. W. Huebsch, 1919), 5.

[2]James Oppenheim, "The Story of the Seven Arts," *American Mercury*, 20 (June 1930), 164. For Marxist views of the cultural radicals, see Michael Gold's columns in the *New Masses* and Joseph Freeman, *An American Testament* (London: Victor Gollancz, 1938).

[3]One Western critic who does believe that cultural developments can have negative political and social consequences is Daniel Bell, who argues in *The Cultural Contradictions of Capitalism* (New York: Basic Books, 1976) that modernism's emphasis on the self, its mystical point of view, and its utopian, sometimes apocalyptic frame of mind still pose a real peril to society's stability. His alarums recall those of an earlier age. Like the progressives of another generation, Bell employs a monistic approach to culture that has little tolerance for ambiguity, irony, or contradiction.

[4]"Stieglitz Assails W.P.A. Art as 'Wall Smears,' " *New York Herald Tribune,* Dec. 3, 1936, 9. Despite their falling-out, in 1946 Strand offered a laudatory obituary of Stieglitz in which he alluded to their contrasting conceptions of photography and politics. "We realize as perhaps [Stieglitz] did not," Strand wrote in a Communist publication, "that the freedom of the artist to create and to give the fruits of his work to people, is indissolubly bound up with the fight for the political and economic freedom of society as a whole" ("Alfred Stieglitz: 1864–1946," *New Masses,* 60 [Aug. 6, 1946], 7). Stieglitz told Dorothy Norman that he sympathized most with the political views of Senator Burton Wheeler of Montana. Wheeler, who saw himself as a true defender of liberalism, joined the conservative opposition to the New Deal on the grounds that Roosevelt's programs placed too much power in the federal government and so threatened personal liberty (Dorothy Norman to author in conversation). For Wheeler's views on the New Deal, see James T. Patterson, *Congressional Conservatism and the New Deal* (Lexington: Univ. of Kentucky Press, 1967), 114–19.

SELECTED
BIBLIOGRAPHY

Manuscript Collections

Randolph Bourne Papers. Rare Book and Manuscript Library, Columbia University, New York.

Van Wyck Brooks Papers. Van Pelt Library, University of Pennsylvania, Philadelphia.

Theodore Dreiser Papers. Van Pelt Library, University of Pennsylvania, Philadelphia.

Waldo Frank Papers. Van Pelt Library, University of Pennsylvania, Philadelphia.

Alyse Gregory Papers. Collection of American Literature, Beinecke Rare Book and Manuscript Library, Yale University, New Haven.

Hutchins Hapgood Papers. Collection of American Literature, Beinecke Rare Book and Manuscript Library, Yale University, New Haven.

Marsden Hartley Papers. Collection of American Literature, Beinecke Rare Book and Manuscript Library, Yale University, New Haven.

Mabel Dodge Luhan Papers. Collection of American Literature, Beinecke Rare Book and Manuscript Library, Yale University, New Haven.

James Oppenheim Papers. Manuscripts and Archives Division, New York Public Library.

Arthur Burton Rascoe Papers. Van Pelt Library, University of Pennsylvania, Philadelphia.

Elizabeth Shepley Sargeant Papers. Collection of American Literature, Beinecke Rare Book and Manuscript Library, Yale University, New Haven.

Gertrude Stein Papers. Collection of American Literature, Beinecke Rare Book and Manuscript Library, Yale University, New Haven.

Alfred Stieglitz Archive. Collection of American Literature, Beinecke Rare Book and Manuscript Library, Yale University, New Haven.

Paul Strand Archive. Center for Creative Photography, University of Arizona, Tucson.

Carl Zigrosser Papers. Van Pelt Library, University of Pennsylvania, Philadelphia.

238

Periodicals

American Amateur Photographer
Atlantic Monthly
Blind Man
Camera Notes
Camera Work
Columbia Monthly
Dial
MSS
New Republic
Seven Arts
Soirées de Paris
Twice-A-Year
291

Books and Pamphlets

Aaron, Daniel. *Writers on the Left*. New York: Oxford Univ. Press, 1977.

Adler, Alfred. *The Neurotic Constitution*. Trans. Bernard Glueck. New York: Moffat Yard, 1917.

————. *Study of Organ Inferiority and Its Psychological Compensation*. Trans. Smith Ely Jelliffe. New York: Nervous and Mental Disease Publishing, 1917.

Akin, William E. *Technocracy and the American Dream*. Berkeley: Univ. of California Press, 1977.

Americanism: Addresses by Woodrow Wilson, Franklin K. Lane, Theodore Roosevelt. N.p.: Americanization Department, Veterans of Foreign Wars of the United States, n.d.

Anderson, Margaret. *My Thirty Years' War*. New York: Covici Friede, 1930.

Anderson, Quentin, et al., eds. *Art, Politics, and Will*. New York: Basic Books, 1977.

An Anonymous Protest against the Present Exhibition of Degenerate "Modernistic" Works in the Metropolitan Museum. New York: N.p., 1921.

Anthony, Katherine. *Feminism in Germany and Scandanavia*. New York: Henry Holt, 1915.

Apollinaire, Guillaume. *The Cubist Painters*. New York: Wittenburn, 1944.

Arens, Egmont. *The Little Book of Greenwich Village*. New York: E. Arens, 1918.

Barr, Alfred H., Jr. *Matisse: His Art and His Public*. New York: Museum of Modern Art, 1951.

Bartholomew, Ralph I. *Greenwich Village*. New York: Champion Coated Paper, 1920.

Barzun, Jacques. *Classic, Romantic, and Modern*. Chicago: Univ. of Chicago Press, 1975.

Baur, John I. H. *Revolution and Tradition in Modern American Art.* Cambridge: Harvard Univ. Press, 1951.

Bell, Daniel. *The Cultural Contradictions of Capitalism.* New York: Basic Books, 1976.

Benton, Thomas Hart. *An Artist in America.* New York: Robert M. McBride, 1937.

Berman, Marshall. *All That Is Solid Melts into Air.* New York: Simon and Schuster, 1982.

Bittner, William. *The Novels of Waldo Frank.* Philadelphia: Univ. of Pennsylvania Press, 1958.

Bourne, Randolph. *Education and Living.* New York: Century, 1917.

——. *The Gary Schools.* Ed. Adeline and Murray Levine. Cambridge: M.I.T. Press, 1970.

——. *The History of a Literary Radical.* Ed. Van Wyck Brooks. New York: B. W. Huebsch, 1920.

——. *The Radical Will.* Ed. Olaf Hansen. New York: Urizen Books, 1977.

——. *Untimely Papers.* Ed. James Oppenheim. New York: B. W. Huebsch, 1917.

——. *War and the Intellectuals.* Ed. Carl Resek. New York: Harper Torchbooks, 1964.

——*Youth and Life.* Boston: Houghton Mifflin, 1913.

——, ed. *Towards an Enduring Peace.* New York: American Association for International Conciliation, 1916.

Bradbury, Malcolm, and James McFarlane, eds. *Modernism.* Middlesex: Penguin Books, 1978.

Brooks, Van Wyck. *American's Coming-of-Age.* New York: B. W. Huebsch, 1915.

——. *An Autobiography.* New York: E. P. Dutton, 1965.

——. *The Confident Years, 1885-1915.* New York: E. P. Dutton, 1952.

——. *Fenollosa and His Circle.* New York: E. P. Dutton, 1962.

——. *Letters and Leadership* New York: B. W. Huebsch, 1918.

——. *The Wine of Puritans.* London: Sisley's, 1908.

Brown, Milton W. *American Painting from the Armory Show to the Depression.* Princeton: Princeton Univ. Press, 1955.

——. *The Story of the Armory Show.* Greenwich, Conn.: Joseph H. Hirshhorn Foundation, 1963.

Bruno, Guido. *Bruno Chap Books.* New York: Privately printed, 1915.

Bry, Doris. *Alfred Stieglitz: Photographer.* Boston: Museum of Fine Arts, 1965.

——. *Exhibition of Photographs by Alfred Stieglitz.* Washington, D.C.: National Gallery of Art, 1958.

Caffin, Charles H. *Photography as a Fine Art.* New York: Doubleday Page, 1901.

Cahill, Holger. *Max Weber.* New York: Downtown Gallery, 1930.

Camfield, William A. *Francis Picabia: His Art, Life and Times.* Princeton: Princeton Univ. Press, 1979.

240

Cantor, Milton. *The Divided Left*. New York: Hill and Wang, 1978.

Carter, Huntley. *The New Spirit in Drama and Art*. New York: Mitchell Kennerley, 1913.

Carter, Paul V. *Waldo Frank*. New York: Twayne, 1967.

Chamberlain, John. *Farewell to Reform*. Chicago: Quadrangle Books, 1965.

Chapin, Anna Alice. *Greenwich Village*. New York: Dodd Mead, 1917.

Churchill, Allen. *The Improper Bohemians*. New York: E. P. Dutton, 1959.

Clayton, Bruce. *Forgotten Prophet: The Life of Randolph Bourne*. Baton Rouge: Louisiana State Univ. Press, 1984.

Cohen, Arthur A., *Acts of Theft*. New York: Harcourt Brace Jovanovich, 1980.

Coke, Van Deren, ed. *One Hundred Years of Photographic History*. Albuquerque: Univ. of New Mexico Press, 1975.

Commons, John R. *Races and Immigrants in America*. New York: Macmillan, 1907.

Conn, Peter. *The Divided Mind: Ideology and Imagination in America, 1898-1917*. Cambridge: Cambridge Univ. Press, 1983.

Cook, Blanche Wiesen, ed. *Crystal Eastman on Women*. New York: Oxford Univ. Press, 1978.

Cortissoz, Royal. *American Artists*. New York: Charles Scribner's Sons, 1923.

———. *Art and Common Sense*. New York: Charles Scribner's Sons, 1913.

Cowley, Malcolm. *Exile's Return*. New York: Penguin, 1978.

Cox, Kenyon. *Artist and Public*. New York: Charles Scribner's Sons, 1914.

Cremin, Lawrence. *The Transformation of the School*. New York: Vintage Books, 1961.

Croly, Hebert. *Progressive Democracy*. New York: Macmillan, 1914.

———. *The Promise of American Life*. New York: Macmillan, 1909.

———. *Willard Straight*. New York: Macmillan, 1924.

Crunden, Robert M. *Ministers of Reform*. New York: Basic Books, 1982.

Dahlberg, Edward. *Alms for Oblivion*. Minneapolis: Univ. of Minnesota Press, 1964.

Davidson, Abraham. *Early American Modernist Painting*. New York: Harper and Row, 1981.

Davidson, Jo. *Between Sittings*. New York: Dial Press, 1951.

Davis, Allen F. *American Heroine: The Life and Legend of Jane Addams*. New York: Oxford Univ. Press, 1973.

———. *Spearheads for Reform*. New York: Oxford Univ. Press, 1967.

de Casseres, Benjamin. *The Shadow Eater*. New York: Albert and Charles Boni, 1915.

Dell, Floyd. *Homecoming*. New York: Farrar and Rinehart, 1933.

———. *Intellectual Vagabondage*. New York: George H. Dorran, 1926.

———. *Love in Greenwich Village*. New York: George H. Dorran, 1926.

———. *Women as World Builders*. Chicago: Forbes, 1913.

Dewey, John. *Democracy and Education*. New York: Macmillan, 1916.

———. *The School and Society*. Chicago: Univ. of Chicago Press, 1916.

de Zayas, Marius. *African Negro Art: Its Influence on Modern Art*. N.p.: M. de Zayas, 1916.

———,and Paul B. Haviland. *A Study of the Modern Evolution of Plastic Expressionism*. New York: "291," 1913.

Diggins, John P. *The American Left in the Twentieth Century*. New York: Harcourt Brace Jovanovich, 1973.

———. *Up from Communism*. New York: Harper and Row, 1975.

Dijkstra, Bram. *The Hieroglyphics of a New Speech*. Princeton: Princeton Univ. Press, 1969.

Dochterman, Lillian. *The Quest of Charles Sheeler*. Iowa City: Univ. of Iowa, 1963.

Doty, Robert. *Photo-Secession: Photography as a Fine Art*. New York: George Eastman House, 1960.

Dow, Arthur Wesley. *Composition*. Garden City, N.Y.: Doubleday Page, 1920.

———. *Theory and Practice of Teaching Art*. New York: Teachers College Columbia University, 1908.

Eastman, Max. *Enjoyment of Living*. New York: Harper and Brothers, 1948.

———. *Love and Revolution*. New York: Random House, 1964.

Eddy, Arthur Jerome. *Cubists and Post-Impressionists*. Chicago: A. C. McClurg, 1914.

Edmiston, Susan, and Linda D. Cirino, eds. *Literary New York: A History and Guide*. Boston: Houghton Mifflin, 1976.

Emerson, P. H. *Naturalistic Photography*. New York: E. and F. Spon, 1889.

Farnham, Emily. *Charles Demuth*. Norman: Univ. of Oklahoma Press, 1971.

Filler, Louis. *Randolph Bourne*. Washington, D.C.: American Council on Public Affairs, 1943.

Fishbein, Leslie. *Rebels In Bohemia*. Chapel Hill: Univ. of North Carolina Press, 1982.

Fitzgerald, Richard. *Art and Politics: Cartoonists of the* Masses *and* Liberator. Westport, Conn.: Greenwood Press, 1973.

Forcey, Charles. *The Crossroads of Liberalism*. New York: Oxford Univ. Press, 1961.

The Forum Exhibition of Modern American Painting. New York: Mitchell Kennerley, 1916.

Frank Waldo. *Our America*. New York: Boni and Liveright, 1919.

———. *The Re-discovery of America*. New York: Charles Scribner's Sons, 1929.

———. *Time Exposures*. New York: Boni and Liveright, 1926.

———, et al., eds. *America and Alfred Stieglitz*. New York: Doubleday Doran, 1934.

Freeman, Joseph. *An American Testament*. London: Victor Gollancz, 1938.

Freund, Gisèle. *Photography and Society*. Boston: David R. Godine, 1980.

Gallup, Donald, ed. *The Flowers of Friendship: Letters Written to Gertrude Stein*. New York: Octagon Books, 1979.

Gee, Helen. *Stieglitz and the Photo-Secession*. Trenton: New Jersey State Museum, 1978.

242

Geldzahler, Henry. *American Painting in the Twentieth Century*. New York: Metropolitan Museum of Art, 1965.

Georgia O'Keeffe: A Portrait by Alfred Stieglitz. New York: Metropolitan Museum of Art, 1978.

Gernsheim, Helmut and Alison, eds. *Alvin Langdon Coburn, Photographer*. New York: Frederick A. Praeger, 1966.

Gilbert, James B. *Writers and Partisans*. New York: John Wiley and Sons, 1968.

Goldwater, Robert J. *Primitivism in Modern Painting*. New York: Harper and Brothers, 1938.

———. *Symbolism*. New York: Harper and Row, 1979.

Goodrich, Lloyd, and Doris Bry. *Georgia O'Keeffe*. New York: Praeger, 1970.

———. *Max Weber* New York: Macmillan, 1949.

Green, Jonathan, ed. *Camera Work: A Critical Anthology*. Millerton, N.Y. Aperture, 1973.

Greenough, Sarah, and Juan Hamilton. *Alfred Stieglitz*. Washington, D.C.: National Gallery of Art, 1983.

Gregory, Alyse. *The Day Is Gone*. New York: E. P. Dutton, 1948.

Haber, Samuel. *Efficiency and Uplift*. Chicago: Univ. of Chicago Press, 1964.

Hahn, Emily. *Mabel: A Biography of Mabel Dodge Luhan*. Boston: Houghton Mifflin, 1977.

———. *Romantic Rebels*. Boston: Houghton Mifflin, 1967.

Hale, Nathan. *Freud and the Americans*. New York: Oxford Univ. Press, 1971.

Handlin, Oscar. *John Dewey's Challenge to Education*. New York: Harper and Brothers, 1959.

Hapgood, Hutchins. *Fire and Revolution*. New York: Free Speech League, 1912.

———. *Story of a Lover*. New York: Boni and Liveright, 1919.

———. *A Victorian in the Modern World*. Seattle: Univ. of Washington Press, 1972.

Hartley, Marsden. *Adventures in the Arts*. New York: Boni and Liveright, 1921.

Hartmann, Sadakichi. *Conversations with Walt Whitman*. New York: E. P. Coby, 1895.

———. *A History of American Art*, 2 vols. London: Hutchinson, 1903.

———. *Japanese Art*. Boston: L. C. Page, 1903.

———. *The Valiant Knights of Daguerre*. Ed. Harry W. Lawton and George Knox. Berkeley: Univ. of California Press, 1978.

Hartshorne, Thomas L. *The Distorted Image*. Cleveland: Press of Case Western Reserve, 1968.

Haskell, Barbara. *Marsden Hartley*. New York: Whitney Museum of American Art, 1980.

Hays, Samuel P. *The Response to Industrialism, 1885–1914*. Chicago: Univ. of Chicago Press, 1957.

Helm, Mackinley. *John Marin*. Boston: Pellegrini and Cudahy, 1948.

Higham, John. *From Boundlessness to Consolidation*. Ann Arbor: William L. Clements Library, 1969.

—————. *Strangers in the Land*. New York: Atheneum, 1975.

Hilfer, Anthony C. *The Revolt from the Village, 1915–1930*. Chapel Hill: Univ. of North Carolina Press, 1969.

Hill, Paul, and Thomas Cooper, eds. *Dialogue with Photography*. New York: Farrar, Straus & Giroux, 1979.

Hoeveler, J. David, Jr. *The New Humanism*. Charlottesville: Univ. Press of Virginia, 1977.

Hoffman, Frederick J., et al. *The Little Magazine*. Princeton: Princeton Univ. Press, 1946.

Homer, William Innes. *Alfred Stieglitz and the American Avant-Garde*. Boston: New York Graphic Society, 1977.

—————. *Alfred Stieglitz and the Photo-Secession*. Boston: Little Brown, 1983.

—————. *Robert Henri and His Circle*. Ithaca: Cornell Univ. Press, 1969.

—————, ed. *Avant-Garde Painting and Sculpture in America, 1910–1925*. Wilmington: Delaware Art Museum, 1975.

Hoopes, James. *Van Wyck Brooks*. Amherst: Univ. of Massachusetts Press, 1977.

Howe, Irving. *World of Our Fathers*. Harcourt Brace Jovanovich, 1976.

Howe, Winifred E. *A History of the Metropolitan Museum of Art*. New York: Metropolitan Museum of Art, 1913.

Hughes, H. Stuart. *Consciousness and Society*. New York: Vintage Books, 1961.

Humphrey, Robert E. *Children of Fantasy*. New York: John Wiley and Sons, 1978.

International Exhibition of Modern Art. N.p.: Association of American Painters and Sculptors, 1913.

James, William. *A Pluralist Universe*. London: Longmans Green, 1909.

Jay, Bill. *Robert Demachy*. London: Academy Editions, 1974.

Johnson, Donald. *The Challenge to American Freedoms*. N.p.: Univ. of Kentucky Press, 1963.

Jullian, Philippe. *Dreamers of Decadence*. Trans. Robert Baldick. New York: Praeger, 1971.

—————. *The Symbolists*. Trans. Mary Anne Stevens. London: Phaidon, 1973.

Jussim, Estelle. *Slave to Beauty: The Eccentric Life and Controversial Career of F. Holland Day*. Boston: David R. Godine, 1981.

Kandinsky, Wassily. *Concerning the Spiritual in Art*. New York: Wittenborn Art Books, 1976.

Kazin, Alfred. *New York Jew*. New York: Alfred A. Knopf, 1978.

—————. *On Native Grounds*. New York: Harcourt Brace Jovanovich, 1970.

—————. *Starting Out in the Thirties*. Boston: Little Brown, 1965.

Kellner, Bruce. *Carl Van Vechten and the Irreverent Decades*. Norman: Univ. of Oklahoma Press, 1968.

244

Keppel, Frederick. *Columbia.* New York: Oxford Univ. Press, 1914.

Kramer, Hilton. *The Age of the Avant-Garde.* New York: Farrar, Straus & Giroux, 1973.

Kreymborg, Alfred. *Troubadour.* New York: Boni and Liveright, 1925.

Lasch, Christopher. *The Agony of the American Left.* New York: Alfred A. Knopf, 1969.

————. *The New Radicalism in America, 1889-1963.* New York: Vintage Books, 1965.

Laurvik, J. Nilsen. *Is It Art?* New York: International Press, 1913.

Lears, T. J. Jackson. *No Place of Grace.* New York: Pantheon, 1981.

Lebel, Robert. *Marcel Duchamp.* Trans. George Hamilton Heard. New York: Paragraphic Books, 1959.

Leonard, Sandra E. *Henri Rousseau and Max Weber.* New York: Richard L. Feigen, 1970.

Lerman, Leo. *The Museum: One Hundred Years and the Metropolitan Museum of Art.* New York: Viking Press, 1969.

Lippmann, Walter L. *Drift and Mastery.* New York: Mitchell Kennerley, 1914.

————. *A Preface to Politics.* New York: Mitchell Kennerley, 1913.

Lipton, Eunice. *Picasso Criticism, 1901–1939.* New York: Garland Publishing, 1976.

Lisle, Laurie. *Portrait of an Artist: A Biography of Georgia O'Keeffe.* New York: Seaview Books, 1980.

Longwell, Dennis. *Steichen: The Master Prints, 1885–1914.* New York: Museum of Modern Art, 1978.

Lowe, Sue Davidson. *Stieglitz.* New York: Farrar, Straus & Giroux, 1983.

Lucie-Smith, Edward. *The Invented Eye.* New York: Paddington Press, 1975.

————. *Symbolist Art.* New York: Praeger, 1972.

Luhan, Mabel Dodge. *Movers and Shakers.* New York: Harcourt Brace, 1936.

Lyons, Nathan, ed. *Photographers on Photography.* Englewood Cliffs, N.J.: Prentice-Hall, 1966.

McCausland, Elizabeth. *A. H. Maurer.* New York: A. A. Wyn, 1951.

————. *Marsden Hartley.* Minneapolis: Univ. of Minnesota Press, 1952.

McDarrah, Fred. W. *Greenwich Village.* New York: Corinth Books, 1963.

Malcolm, Janet. *Diana and Nikon: Essays on the Aesthetics of Photography.* Boston: David R. Godine, 1980.

Marcaccio, Michael D. *The Hapgoods.* Charlottesville: Univ. Press of Virginia, 1977.

May, Henry F. *The End of American Innocence.* Chicago: Quadrangle Books, 1964.

Mayer, Edwin J. *A Preface to Life.* New York: Boni and Liveright, 1923.

Mellquist, Jerome. *The Emergence of an American Art.* New York: Charles Scribner's Sons, 1942.

————, and Lucie Wiese, eds. *Paul Rosenfeld: Voyager in the Arts.* New York: Creative Age Press, 1948.

Meyer, Agnes E. *Out of These Roots*. Boston: Little Brown, 1953.
Moffatt, Frederick C. *Arthur Wesley Dow*. Washington, D.C.: Smithsonian Institution Press, 1977.
Moreau, John Adam. *Randolph Bourne*. Washington, D.C.: Public Affairs Press, 1966.
Morgan, H. Wayne. *New Muses: Art in American Culture, 1865–1920*. Norman: Univ. of Oklahoma Press, 1978.
Munson, Gorham B. *Waldo Frank*. New York: Boni and Liveright, 1923.
Murphy, Paul L. *World War I and the Origin of Civil Liberties in the United States*. New York: W. W. Norton, 1979.
Naef, Weston. *The Collection of Alfred Stieglitz*. New York: Metropolitan Museum of Art, 1978.
Nelson, Raymond. *Van Wyck Brooks: A Writer's Life*. New York: E. P. Dutton, 1981.
Newhall, Beaumont. *The History of Photography*. New York: Museum of Modern Art, 1964.
Newman, Sasha M. *Arthur Dove and Duncan Phillips*. Washington, D.C.: The Phillips Collection, 1981.
Noble, David W. *The Paradox of Progressive Thought*. Minneapolis: Univ. of Minnesota Press, 1958.
———. *The Progressive Mind, 1890–1917*. Chicago: Rand McNally, 1970.
Norman, Dorothy. *Alfred Stieglitz*. Millerton, N.Y.: Aperture, 1976.
———. *Alfred Stieglitz: An American Seer*. New York: Random House, 1973.
———. *Alfred Stieglitz: Introduction to an American Seer*. New York: Duell Sloan and Pearce, 1960.
———, ed. *The Selected Writings of John Marin*. New York: Pellegrini and Cudahy, 1949.
O'Keeffe, Georgia. *Georgia O'Keeffe*. New York: Viking Press, 1976.
O'Neill, William L., ed. *Echoes of Revolt: The Masses, 1911–1917*. New York: Quadrangle Books, 1966.
———. *The Last Romantic: A Life of Max Eastman*. New York: Oxford Univ. Press, 1978.
Oppenheim, James. *Songs for the New Age*. New York: Century, 1914.
Oppenheimer, Franz. *The State*. Trans. John M. Gitterman. Indianapolis: Bobbs-Merrill, 1914.
Ostrander, Gilman M. *American Civilization in the First Machine Age, 1890–1940*. New York: Harper and Row, 1970.
Pach, Walter. *Queer Thing, Painting*. New York: Harper and Brothers, 1938.
Paret, Peter. *The Berlin Succession*. Cambridge: Belknap Press of Harvard Univ. Press, 1980.
Parry, Albert. *Garrets and Pretenders*. New York: Covici Friede, 1933.
Parsons, Melinda Boyd. *To All Believers: The Art of Pamela Colman Smith*. Wilmington: Delaware Art Museum, 1975.
Paul, Sherman. *Randolph Bourne*. Minneapolis: Univ. of Minnesota Press, 1966.

246

————. *Repossessing and Renewing: Essays in the Green American Tradition*. Baton Rouge: Louisiana State Univ. Press, 1976.

Paul Strand. Millerton, N.Y.: Aperture, 1976

Paz, Octavio. *Marcel Duchamp*. New York: Viking Press, 1978.

Penrose, Roland. *Man Ray*. Boston: New York Graphic Society, 1975.

Photography Rediscovered. New York: Whitney Museum of American Art, 1979.

Photo-Secession. Lunn Gallery Graphics International Catalog, 6. Washington, D.C. 1977.

Photo-Secessionism and Its Opponents: Five Recent Letters. New York: N.p. 1910.

Poggioli, Renato. *The Theory of the Avant-Garde*. Trans. Gerald Fitzgerald. Cambridge: Belknap Press of Harvard Univ. Press, 1968.

Poore, Henry Rankin. *The Conception of Art*. New York: G. P. Putnam's Sons, 1913.

————. *The New Tendency in Art*. Garden City, N.Y.: Doubleday Page, 1913.

Preston, William, Jr. *Aliens and Dissenters*. Cambridge: Harvard Univ. Press, 1963.

Pusey, Merlo J. *Eugene Meyer*. New York: Alfred A. Knopf, 1974.

Quennell, Peter, ed. *The Salon*. Washington, D.C.: New Republic Books, 1979.

Ray, Man. *Self-Portrait*. Boston: Little Brown, 1963.

Reed, John. *The Day in Bohemia, or, Life among the Artists*. New York: Privately printed, 1913.

Reich, Sheldon. *John Marin*. Tucson: Univ. of Arizona Press, 1970.

Reid, B. L. *The Man from New York: John Quinn and His Friends*. New York: Oxford Univ. Press, 1968.

Rideout, Walter B. *The Radical Novel in the United States, 1900–1954*. Cambridge: Harvard Univ. Press, 1956.

Robinson, Henry Peach. *Pictorial Effect in Photography*. London: Pier & Carter, 1869.

Rose, Barbara. *American Art since 1900*. New York: Praeger, 1973.

Rosenberg, Harold. *Discovering the Present*. Chicago: Univ. of Chicago Press, 1973.

————. *The Tradition of the New*. New York: Horizon Press, 1959.

Rosenblum, Robert. *Modern Painting and the Northern Romantic Tradition*. New York: Harper and Row, 1975.

Rosenfeld, Paul. *Men Seen*. New York: Dial Press, 1925.

————. *Port of New York*. New York: Harcourt Brace, 1924.

Rosenstone, Robert. *Romantic Revolutionary: A Biography of John Reed*. New York: Alfred A. Knopf, 1975.

Ross, Edward A. *The Old World in the New*. New York: Century, 1914.

Rourke, Constance. *Charles Sheeler*. New York: Harcourt Brace, 1938.

Sandeen, Eric J., ed. *The Letters of Randolph Bourne*. Troy, N.Y.: Whiston, 1981.

Santayana, George. *Winds of Doctrine*. New York: Charles Scribner's Sons, 1913.

Schapiro, Meyer. *Modern Art*. New York: George Braziller, 1978.

Scharf, Aaron. *Art and Photography*. Baltimore: Penguin Books, 1974.

Schorske, Carl E. *Fin-de-Siècle Vienna*. New York: Alfred A. Knopf, 1980.

Schlissel, Lillian, ed. *The World of Randolph Bourne*. New York: E. P. Dutton, 1965.

Schwarz, Arturo. *The Complete Works of Marcel Duchamp*. London: Thames and Hudson, 1969.

————. *Man Ray*. London: Thames and Hudson, 1977.

Sedgwick, Ellery. *The Happy Profession*. Boston: Little Brown, 1947.

Seligmann, Herbert J. *Alfred Stieglitz Talking*. New Haven: Yale Univ. Press, 1966.

Shapiro, David, ed. *Social Realism: Art as a Weapon*. New York: Frederick Unger Publishing, 1973.

Shapiro, Theda. *Painters and Politics: The European Avant-Garde and Society, 1900–1925*. New York: Elsevier, 1976.

Shattuck, Roger. *The Banquet Years: The Origins of the Avant-Garde in France, 1885 to World War I*. New York: Vintage Books, 1968.

Sochen, June, ed. *Movers and Shakers: American Women Thinkers and Activists, 1900–1970*. New York: Quadrangle Books, 1973.

————. *The New Woman In Greenwich Village, 1910–1920*. New York: Quadrangle Books, 1972.

Sontag, Susan. *On Photography*. New York: Farrar, Straus & Giroux, 1977.

Spender, Stephen. *The Struggle of the Modern*. London: Hamish Hamilton, 1963.

Sprague, Claire, ed. *Van Wyck Brooks: The Early Years*. New York: Harper Torchbooks, 1968.

Spring, Joel. *Education and the Rise of the Corporate State*. Boston: Beacon Press, 1972.

Stearns, Harold E., ed. *Civilization in the United States*. New York: Harcourt Brace, 1972.

————. *The Street I Know*. New York: Leo Furman, 1935.

Steegmuller, Francis. *Apollinaire: Poet among Painters*. New York: Farrar Straus, 1963.

Steel, Ronald. *Walter Lippmann and the American Century*. Boston: Little Brown, 1980.

Steichen, Edward. *A Life in Photography*. Garden City, N.Y.: Doubleday, 1963.

Stieglitz, Alfred. *Camera Work: A Pictorial Guide*. Ed. Marianne Fulton Margolis. New York: Dover Publications, 1978.

Stieglitz Memorial Portfolio, 1864–1946. New York: Twice-A-Year Press, 1947.

Tashjian, Dickran. *Skyscraper Primitives: Dada and the American Avant-Garde, 1910–1925*. Middletown, Conn.: Wesleyan Univ. Press, 1975.

248

————. *William Carlos Williams and the American Scene, 1920–1940*. New York: Whitney Museum of American Art, 1978.

Trachtenberg, Alan, ed. *Memoirs of Waldo Frank*. Amherst: Univ. of Massachusetts Press, 1973.

Trilling, Lionel. *Beyond Culture*. New York: Viking Press, 1965.

Trotter, W. *Instincts of the Herd in Peace and War*. New York; Macmillan, 1916.

Untermeyer, Louis. *From Another World*. New York: Harcourt Brace, 1939.

Van Vechten, Carl. *Peter Whiffle*. New York: Alfred A. Knopf, 1922.

————, ed. *Selected Writings of Gertrude Stein*. New York: Vintage Books, 1972.

Vitelli, James R. *Randolph Bourne*. Boston: Twayne, 1981.

Ware, Caroline. *Greenwich Village, 1920-1930*. New York: Houghton Mifflin, 1935.

Walters, Thomas N. *Randolph Silliman Bourne: Education through Radical Eyes*. Kennebunkport, Maine: Mercer House, 1982.

Wasserstrom, William. *The Time of the* Dial. Syracuse: Syracuse Univ. Press, 1963.

————. *Van Wyck Brooks*. Minneapolis: Univ. of Minnesota Press, 1968.

Weber, Max. *Cubist Poems*. London: Elkin Mathews, 1914.

————. *Essays on Art*. New York: William Edwin Rudge, 1916.

Weinberg, Julius. *Edward Alsworth Ross and the Sociology of Progressivism*. Madison: State Historical Society of Wisconsin, 1972.

Weinstein, James. *The Corporate Ideal in the Liberal State, 1900-1918*. Boston: Beacon Press, 1968.

Werner, Alfred. *Max Weber*. New York: Harry N. Abrams, 1975.

Wertheim, Arthur Frank. *The New York Little Renaissance*. New York: New York Univ. Press, 1976.

Weyl, Walter E. *The New Democracy*. New York: Macmillan, 1912.

White, Morton. *Social Thought in America*. Boston: Beacon Press, 1957.

Wiebe, Robert H. *The Search for Order, 1877-1920*. New York: Hill and Wang, 1967.

Wight, Frederick S. *Arthur G. Dove*. Berkeley: Univ. of California Press, 1958.

Wilder, Mitchell A., ed. *Georgia O'Keeffe*. N.p.: Amon Carter Museum of Western Art, 1966.

Wolf, Ben. *Morton Livingston Schamberg*. Philadelphia: Univ. of Pennsylvania Press, 1963.

Wright, Willard Huntington. *Modern Painting*. New York: John Lane, 1915.

Young, Art. *Art Young: His Life and Times*. Ed. John N. Beffel. New York: Sheridan House, 1939.

Young, Mahonri Sharp. *Early American Moderns*. New York: Watson-Guptill Publications, 1974.

Zigrosser, Carl. *The Artist in America*. New York: Alfred A. Knopf, 1942.

————. *My Own Shall Come to Me*. N.p., Casa Laura, 1971.

————. *A World of Art and Museums*. Philadelphia: Art Alliance Press, 1975.

Zilczer, Judith. *"The Noble Buyer": John Quinn, Patron of the Avant-Garde.* 249
Washington, D.C.: Smithsonian Institution Press, 1978.

Articles

Aaron, Daniel. "American Prophet." *New York Review*, 25 (Nov. 23, 1978), 36–40.

Abrahams, Edward. "Alfred Stieglitz and/or Thomas Hart Benton." *Arts Magazine*, 55 (June 1981), 108–13.

———. "Alfred Stieglitz and the Metropolitan Museum of Art." *Arts Magazine*, 53 (June 1979), 86–89.

———. "Randolph Bourne on Feminism and Feminists." *Historian*, 43 (May 1981), 365–77.

"American Photography Honored." *Outlook*, 136 (Feb. 20, 1924), 296–98.

Anderson, Sherwood. "Alfred Stieglitz." *NR*, 32 (Oct. 25, 1922), 215–17.

Bailey, Craig R. "The Art of Marius de Zayas." *Arts Magazine*, 53 (Sept. 1978), 136–44.

Beringause, A. F. "The Double Martyrdom of Randolph Bourne." *Journal of the History of Ideas*, 18 (Oct. 1957), 594–99.

Bohn, Willard. "The Abstract Vision of Marius de Zayas." *Art Bulletin*, 62 (Sept. 1980), 434–52.

———. "Marius de Zayas and Visual Poetry: 'Mental Reactions.' " *Arts Magazine*, 55 (June 1981), 114–17.

Bourke, Paul F. "The Status of Politics, 1909-1919: The *New Republic*, Randolph Bourne, and Van Wyck Brooks." *Journal of American Studies*, 8 (Aug. 1974), 171–202.

Buffet-Picabia, Gabrielle. "Some Memories of Pre-Dada: Picabia and Duchamp." In Robert Motherwell, ed. *The Dada Painters and Poets* (New York: Wittenborn Shultz, 1951), 255–67.

Corn, Wanda M. "Apostles of the New American Art: Waldo Frank and Paul Rosenfeld." *Arts Magazine*, 54 (Feb. 1980), 159–63.

———. "Toward a Native Art." *Wilson Quarterly*, 5 (Sum. 1981), 166–77.

Davidson, Abraham A. "Early American Modernists: The Stieglitz Group." *Arts and Antiques*, 3 (Sept.-Oct. 1980), 69–77.

Dell, Floyd. "Randolph Bourne." *NR*, 7 (Jan. 4, 1919), 376.

———. "The Rise and Fall of Greenwich Village." *Century*, 110 (Oct. 1925), 643–55.

Diggins, John P. "The *New Republic* and Its Times." *NR*, 191 (Dec. 10, 1984), 23–73.

de Zayas, Marius. "How, When, and Why Modern Art Came to New York." *Arts Magazine*, 54 (Apr. 1980), 96–126.

Dow, Arthur Wesley. "Modernism in Art." *American Magazine of Art*, 8 (Jan. 1917), 113–16.

Dreiser, Theodore. "Appearance and Reality." In *The American Spectator Yearbook* (New York: Frederick A. Stokes, 1934), 204–9.

250

————. "A Remarkable Art, the New Pictorial Photography." *Great Round World*, 19 (May 3, 1902), 430–34.

Egbert, Donald D. "The Idea of 'Avant-Garde' in Art And Politics." *American Historical Review*, 73 (Dec. 1967), 339–66.

Fairlie, Henry. "A Radical and a Patriot." *NR*, 188 (Feb. 28, 1983), 25–32.

Farrell, John C. "John Dewey and World War I." *Perspectives in American History*, 9 (1975), 299–340.

Frank, Waldo. "How I Came to Communism." *New Masses*, 8 (Sept. 1932), 6–7.

Gallup, Donald. "The Weaving of a Pattern: Marsden Hartley and Gertrude Stein." *Magazine of Art*, (Nov. 1948), 256–261.

G.B. "The Passing of '291.' " *Pearson's Magazine*, 13 (Mar. 1918), 402–3.

Hays, Samuel P. "The Politics of Municipal Reform." *Pacific Northwest Quarterly*, 55 (Oct. 1964), 157–69.

Heard, George Hamilton. "The Alfred Stieglitz Collection." *Metropolitan Museum Journal*, 3 (1970), 371–392.

Hess, Thomas B., and John Ashbery, eds. "The Avant-Garde." *Art News Annual*, 34 (1968).

Higham, John. "The Reorientation of American Culture in the 1890's." In *Writing American History* (Bloomington: Indiana Univ. Press, 1970), 73–102.

Hollinger, David A. "Ethnic Diversity, Cosmopolitanism and the Emergence of the Liberal Intelligentsia." *American Quarterly*, 27 (May 1975), 131–51.

————. "Science and Anarchy: Walter Lippmann's *Drift and Mastery*." *American Quarterly*, 29 (Winter 1977), 463–75.

Homer, William Innes. "Edward Steichen as Painter and Photographer, 1897–1908." *American Art Journal*, 6 (Nov. 1974), 45–55.

————. "Identifying Arthur Dove's 'The Ten Commandments.' " *American Art Journal*, 12 (Summer 1971), 21–32.

Hoopes, James. "The Culture of Progressivism: Croly, Lippmann, Brooks, Bourne, and the Idea of American Artistic Decadence." *Clio*, 7 (1977), 91–111.

Hyland, Douglas K. S. "Agnes Ernst Meyer, Patron of American Modernism." *American Art Journal*, 12 (Winter 1980), 64–81.

Josephson, Matthew. "Commander with a Camera—II." *New Yorker*, Jun. 10, 1944, pp. 29–41.

Kaplan, Sidney. "Social Engineers as Saviors: Effects of World War I on Some American Liberals." *Journal of the History of Ideas*, 17 (June 1956), 347–69.

Krauss, Rosalind. "Alfred Stieglitz's 'Equivalents.' " *Arts Magazine*, 54 (Feb. 1980), 134–37.

Laski, Harold. "The Liberalism of Randolph Bourne." *Freeman*, 1 (May 1920), 237–38.

Laurvik, J. Nilsen. "Alfred Stieglitz, Pictorial Photographer." *International Studio*, 44 (Aug. 1911), XXI–XXVII.

Leonard, Neil. "Alfred Stieglitz and Realism." *Art Quarterly*, 29 (1966), 277–86.

Lerner, Max. "Randolph Bourne and Two Generations." *Twice-A-Year*, 5–6 (Fall-Winter 1940, Spring-Summer 1941), 54–78.

Levin, Gail. "Marsden Hartley and the European Avant-Garde." *Arts Magazine*, 54 (Sept. 1979), 158–63.

Liasson, Mara. "The Eight and 291: Radical Art in the First Two Decades of the 20th Century." *American Art Review*, 2 (July-Aug. 1975), 91–106.

Longwell, Dennis. "Alfred Stieglitz vs. the Camera Club of New York." *Image*, 14 (Dec. 1971), 21–23.

Lynn, Kenneth S. "The Rebels of Greenwich Village." *Perspectives in American History*, 8 (1974), 335–77.

McDonald, M. Irwin. "The Fairy Faith and Pictured Music of Pamela Colman Smith." *Craftsman*, 23 (Oct. 1912), 20–34.

Maddox, Jerald C. "Photography in the First Decade." *Art in America*, 61 (Aug. 1973), 72–79.

Miller, Henry. "Stieglitz and Marin." *Twice-A-Year*, 8–9 (Spring-Summer 1942, Fall-Winter 1942), 146–55.

Morgan, Ann Lee. "An Encounter and Its Consequences: Arthur Dove and Alfred Stieglitz." *Biography*, 2 (Winter 1979), 35–59.

Mumford, Lewis. "The Image of Randolph Bourne." *NR*, 64 (Sept. 24, 1930), 151–52.

Noble, David W. "The *New Republic* and the Idea of Progress, 1914–1920." *Mississippi Valley Historical Review*, 38 (Dec. 1951), 387–402.

Norman, Dorothy. "From the Writings and Conversations of Alfred Stieglitz." *Twice-A-Year*, 1 (Fall-Winter 1938), 77–110.

O'Keeffe, Georgia. "Stieglitz: His Pictures Collected Him." *New York Times Magazine* (Dec. 11, 1949), 24, 26, 28–30.

Oppenheim, James. "Randolph Bourne." *Liberator*, 1 (Feb. 1919), 14–15.

———. "The Story of the Seven Arts." *American Mercury*, 20 (June 1930), 156–64.

Plagens, Peter. "The Critics: Hartmann, Huneker, de Casseres." *Art In America*, 61 (Aug. 1973), 66–71.

Pollitzer, Anita. "That's Georgia." *Saturday Review of Literature* (Nov. 4, 1950), 41–43.

Potter, Hugh. "Paul Rosenfeld: Criticism and Prophecy." *American Quarterly*, 22 (Spring 1970), 82–94.

Reed, John. "Almost Thirty." *NR*, 131 (Nov. 22, 1954), 34–40.

Reich, Sheldon. "Abraham Walkowitz: Pioneer of American Modernism." *American Art Journal*, 3 (Spring 1971), 72–83.

Rose, Barbara. "O'Keeffe's Trail." *New York Review*, 24 (Mar. 31, 1977), 29–33.

252

Rosenfeld, Paul. "Alfred Stieglitz." *Twice-A-Year*, 14–15 (Fall-Winter 1946–47), 203–05.

———. "Randolph Bourne." *Dial*, 75 (Dec. 1923), 545–60.

Shiffman, Joseph. "The Alienation of the Artist: Alfred Stieglitz." *American Quarterly*, 3 (Fall 1951), 244–58.

Sillen, Samuel. "The Challenge of Randolph Bourne." *Masses and Mainstream*, 6 (Dec. 1953), 24–32.

Stieglitz, Alfred. "Four Happenings." *Twice-A-Year*, 8–9 (Spring-Summer 1942, Fall-Winter 1942), 105–36.

———. "Four Marin Stories." *Twice-A-Year*, 8–9 (Spring-Summer 1942, Fall-Winter 1942), 156–62.

———. "How I Came to Photograph Clouds." *Amateur Photography and Photography* (Sept. 19, 1923), 255.

———. "Six Happenings." *Twice-A-Year*, 14–15 (Fall-Winter, 1946-47), 188–202.

———. "Ten Stories." *Twice-A-Year* 5–6 (Fall-Winter 1940, Spring-Summer 1941), 135–63.

———. "Thoroughly Unprepared." *Twice-A-Year*, 10–11 (Fall-Winter 1943), 245–64.

———. "Three Parables and a Happening." *Twice-A-Year*, 8–9 (Spring-Summer 1942, Fall-Winter 1942), 163–71.

Strand, Paul. "Alfred Stieglitz: 1864–1946." *New Masses*, 60 (Aug. 6, 1946), 6–7.

———. "Alfred Stieglitz and a Machine." *MSS*, 2 (Mar. 1922), 6–7.

———. "Photography and the New God." *Broom*, 3 (Nov. 1922), 252–58.

Sussman, Warren I. "Personality and the Making of Twentieth-Century Culture." In John Higham and Paul Conkin, eds. *New Directions in American Intellectual History* (Baltimore: Johns Hopkins Univ. Press, 1979), 212–26.

Teall, Dorothy. "Bourne into Myth." *Bookman*, 75 (Oct. 1932), 590–99.

Tomkins, Calvin. "The Rose in the Eye Looked Mighty Fine." *New Yorker*, Mar. 4, 1974, pp. 40–66.

True, Michael D. "The Achievement of a Literary Radical: A Bibliography of the Writings of Randolph Silliman Bourne." *Bulletin of the New York Public Library*, 69 (Oct. 1965), 523–36.

———. "Writings about Randolph Bourne." *Bulletin of the New York Public Library*, 70 (May 1965), 331–37.

Wright, Willard Huntington. "The Aesthetic Struggle in America." *Forum*, 55 (Feb. 1916), 201–20.

Zigrosser, Carl. "Alfred Stieglitz." *Twice-A-Year*, 8–9 (Spring-Summer 1942, Fall-Winter 1942), 137–45.

———. "Randolph Bourne." *Modern School* (Jan. 1919), 5.

Zilczer, Judith K. "The Armory Show and the American Avant-Garde: A Reevaluation." *Arts Magazine*, 53 (Sept. 1978), 126–30.

————. "The World's New Art Center: Modern Art Exhibitions in New York City, 1913–1918." *Archives of American Art Journal,* 14 (1974), 2–7.

Unpublished Material

Bourke, Paul Francis. "Culture and the Status of Politics, 1909–1917: Studies in the Social Criticism of Herbert Croly, Walter Lippmann, Randolph Bourne, and Van Wyck Brooks." Ph.D. diss., University of Wisconsin, 1967.

Gregory, Alyse. "Randolph Bourne: Life and Selected Letters." Ms., Collection of American Literature, Beinecke Rare Book and Manuscript Library, Yale University, New Haven.

Haines, Robert Eugene. "Image and Idea: The Literary Relationships of Alfred Stieglitz." Ph.D diss., Stanford University, 1968.

Hartley, Marsden. "The Spangle of Existence: Casual Dissertations." Ms., Collection of American Literature, Beinecke Rare Book and Manuscript Library, Yale University, New Haven.

Kent, Richard J., Jr. "Alfred Stieglitz and the Maturation of American Culture." Ph.D. diss., Johns Hopkins University, 1974.

Levin, Sandra Gail. "Wassily Kandinsky and the American Avant-Garde, 1912–1950." Ph.D. diss., Rutgers University, 1976.

McGrath, Jack, as told to Arthur M. Row. "The Legend of Greenwich Village." Typescript. New York Public Library.

Pumphrey, Martin. "Art and Leadership in America: The Quest for Synthesis." Ph.D. diss., University of Iowa, 1977.

Rosenblum, Naomi. "Paul Strand: The Early Years, 1910–1932." Ph.D. diss., City University of New York, 1978.

Sacks, Claire. "The *Seven Arts* Critics: A Study of Cultural Nationalism in America, 1910–1930." Ph.D. diss., University of Wisconsin, 1955.

Zilczer, Judith Kathy. "The Aesthetic Struggle in America, 1913–1918: Abstract Art and Theory in the Stieglitz Circle." Ph.D. diss., University of Delaware, 1975.

INDEX

Page numbers in *italics* indicate illustrations.